Adobe® Photoshop®

Lightroom™
Workflow

Adobe® Photoshop®

Lightroom™ Workflow

The Digital Photographer's Guide

Tim Grey

WILEY PUBLISHING, INC.

Acquisitions and Development Editor: Pete Gaughan
Technical Editor: Robert Birnbach
Production Editor: Rachel Meyers
Copy Editor: Sharon Wilkey
Production Manager: Tim Tate
Vice President and Executive Group Publisher: Richard Swadley
Vice President and Executive Publisher: Joseph B. Wikert
Vice President and Publisher: Neil Edde
Compositor: Chris Gillespie and Maureen Forys, Happenstance Type-O-Rama
Proofreader: Nancy Riddiough
Indexer: Jack Lewis
Anniversary Logo Design: Richard Pacifico
Cover Designer: Ryan Sneed
Cover Images: André Costantini

For general information on our other products and services or to obtain technical support, please contact our Customer Care Department within the U.S. at (800) 762-2974, outside the U.S. at (317) 572-3993 or fax (317) 572-4002.

Wiley also publishes its books in a variety of electronic formats. Some content that appears in print may not be available in electronic books.

Library of Congress Cataloging-in-Publication Data

Grey, Tim.

 Lightroom workflow : the digital photographer's guide / Tim Grey.

 p. cm.

 Includes index.

 ISBN 978-0-470-11919-8 (pbk.)

 1. Photography—Digital techniques—Computer programs. 2. Adobe Photoshop lightroom. I. Title.

 TR267.5.A355G74 2007

 006.6'9—dc22

 2007002730

10 9 8 7 6 5 4 3 2 1

Dear Reader

Thank you for choosing *Lightroom Workflow*. This book is part of a family of premium-quality Sybex graphics books, all written by outstanding authors who combine practical experience with a gift for teaching.

Sybex was founded in 1976. More than 30 years later, we're still committed to producing consistently exceptional books. With each of our graphics titles, we're working hard to set a new standard for the industry. From the paper we print on, to the writers and artists we work with, our goal is to bring you the best graphics books available.

I hope you see all that reflected in these pages. I'd be very interested to hear your comments and get your feedback on how we're doing. Feel free to let me know what you think about this or any other Sybex book by sending me an email at nedde@wiley.com, or if you think you've found an error in this book, please visit http://wiley.custhelp.com. Customer feedback is critical to our efforts at Sybex.

Best regards,

NEIL EDDE
Vice President and Publisher
Sybex, an Imprint of Wiley

To the old man selling hand-carved wooden angels in Köln, Germany. What a difference a handshake can make.

Acknowledgments

Sometimes it feels so unfair that I get most of the credit for the books that bear my name. All too often those who work behind the scenes don't get the credit they deserve. For the vast majority of my books, one person has consistently supported me, gently prodded me, and helped to make sure I did everything I needed to do (even if it was past deadline) so the latest book could actually get printed. That person is Pete Gaughan, and I can assure you that at least a few of my books would have never seen the light of day without his support and help. Pete, I've caused far too much stress for you as I let deadlines slip, and you deserve much of the credit for the books I am so proud to have written. Thank you for all you've done for me. Your kindness doesn't go unnoticed.

I'm incredibly proud of my two daughters, Miranda and Riley, and appreciate the inspiration they provide for me. Both have taught me so much, and I feel remarkably lucky to be blessed with them in my life.

My family also doesn't get enough credit for helping me get where I am. Thanks in particular to Mom, Heidi, Amy, Tiffanie, Grandma, and Greg. And of course, thank you to Bob. Though he is no longer with us, his influence will live with me forever.

I am very grateful to André Costantini for providing the incredible photographic images that grace the pages of this book. André is a talented photographer who was kind enough to share many of his images to help illustrate these pages. I think you'll agree that they add to the enjoyment of the topics discussed. More of his great images can be viewed at www.sillydancing.com. Thank you, André.

Thank you to the many friends who have supported me in so many ways over the years, including Angel, Bruce, Dan, Marianne, John, Peter, Jeff, Mike, and everyone else who has supported me.

I also want to thank the entire Lightroom team at Adobe for creating a great product for me to use and write about.

And finally, I'd like to thank all the great people at Wiley, and specifically Sybex, who helped make this book possible. I already mentioned editor Pete Gaughan, who shepherded this project with tremendous patience. I also want to thank Robert Birnbach for his efforts as technical editor, production editor Rachel Meyers, copy editor Sharon Wilkey, and compositor Chris Gillespie at Happenstance Type-O-Rama. The entire team at Wiley has been a joy to work with, and I appreciate all the effort they've put forth to help me produce the best books possible.

About the Author

A lifetime of working with computers and a love of photography combine as the perfect passion for Tim Grey. He loves learning as much as he possibly can about digital imaging, and he loves sharing that information even more. He does so through his writing and speaking appearances. He has authored or coauthored over a dozen books on digital imaging for photographers, including *Color Confidence* (Sybex, second edition 2006) and *Photoshop Workflow* (Sybex, 2007). His articles have been published in *Outdoor Photographer*, *PCPhoto*, and *Digital Photo Pro* magazines, among others. He also presents seminars and workshops at a variety of industry trade shows and other venues.

Tim also publishes a regular "Digital Darkroom Questions" email list, where he answers questions related to digital imaging for photographers. To add your email address to the list, visit www.timgrey.com.

Contents

"This new category of software will close the loop for digital photographers."

Introduction

Adobe Photoshop Lightroom is a brand new product that fits into a new category of software offering an end-to-end workflow for digital photographers. It is my belief that this category of software will "close the loop" for them.

For years, photographers were focused on improving their skills at capturing better images. Books, seminars, workshops, field trips, and other offerings were utilized by countless photographers to improve their skills behind the camera.

When digital cameras started taking photography by storm, things shifted. More and more photographers were more interested in improving their computer skills to make the most of their digital images. Instead of learning about photography, they were by and large learning how to use Photoshop, how to best manage their images, how to deal with color management, and other similar issues. Digital was new to them in terms of photography, and they wanted to learn everything they could to take full advantage of what digital had to offer.

Of course, during this time many photographers started to realize that they were spending so much time behind the computer, they didn't have much time available to be behind the camera. They enjoyed the process of working with their images digitally, especially the ability to exercise so much control over the final image, but they really wanted to be spending more time with their camera. They may not have realized it, but this focus on digital also meant they likely weren't maximizing their photographic skill because they were so focused on their digital skills.

After you've read this book and are making full use of Lightroom, you'll find you are able to manage and process your images much more quickly. As a result, you'll need to spend less time at your computer. You'll enjoy the time you do spend working with your images more, and you'll have more time to get out and take more pictures.

I think for many photographers, the efficiency that an application such as Lightroom can introduce into their digital workflow will inspire them to spend more time on their photography, and to spend more time improving their photographic skills. Is it possible that Lightroom will actually improve the quality of photography at large? We'll have to wait and see....

Regardless of what Lightroom does for photography, it will most certainly provide you with significant benefits. You've probably experienced the frustration—at one time or another—of not being able to find a particular image, or of spending far too long creating proof prints for clients, or of trying to create a web gallery of favorite images to share with friends, or any of the other tasks that can be so time-consuming. Lightroom will enable you to get things done easier and in less time. It offers a consistent interface for performing the tasks that are most important to you in your digital photography workflow. And this is only the beginning. The first release of Lightroom offers tremendous workflow advantages to the digital photographer, but Adobe will continue to provide new versions with new features and improvements to make the product—and therefore your experience and efficiency—even better.

Who Should Use This Book

This book is well suited to any digital photographer who wants to maximize the efficiency of their workflow by using Adobe Photoshop Lightroom. Whether you're just getting started in digital photography and looking for direction, or a master who has been working with digital images for years, this book will help you. You'll find this book easy to read and understand, as you are guided through a practical approach to using Lightroom to maximize the efficiency of your workflow.

If you haven't started using Lightroom yet, this book will help you understand the benefits it offers, and may well convince you to immediately start using Lightroom to manage your images. If you've already been using Lightroom, this book will help show you the best ways to work within Lightroom. In either case you'll be better prepared to optimize your workflow so you can spend less time at the computer and more time behind the camera.

What's Inside

This book covers the full workflow for optimizing your images. Here's a quick guide to what each chapter covers:

Chapter 1: Workflow Foundations helps you prepare for a workflow that revolves around Lightroom.

Chapter 2: Configuring Lightroom shows you the many configuration options available in Lightroom, and guides you through making decisions about which settings are most appropriate for you.

Chapter 3: Library demonstrates the best techniques for organizing and managing your images by using the Library module in Lightroom.

Chapter 4: Develop includes detailed coverage of the many nondestructive tonal and color adjustments available in Lightroom so you can optimize your images.

Chapter 5: Slideshow teaches you everything you need to know in order to quickly create digital slideshows for sharing your images.

Chapter 6: Print shows you how to print your images to meet a variety of needs, from fine-art prints to contact sheets of many images.

Chapter 7: Web covers the process of creating web galleries quickly and easily so you can share your images on the Web.

The appendix is a concise checklist of the steps to follow to build a professional photo workflow with Lightroom.

How to Contact the Author

Sybex strives to keep you supplied with the latest tools and information you need for your work. Please check their website at www.sybex.com for additional content and updates that supplement this book. Enter **lightroom** in the Search box (or type the book's ISBN, **0470119195**), and click Go to get to the book's update page.

If you'd like to provide feedback about this book, or input on the types of books you'd like to see from me in the future, you can contact me via email at tim@timgrey.com. More information about my writing and appearances can be found on the Web at www.timgrey.com.

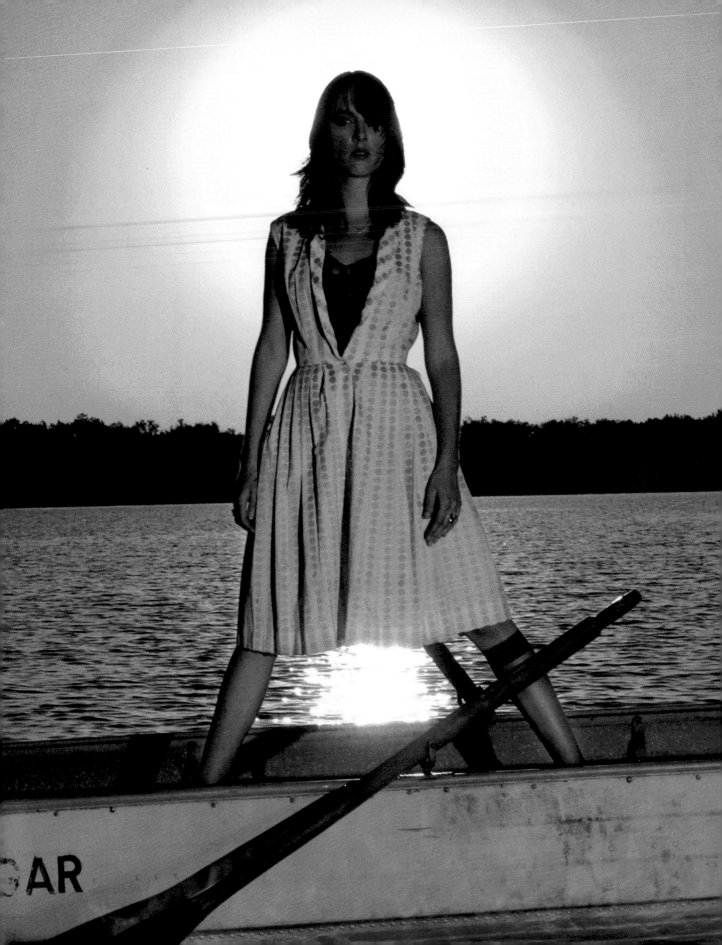

Workflow Foundations

1

Adobe Photoshop Lightroom provides an end-to-end workflow solution, helping you work more efficiently with your digital photographs. Before you get started working with the many features you'll find in Lightroom, it is important to understand some of the fundamentals of workflow, especially as it relates to the approach Lightroom takes to that workflow. Then you'll be ready to dive in and start getting to know Lightroom, and using it to manage and process your digital photographs.

Chapter Contents
Getting Organized
Lightroom Workflow

Some Background

It still surprises me how quickly so many photographers made a complete switch from film photography to digital photography. Very early in the development of digital photography, it was clear there would be significant benefits. But human nature being what it is, it seemed reasonable to expect that the transition would be slow and cautious.

Instead, photographers made the switch with incredible speed. I think this took most of the industry by surprise—even those who were rooting for the success of digital cameras. In fact, digital photography grew at a frantic pace not only because many photographers saw benefits in digital photography compared to film, but also because the accessibility provided by digital imaging created tremendous enthusiasm. Many who are enjoying digital photography today never pursued film photography as a passion or hobby. Digital has certainly increased the number of photographers out there who could be considered very serious about it for art, business, or pure fun.

Although digital photography offers many benefits over film, there are also drawbacks. In fact, some of the great advantages led to challenges. Because there wasn't the sense of "wasting film," and because after purchasing gear there really wasn't an incremental cost for each new digital photograph that was captured, photographers have generally found themselves capturing far more images with digital cameras than they ever did with film. That creates an incredible challenge when it comes to processing and managing images. Many photographers feel that their digital captures are locked away inside their computer, either difficult or impossible to access.

Early on, digital photography could be thought of as being something akin to a big experiment. Tools were generally difficult to learn and customized to a particular task. And the tools didn't provide an end-to-end solution for photographers dealing with their images. Many photographers had to cobble together a variety of tools to meet their needs, with perhaps one application used for downloading images onto the computer, another for browsing and sorting the images, and yet another for optimizing and printing those images. It wasn't efficient, and it certainly created barriers for many photographers. Still, somehow we found a way, in large part because of our tremendous enthusiasm and also because we enjoyed the control we were able to exercise without the challenges (and smelly chemicals) when processing film images.

Fortunately, the trend in digital is for things to move pretty quickly. This has certainly been the case with digital photography. The number of software applications aimed at digital photographers grew very quickly, and they became better with each new release. Photographers were still cobbling together a solution from a variety of applications, but those applications were more feature-rich and efficient.

More recently, as photographers started getting a handle on the processing of their digital images, they also started realizing some of the many challenges inherent in a digital photography workflow. Specifically, they realized that the workflow didn't flow very smoothly at all in many cases. Workflow became a major buzzword, and was often cited by photographers as the number one issue they were concerned about in their photography. Workflow effectively focuses on the process you go through from

the time the images get onto your computer, organize them, optimize them, and share them with others.

Many software developers heard the concerns of photographers, and started addressing those concerns in their software applications. Instead of leaving the photographer to move the image through each step of their workflow, applications started offering features that helped move the images through the workflow. Some of these efforts included bringing features that had previously been handled by separate applications into one place, such as the addition of a File Browser and then Adobe Bridge to Adobe Photoshop (www.adobe.com). In other cases it was reflected in a more process-oriented approach to handling images, such as the concepts applied to the Capture One software for processing RAW images from Phase One (www.phaseone.com).

Adobe Photoshop Lightroom—the subject of this book—represents Adobe's latest effort to address the need for a cohesive and efficient end-to-end workflow for digital photography. It combines the core features photographers need to be able to organize, manage, optimize, and share their images (Figure 1.1).

Note: Thank you to photographer André Constantini (www.sillydancing.com) for providing the beautiful photographs for this chapter.

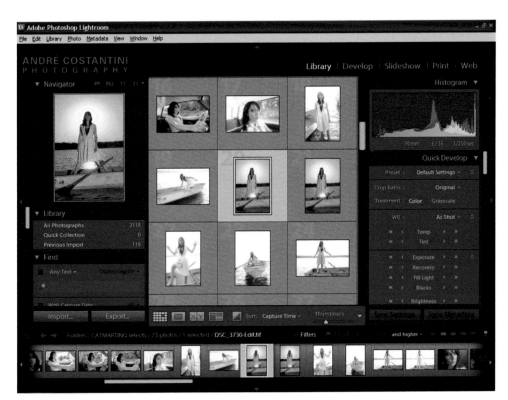

Figure 1.1 Lightroom provides a cohesive and efficient way to handle end-to-end workflow.

Designed for a Sensible Workflow

Lightroom is best thought of as a workflow tool for digital photography. I think of it as "command central" for managing and processing digital photographs. To understand what Lightroom provides, it is helpful to understand the basic stages of a digital photography workflow. The key stages of such a workflow are as follows:

Importing There are various names and approaches to this phase of the workflow. In general, this is when the images are copied onto your computer or imported into a database so you can actually view the images.

Sorting You need to be able to review and evaluate your images so you can decide which aren't worth keeping, which are your favorites, and which you want to process in some way.

Managing Especially because photographers tend to capture many more images with digital cameras then they ever did with film, it is critical that you have some method for managing your images so you can find the one you need when you need it.

Optimizing No matter how well you've configured your camera to capture a particular image, you'll likely need to apply some adjustments to the images in order to make them look their best or realize your photographic vision.

Sharing Whether you are sharing your images through prints, digital slideshows, websites, or other means, you want to have a way to share those images quickly and easily with others.

Lightroom provides solutions for all of these stages of a digital photography workflow—in one application with a common interface that makes it easy to learn in a relatively short period of time.

Lightroom Modules

Lightroom divides your workflow into five individual modules that each address specific stages of the workflow. The modules are as follows:

Library This module provides tools that enable you to import, sort, manage, locate, and apply basic adjustments to your images (Figure 1.2). It is the module you'll likely use most often in Lightroom as you work with your images. Lightroom is not an image browser, but rather a form of image management tool. You can't view images in Lightroom until you have imported them into the Lightroom database.

Develop This module provides tools for applying adjustments to your images, including RAW captures (Figure 1.3). It is important to realize that Lightroom provides a nondestructive optimization solution. That means that all adjustments you apply in Lightroom don't alter your original pixel values, but are rather stored as instructions within Lightroom about what adjustments should be applied to the image, and those adjustments are applied on the fly to the preview images you see within Lightroom.

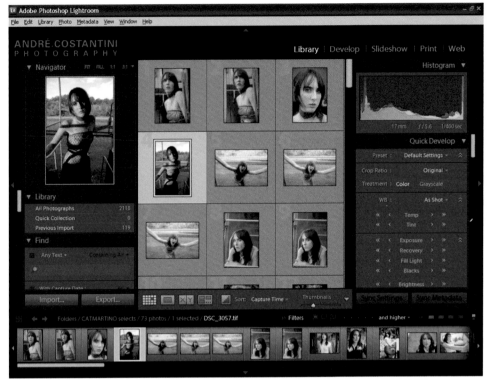

Figure 1.2 The Library module enables you to import, sort, manage, locate, and apply basic adjustments to your images.

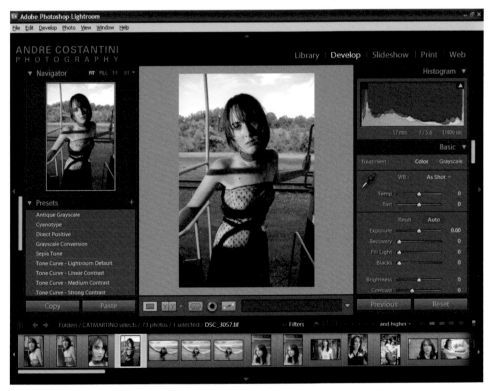

Figure 1.3 The Develop module is where you'll make most of your adjustments to images within Lightroom.

Slideshow This module allows you to quickly create basic digital slideshows for sharing your images (Figure 1.4).

Print This module allows you to print your images with great flexibility and control, producing anything from fine-art prints with a single image filling the page to contact sheets with many images per page (Figure 1.5).

Web This module allows you to create web galleries for sharing your images on the Internet very quickly and easily (Figure 1.6). It even allows you to enter your server information so the web gallery can be automatically uploaded to your website from within Lightroom.

Workflow Strategy

Each of the modules in Lightroom is the topic of an individual chapter of this book. But just as this book is a cohesive unit divided into chapters, you should think of each of the modules in Lightroom as part of a single unit. As you work through each of the chapters, keep in mind that all of the modules work together, and that each represents a stage of your workflow. You can move between modules very easily as you work on your images, and don't need to think of them as individual components that stand alone.

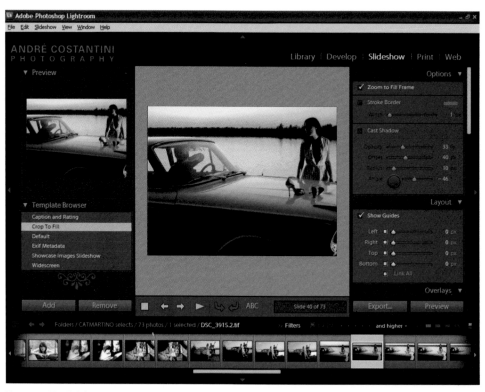

Figure 1.4 The Slideshow module makes it easy to quickly create digital slideshows.

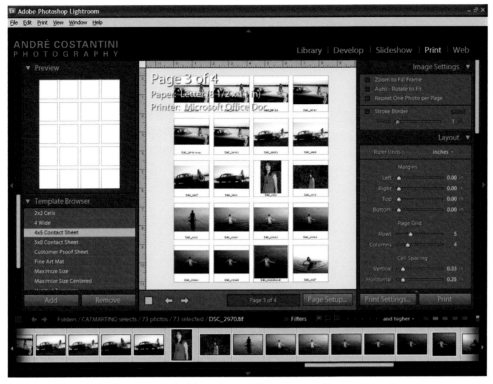

Figure 1.5 The Print module provides great flexibility and control for creating printed output with your images.

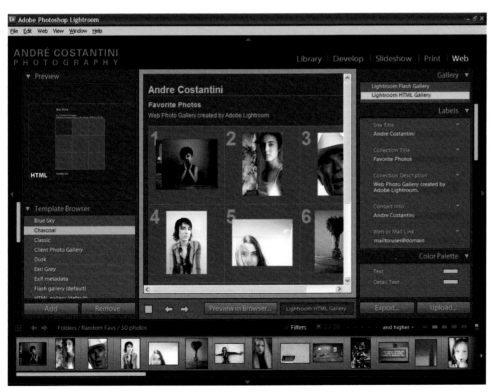

Figure 1.6 The Web module enables you to create web galleries to showcase your images.

Photoshop Replacement?

As you review the list of features found in each of the modules, you may wonder how Photoshop fits into the picture. The Library module contains many of the features and capabilities you'll find in Adobe Bridge and Adobe Camera Raw, both included as part of Photoshop. The Develop module contains tools for optimizing your photos that match many of the capabilities of Photoshop. The Slideshow, Print, and Web modules contain features that are similar to some of the automation tools found in Photoshop. In many ways, Lightroom contains the core capabilities of Photoshop that photographers are most interested in, bundled into a new interface with a more cohesive approach to the tasks photographers need to perform. This raises the question among many photographers as to whether Lightroom represents a replacement for Photoshop.

In some respects, Lightroom is exactly that. It provides all the basic features most photographers need, and might otherwise find in Photoshop. However, I consider it to be very much a supplement to Photoshop, not a replacement.

The key area where Lightroom leaves room for Photoshop is in the depth of adjustments you can apply with Photoshop. Lightroom doesn't, for example, include any ability to apply targeted adjustments to your images. I therefore think of Lightroom as a basic tool that provides enough adjustments for you to share your images with clients, but in some cases not the deeper features that will enable you to produce an image that you feel is truly ready to be considered "final."

As a result, I feel that Photoshop still has a significant role in any workflow, even with Lightroom. I cover the details of an image-optimization workflow in Photoshop in my book *Photoshop Workflow* (Sybex, 2007). Although Lightroom is a very powerful tool that allows you to process your images with great flexibility and efficiency, it is still first and foremost a tool for managing your images. You'll still often find the need to apply more-sophisticated adjustments with Photoshop. Think of Lightroom as providing an image-management workflow with some optimization, and Photoshop as providing an image-optimization workflow. The two work together to help you stay organized while producing the very best images possible.

Fortunately, Lightroom makes it easy to open images in Photoshop when the need arises, so the workflow stays cohesive and efficient even when Lightroom doesn't provide all the features you need.

We'll have to wait to see what the future holds for Lightroom. It is certainly conceivable that more image-optimization features will be added, and that Lightroom will become more of a competitor to Photoshop. In the meantime, the two work together to provide powerful solutions for digital photographers.

In general you'll likely find yourself moving through the modules in order. Each is listed at the top-right corner of the Lightroom interface, and you can switch between them by clicking on the name of the module you want to work in. As you do so, the images you're working on don't change. You select the images you want to work on in the Library module, and then work on them by switching to the other modules as appropriate, based on what you want to accomplish with the current images. Throughout each of the modules, you'll notice that the filmstrip along the bottom maintains a persistent view of the images you have selected in the Library module. This is just one example of the notion that Lightroom provides a single workflow that is simply structured into multiple modules to help you divide your work into more-manageable segments.

As you're getting started with Lightroom, I recommend that you move through the modules in order, from the Library module to Develop, and then through Slideshow, Print, and Web. The first two I think of as being somewhat "mandatory," in the sense that you certainly want to organize all your images and probably want to optimize at least your favorite images. The final three are all about sharing your images, and whether you use any, some, or all of them depends on your needs for a specific group of images.

Although any new software application can be a bit intimidating or overwhelming at first, I think you'll quickly find that Lightroom provides a logical and efficient approach to working with your images. This book will guide you through each of the modules and show you how to work with your images in each, and I think you'll soon realize that Lightroom is quite simple to work with, despite the many powerful features it provides. After you've finished reading this book and spent some time processing your images in Lightroom, I think you'll agree that it is a pleasant—even fun—experience. You'll gain efficiency in working with your images, and will likely find that Lightroom provides the time savings you need to be able to spend less time in front of your computer, and more time behind your camera doing what you enjoy most.

A Typical Workflow

To give you a sense of how well suited Lightroom is to enabling an efficient workflow, I think it is helpful to consider how you'll use Lightroom to work with your images.

Imagine that you return from a photo shoot, whether that's in your own studio or halfway around the world. You launch Lightroom and use it to download your images from your digital media cards and import them all in one step.

You then use the Library module to review the images. You start with a quick overview, using the grid view of the images. Then you start to review them in more detail, using the loupe view to get a close look at the images and decide which are your favorites and which should be discarded. You apply metadata to the images, adding your copyright information and perhaps adding keywords to individual images to help you find them later. As you're going through your images, perhaps

you even apply some quick adjustments to get them closer to matching your original vision. As you start to decide which are your favorites, you apply star ratings to the images. As you prepare to move on to the next step of the workflow, you might filter the images so you're looking at only the four- and five-star-rated images from the current photo shoot.

Wanting to spend some time making your favorite images from the shoot look their best, you move to the Develop module. Here you apply tonal and color adjustments to individual images as you examine them closely. This work goes pretty quickly, as you can use the filmstrip display to select individual images and then use the various sliders to apply adjustments to each image.

At this point you're ready to share your images. Lightroom provides plenty of options to you in the Slideshow, Print, and Web modules. Perhaps you immediately jump to the Web module so you can take your best images from the current photo shoot and quickly post them to an image gallery on your website. This is a simple matter of selecting the images, selecting the template, and uploading the result to your website because you have already entered your server information in the settings. Next you might create a slideshow, literally in seconds, so you can show the best images to your clients or friends. Next you might create a set of prints from the images so you can share those with clients. In total you probably spend about five minutes creating a web gallery, digital slideshow, and prints of the best images from the shoot. The only real time involved here is waiting for the printer to create the printed output, thanks to the efficiency of the Lightroom workflow.

How I Think about Lightroom

Lightroom is a completely new software application. Obviously, Adobe built upon a huge amount of experience from the work they've done on Photoshop and other applications. But with Lightroom, they had the luxury of starting from scratch.

Lightroom contains many indications of its ties to the past. In many ways it includes the features you'll find in the various components of Photoshop, which you're probably already familiar with. As I have said, the core features of Lightroom are contained in some form in Bridge and Adobe Camera Raw, as well as the various adjustment and automation tools found in Photoshop. In fact, at some very basic level you can perform just about every task you might otherwise perform in Lightroom by using Photoshop. So why would you use Lightroom?

My answer lies in how I actually think about Lightroom. Although it contains many of the features you'll find in Photoshop, the major benefit is that Lightroom was created from the ground up with workflow in mind. Although Photoshop improves significantly with each new release, each new release is an update to an existing product that requires a certain amount of continuity in the user experience. With Lightroom Adobe was able to start from scratch, making decisions based on what was best for the photographer rather than what made the most sense in the context of Photoshop.

continues

How I Think about Lightroom *(Continued)*

As a result, Lightroom is a simple and efficient application that enables you to work quickly with your images. After you've gone through this book and have become familiar with what Lightroom has to offer, your first reaction is probably to think that Lightroom is a relatively simple application that in some ways doesn't offer a huge number of features. However, as you continue working with Lightroom I think you'll find that it offers an elegant solution to the photographer workflow. It isn't overly complex, and yet it still affords tremendous flexibility. More importantly, because it maintains a certain degree of simplicity, it allows you to work very quickly after you've become familiar with all it has to offer. This book aims to give you exactly that level of understanding, so you'll grow to see Lightroom as a tremendous asset in your digital photography workflow.

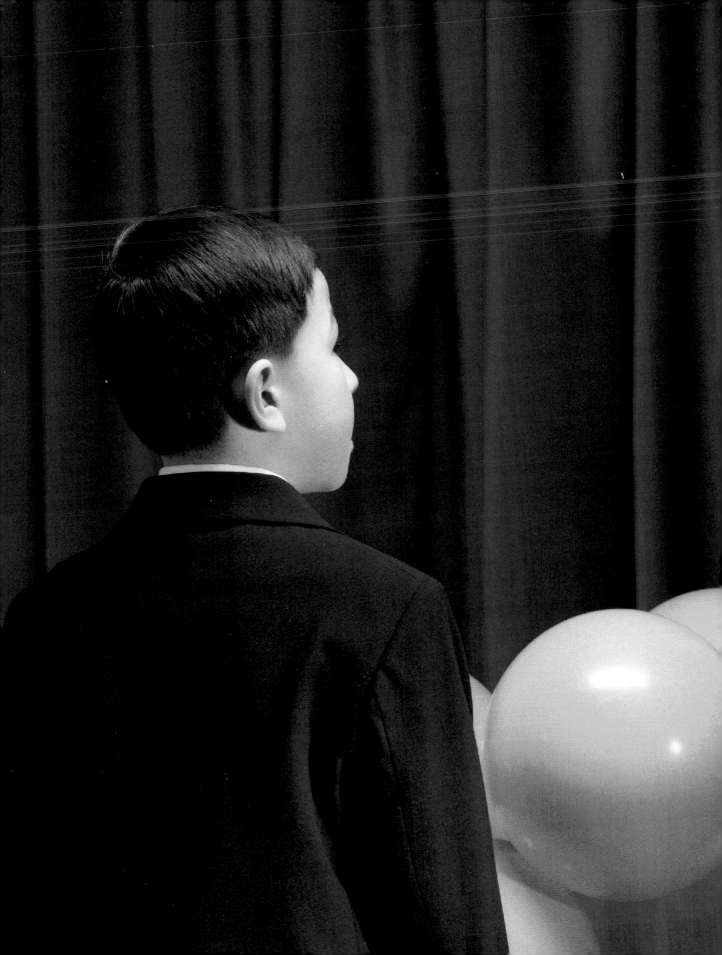

Configuring Lightroom

2

Just as each photographer tends to have a work-flow that meets their specific needs, Lightroom contains a wide variety of configuration options that allow you to modify its appearance or behavior. In this chapter I'll show you the many options available and provide suggestions on how you may want to set those options. When you're finished, you'll have a Lightroom environment tailored to your preferences and you'll be ready to move on to the real work of processing your images.

Chapter Contents

Understanding the Lightroom Interface

Before you jump into configuring or using Lightroom, it is helpful to have an understanding of how the interface is organized. That interface—appropriately enough—revolves around your images. Although there are many interface elements you can use to control how you view, find, and process your images, the images are always central to the experience. In fact, by using a few quick keystrokes, you can quickly switch from a display rich with information and controls to a display that shows your image almost exclusively (Figure 2.1).

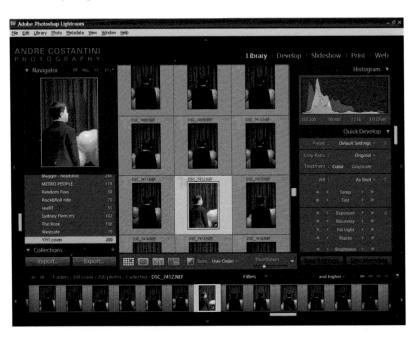

Figure 2.1 Lightroom makes it easy to switch from an information-rich display to one that shows a single image almost exclusively.

The Lightroom interface with all the available controls displayed has five major areas: the identity plate, the primary display, the left panel, the right panel, and the filmstrip at the bottom (Figure 2.2).

Identity plate Primary display Right panel

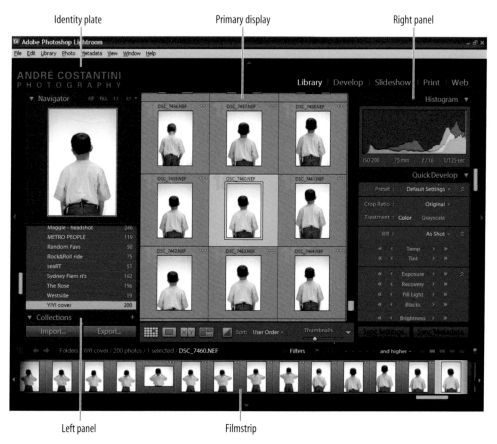

Left panel Filmstrip

Figure 2.2 With all of the available controls visible, the Lightroom interface is divided into five key areas.

Identity Plate

The identity plate is the simplest of the areas within Lightroom, with very few controls. It resides directly below the menu bar and serves as a banner across the entire width of the Lightroom display (Figure 2.3). You can hide the identity plate by clicking the triangle at the center of the top edge of this area of Lightroom. To show it again, either click the triangle again or hold your mouse over the area where the triangle is displayed at the top of the window. I'll talk more about hiding and showing the elements within the Lightroom window later in this chapter.

Note: The identity plate is a good candidate for hiding and then revealing by moving your mouse to the top of the window, because the only real controls are for changing modules, which aren't accessed as often as the other controls in Lightroom.

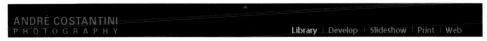

Figure 2.3 The identity plate spans the full width of the Lightroom interface directly below the menu bar.

On the left side is the namesake of the identity panel, and as you'll see later in this chapter it is where you can customize the interface with some branding. To the right are the links to the various modules found in Lightroom.

As discussed in Chapter 1, "Foundations of Workflow," Lightroom divides your workflow into five modules, and links to each of the modules can be found at the far right of the identity plate. These are simple text buttons that enable you to quickly shift between the different stages of your workflow within Lightroom (Figure 2.4). Much like the branding side of the identity plate, the text appearance for the module buttons can be customized as discussed later in this chapter.

Library | Develop | Slideshow | Print | Web

Figure 2.4 The modules are accessed from text links at the right of the identity plate.

Status Indicator

Whenever Lightroom is processing a task that requires some time, it shows a status indicator in place of the identity plate (Figure 2.5). This status indicator makes excellent use of a small amount of space, providing a significant amount of information about the task being processed. This information includes a thumbnail of the image currently being processed, text describing the task being performed, and text showing the path of the image currently being processed. In addition, a progress bar is displayed, showing the relative progress toward completion. At the end of the progress bar is an X you can click to cancel the task.

If you start more than one task, the display will change to include text indicating the number of tasks that are in progress, with individual progress bars for each. The thumbnail will be replaced by a black box (Figure 2.6).

Figure 2.5 The status indicator replaces the identity plate whenever Lightroom is processing a task and indicates the progress of that work.

Figure 2.6 When Lightroom is performing multiple tasks in the background, the status indicator changes to reflect that information.

The Panels

There are two panels in Lightroom, one along each side of the main window. The contents of each panel change based on the module you're currently working in. The left panel generally contains broader controls that affect navigation or layout options (Figure 2.7). The panel on the right side contains more-specific information and controls for fine-tuning adjustments or settings for the work you're currently performing (Figure 2.8). I'll talk about all of the controls as we work through the workflow for each module in later chapters, but for now, know that you'll find all of them on one of these two panels.

Working with the panels is straightforward. There are a variety of controls and adjustments available, and they can be adjusted directly within the panels.

Figure 2.7 The panel on the left side of the Lightroom window contains more-general options that change with the current module. Shown here are the Histogram and Quick Develop controls available within the Library module.

Figure 2.8 The panel on the right side of the Lightroom window contains more-specific options for fine-tuning adjustments or settings, with the specific controls changing based on the current module. Shown here are the controls available with the Quick Develop module.

Navigating through Sections

In terms of the layout of the panels, there's not a lot to deal with. The two key things to keep in mind are the ability to collapse or expand individual sections of each panel and the ability to scroll to see sections that aren't currently visible if there are too many to fit on your current display.

Expanding and collapsing individual sections of the panels is done by clicking the triangle found next to the title for each section (Figure 2.9). If the triangle is pointing downward, it indicates that the section is currently expanded. If it is pointing left or right (depending on which panel it appears in), the section is currently collapsed. The control is a toggle, so simply click to change the current status. This is a quick way to clean up the interface a bit if there are particular sections of either panel that you don't typically use. For example, I rarely use the Camera Calibration section found in the right panel for the Develop module, so I tend to keep it collapsed just to simplify the interface a bit.

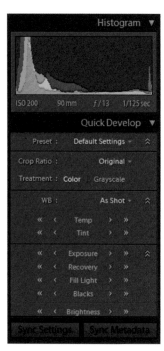

Figure 2.9 Each section of the panels can be quickly collapsed or expanded by clicking the triangle next to the title for each section.

In many cases, unless you're using a particularly high-resolution display, you'll find that there are more sections on the panels (especially the right panel) than can be displayed in the space available (Figure 2.10). When that's the case, there will be a scroll bar active along the outside edge of the panel. Simply click and drag the "handle" in the scroll bar to move up or down among the available controls. You can also click above or below the handle in the scroll bar to move in steps up or down, respectively, through the sections of the panel.

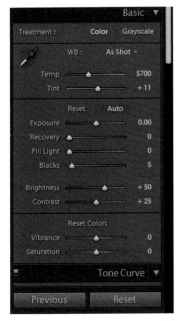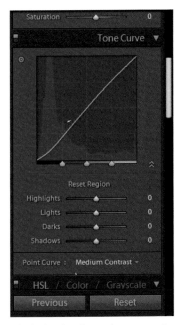

Figure 2.10 When there are more controls than can be displayed on the panel, you can scroll up or down to find the control you need.

Hiding and Showing Panels

Although the panels on either side of the Lightroom window are incredibly helpful and full of controls you'll use frequently, they do use up space on your monitor display. It is therefore very helpful at times to hide them from view.

> **Note:** I'm hoping that a future version of Lightroom will include the capability to move the panels onto a second monitor in much the same way you can move palettes in Photoshop, but that isn't possible with the current version.

Hiding the panels can be done in two basic ways. On the outer edge of each panel you'll see a small triangle, which will be pointing outward when the panels are visible. Click the triangle (you can actually click anywhere along the bar that contains the triangle) for the panel you want to hide, and it will slide off the display (Figure 2.11). The triangle will then change to a dotted triangle pointing inward. At this point, you can click that triangle to bring the panel back, but you might want to keep the panel hidden all the time, depending on your personal preference. Even when they're hidden, the panels can be brought back quickly and easily. Simply drag your mouse out toward the outer edge of the window, and the panel will pop back out, enabling you to work with the controls on that panel. When you move your mouse back toward the Lightroom window and off the panel, the panel will disappear again.

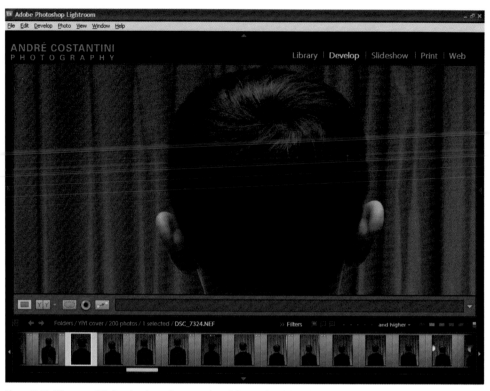

Figure 2.11 When you click the triangle on the outer edge of the panel, it slides off the Lightroom display to maximize the space available for the images you're reviewing.

I find that I tend to vary my approach to hiding the panels depending on what I'm currently working on. Sometimes I want to have the controls available to me all the time, and seeing the images as large as possible in an uncluttered display simply isn't all that important. For example, when using the Print module, I already know the images are ready to go, and I want to be able to adjust all the controls on both panels with minimal fuss. At other times, such as when doing an initial sorting after a photo shoot, I just want to see the images without a lot of clutter in the display.

You can use keyboard shortcuts to hide the panels quickly as well, and I find this to be a convenient way to quickly de-clutter the display. The keyboard shortcut for hiding the panels is Tab. Simply press the Tab key to toggle the panels on or off, which produces the same effect as if you had clicked the triangle to hide or show the panels. I'll talk about some other options for cleaning up the interface in Lightroom later in this chapter.

Primary Display

The primary display is central to Lightroom and consumes most of the available space of the display (Figure 2.12). As with so much of the Lightroom interface, this area changes based on the module in which you're currently working. I'll talk about each of the specific preview displays available as I discuss each module in later chapters. Just keep in mind that this area is central to the work you'll be doing in Lightroom and that you'll likely spend most of your time looking at this area of the window.

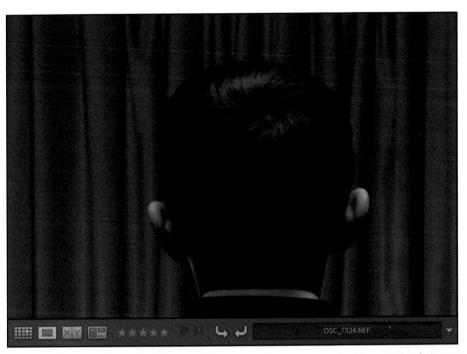

Figure 2.12 The primary display of the Lightroom window consumes the most space, and enables you to view the image or images you're currently working with based on the current module.

Filmstrip

The filmstrip, displayed across the bottom of the Lightroom window, provides a quick and easy way to navigate through a group of images and select those that you want to work with in a particular module (Figure 2.13). The filmstrip display is one of the few elements within Lightroom that remains consistent regardless of which module you're currently working in.

Figure 2.13 The filmstrip provides a quick and easy way to navigate through a group of images and select those you want to work with.

As with the panels, you can hide the filmstrip at any time by clicking the triangle at the bottom of the window, below the filmstrip itself. Simply click the triangle to hide

the filmstrip (Figure 2.14). You can then click the triangle again to bring the filmstrip back, or move the mouse over the bar at the bottom of the display to bring the filmstrip back temporarily until you move the mouse back off the filmstrip.

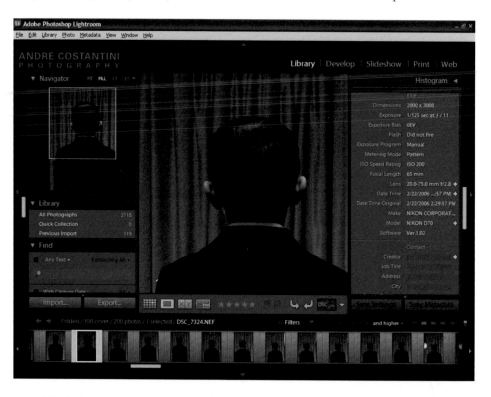

Figure 2.14 You can show or hide the filmstrip just as you can the panels.

If you tested out the Tab key shortcut to hide the panels earlier, you may have noticed that the filmstrip didn't disappear, despite having a control very similar to the panels for hiding the display. This is because the filmstrip panel is more likely to be used frequently even when you don't need the panels on the side of the Lightroom window. However, a shortcut key is still available. Simply hold the Shift key as you press Tab and you'll hide or show all panels at once. This will include the filmstrip, both side panels, and the identity strip.

I'll talk more about working with the filmstrip in the next chapter when I discuss the Library module.

Customizing Lightroom Behavior

So far I've talked about some of the ways you can customize the Lightroom interface. There are also a wide variety of settings available to you for customizing how Lightroom works and how it displays various interface elements. In this section, I'll guide you through the many options available to you.

Preferences

The Preferences dialog box contains most of the options that affect the overall behavior of Lightroom. To review or modify these settings, choose Edit → Preferences from the menu. The dialog box is divided into four sections: General, External Editors, File Management, and Interface. (Figure 2.15).

Figure 2.15 The Preferences dialog box is divided into four sections containing all the settings affecting the overall behavior of Lightroom.

General

The General section of the Preferences dialog box contains settings affecting the overall behavior of Lightroom. These are mostly a matter of personal preference.

In the Settings section are two check boxes. The Show Splash Screen During Startup check box determines whether the About dialog box (Help → About Adobe Lightroom) is displayed as Lightroom is loaded into memory when you launch it (Figure 2.16).

Figure 2.16 The splash screen doesn't serve any particular purpose during startup, but there's no harm in having it display.

The other check box in the Settings section is Automatically Check For Updates. I highly recommend keeping this check box selected so Lightroom will check for any updates that will fix bugs or add features online automatically. In general, it is best to work with the latest update to ensure that any problems in the program have been solved in the version you're working with.

The Default Library settings relate to the database containing all the information about your images. The first dropdown allows you to specify which library file (the database) should be opened when you start Lightroom. For most photographers this isn't a significant consideration because you aren't likely to use more than one library. Therefore, I recommend simply selecting the "Load most recent library" option. The second dropdown determines when you would like the library to be automatically backed up by Lightroom. Assuming you already back up all the data on your computer on a regular basis, I recommend the "Once a week, upon starting Lightroom" option. If you have a particularly consistent and reliable back up system already in place, you could even skip this backup, which would save you the additional time required upon startup. However, my feeling is you can never be too careful with your important data, so I recommend taking advantage of this additional backup option.

The Completion Sounds section offers a nice feature for photographers who tend to capture a large number of images on their photo shoots. Importing or exporting such a large collection of images can take considerable time, so you might tend to move on to other tasks at your desk while the process is being completed. By setting a sound from the drop-down list for either import or export operations, you can have Lightroom play a sound to alert you when those tasks are complete. A button is also available to Configure System Sounds, which will take you to the sound dialog box for your operating system.

The Prompts section includes a single button to "Reset all warning dialogs." Many warning dialog boxes include a check box that allows you to specify you don't want that particular warning to be displayed in the future. Clicking this button will cause all of those warnings to be displayed again as appropriate.

The Presets section contains four buttons that allow you to reset the default presets and templates within Lightroom. These buttons only affect the presets and templates that are included with Lightroom, and will not affect new presets and templates you have created. However, care should be taken not to use this reset option unless you're certain you don't in fact want to retain the changes you've made to the default presets and templates. I only recommend using this option if you've actually created a problem for your workflow by the changes you have made. When you click any of these buttons, a warning dialog box will appear to confirm you want to take the indicated action.

External Editors

The Application External Editor section enables you to designate a separate application that you want to use for making adjustments to images within Lightroom. I'll discuss using an external editor in Chapter 4, "Develop," but for now it is enough to assume that you'll likely use Adobe Photoshop or another editor for this purpose.

This section has two sets of the same controls. The first set are for adjusting the behavior of Photoshop as your primary editor. The second set apply to a second external editor you can specify. You can designate a second editor by clicking the Choose button found among the second set of controls and navigating to and selecting the executable for the other image editor you would like to use for images from Lightroom.

The controls are as follows:

File Format The File Format dropdown allows you to select between TIFF and PSD file formats. The TIFF format is recommended because it can be more efficient for metadata updates to the files.

Color Space The Color Space dropdown offers several options that determine the range of colors available in your images. If you are working in 16-bit (which is recommended, and the subject of the next control) you should use ProPhoto RGB because it offers the widest range of colors. If you are working with 8-bit you should use Adobe RGB (1998).

Bit Depth The Bit Depth dropdown allows you to select between editing images in 8-bit or 16-bit. This relates to the bit depth on a per-channel basis, but the controls list these as being per "component" instead of channel. This is because you may choose to edit images in applications other than Photoshop, which may not support channels. I recommend always working in 16-bit when possible, and since Photoshop provides extensive support for 16-bit images this makes it an easy choice. Of course, this does result in files that are twice as large, but it also means you are preserving a significantly greater amount of information for each image.

Compression If you select the TIFF option for File Format, the Compression dropdown will also be available. The default compression is None. For 8-bit images you can also select LZW or ZIP compression, which are two different algorithms that determine how the data is compressed. I recommend LZW if you prefer compression, as it provides

effective and lossless compression (your image data will not be altered). I don't recommend ZIP compression because many other applications that are able to read TIFF files are not able to read those compressed with ZIP.

For 16-bit images the only options are None and ZIP compression. I recommend the None option for greater compatibility, even though it means you won't be achieving the benefit of smaller file sizes.

File Management

The File Management section of the Preferences dialog box provides a series of settings that affect how Lightroom handles the various files it needs to create (Figure 2.17).

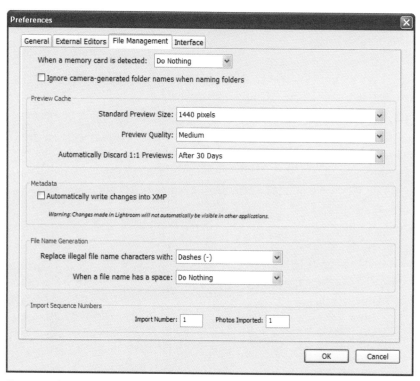

Figure 2.17 The File Management section of the dialog box contains settings related to the files created by Lightroom.

A dropdown at the top of this section allows you to determine what action should be taken when a memory card is inserted into a reader. The default is to "Show Import Dialog." Using this setting helps you streamline the process of bringing your images into Lightroom at the very start of your workflow. This option will be discussed in more detail in Chapter 3, "Library." If you don't want the Import dialog to be shown, simply select None from this dropdown. Below this option is a check box that allows you to have Lightroom ignore the camera-generated folder names when naming folders within Lightroom. I prefer to select this option so that I can use more meaningful folder names when importing images.

The Preview Cache section includes several options that relate to the previews of your images generated by Lightroom. The first dropdown determines the size of these previews. Several options are available, ranging from 1024 pixels to 2048 pixels. While

smaller sizes will require less time to generate, they also won't provide as much quality or detail unless a 1:1 preview is created (by zooming in to that setting within Lightroom). Of course, a larger setting is only helpful if your monitor display is set to a particularly high resolution. I actually don't find a significant benefit to any particular setting here, and simply use the default of 1440 pixels.

The next control in the Preview Cache section allows you to determine the quality of the previews that are generated by Lightroom. The options are High, Medium, and Low. While High quality is always preferred, keep in mind that these previews are generally used for overall image review. If you want to evaluate critical sharpness in an image you should switch to the 1:1 view option, which will cause Lightroom to generate a new full-resolution view of the image. I find the Medium setting more than adequate for basic image review.

The final dropdown provides an option to specify how often Lightroom should discard 1:1 (full-resolution) previews after they are created. I'll talk more about the use of these previews in Chapter 3, but I consider the default of After 30 Days to be a good choice. If hard-disk space is a significant concern, you can set a shorter duration. If you have all the hard-disk space you could ever need (but who does?), you can choose Never.

The Metadata section has a single check box that allows you to have Lightroom write changes that you've made into XMP sidecar files. These are files that contain additional information about the source image file. In the case of Lightroom, that primarily means the information about the adjustments you've applied to images. This setting can be especially helpful if you'll still use Adobe Bridge and Photoshop to work with your files, so I recommend keeping that option selected. Note that at this writing the Develop module settings are not compatible with Adobe Camera Raw.

The File Name Generation section includes some options for dealing with filename issues. The first allows you to specify a character to replace illegal filename characters (those not supported by your operating system). I recommend keeping this set to the default of Dashes so the change will be more obvious in the final filenames. The second option allows you to make changes when a space is included in filenames. However, because spaces are supported in filenames in the operating system, I recommend leaving this set to the default of Do Nothing.

The Import Sequence Numbers section includes two options that will automatically increment, but that can also be modified. The Import Number keeps a count of how many import operations have been completed. You can reset it at any time if desired (though there really isn't a good reason for most photographers to do this). The Photos Imported text box indicates the number of images in the current import, and will be reset with each import operation.

Interface

The Interface section of the Preferences dialog box contains a few settings related to the appearance of the Lightroom interface (Figure 2.18).

The Panels section includes two dropdowns. The first allows you to select the mark you would like to appear at the bottom of the left and right panels, indicating the

end of the panel. I personally find that the scroll bar reaching its end at the bottom of the panel is an adequate indication that the end has been reached, but if you like to have a more obvious indicator the "Box" or (in particular) "Flourish" options will make sure you clearly recognize the end of the panel. The other dropdown allows you to set the Panel Font Size, which affects how large the text within the panels appears. I generally leave this set to Small, which is the default setting. However, if you're using a particularly high resolution on your monitor, you might want to use the Large option to make the text easier to read. Similarly, if you're on a computer with a relatively low display resolution (such as a laptop), you might want to use the Small option to minimize the amount of space consumed by the text within the panels.

Figure 2.18 The Interface section of the dialog box contains settings related to the appearance of the Lightroom interface.

The Lights Out section includes two controls to modify the appearance of the display when you use the "Lights Out" option, which I'll discuss in Chapter 3, "Library." The Lights Out option allows you to dim everything but the image to help you better evaluate that image. The first option here determines how dim everything (except the image) should get when you apply the Lights Out display. The default is 80% (nearly black), which I find to be an appropriate value. The Screen Color allows you to set shade of gray (or black or white) to use for the overlay that produces the "Lights Out" appearance. I prefer to keep the default of black.

The Background section allows you to select a Fill Color for the background of the primary display within Lightroom. All of the options provided are neutral values

ranging from white to black, with three shades of gray in between. I prefer to keep this set to Medium Gray, which is the default, because it provides a good neutral value that doesn't cause a perceived change in the relative brightness of your images. You can also set an Overlay Texture in this section. The only options are None and Pinstripes. I prefer the None option because I find a striped texture around my image in the preview section to be a bit annoying (Figure 2.19).

Figure 2.19 I find the Pinstripes setting for Overlay Texture to be a bit annoying, so I leave this option set to None.

At the bottom of the Interface section you'll find three check boxes in the Tweaks section. The first allows you to "Show ratings and picks in filmstrip." While seeing these options (which I'll discuss in Chapter 3, "Library") can be helpful, I prefer to leave this setting off. There are many other options for seeing this information for your images, and they appear very small on the Filmstrip in any event. I find them to be more of a distraction than a benefit.

The next check box is "Zoom clicked point to center." This affects how the image is zoomed when you click on it in the primary display. By default, the image is simply zoomed with the center remaining in the center. By selecting this check box, the image will instead be zoomed so the point you click becomes the center of the display. I prefer to select this option, probably because I've grown so accustomed to this behavior with the Zoom tool in Photoshop.

The final check box allows you to use the operating system's settings for font smoothing instead of those employed by Lightroom. There's really no need to use this control unless you find the text in Lightroom doesn't appear particularly smooth (which is not likely to be the case).

Applying Your Preferences

When you're finished configuring your desired settings in the Preferences dialog box, simply click OK to apply the changes. Note that changes to the font smoothing option won't take effect until you restart Lightroom.

Identity Plate Setup

Earlier in this chapter I talked about the identity plate in Lightroom. It may seem a bit silly, or at least a bit egocentric, to put your branding within the Lightroom interface. However, consider that there is a good chance that many photographers will review images with their clients from within Lightroom, and you can probably appreciate the benefit that this extra branding might provide.

To modify the text for the identity plate, choose Edit → Identity Plate Setup from the menu. This brings up the Identity Plate Editor dialog box, which enables you to adjust the settings for both the branding and the module picker buttons (Figure 2.20).

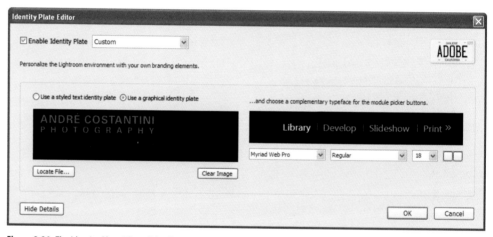

Figure 2.20 The Identity Plate Editor dialog box allows you to modify the branding within Lightroom as well as the text for the module picker buttons.

To enable the custom identity plate, be sure to select the Enable Identity Plate check box in the Identity Plate Editor dialog box. You can then choose between options to use stylized text or an image to apply your branding. For text, simply enter the text you want to have appear for the branding and then select the font, text size, text attributes, and color from the available options. If you prefer to use an existing graphic element for this branding, select that option and then either drag the image into the space provided or click the Locate File button to select a file on your computer to use for this purpose.

You can also change the text font, style, size, and color for the module picker buttons on the right side of the Identity Plate Editor dialog box. Note that there are

two color boxes you can click on. The first sets the color of the currently active module, and the second sets the color of the remaining modules.

The Hide Details button at the bottom-left of the Identity Plate Editor dialog box will hide the options that allow you to modify the module picker buttons. When clicked, that button will become the Show Details button. There's really no significant advantage to using this option because you'll likely not visit this dialog box very often, so I'd just leave it alone.

When you're finished making the desired changes, click OK to apply them, resulting in customized branding for your copy of Lightroom (Figure 2.21).

Figure 2.21 The Identity Plate Editor options allow you to customize the branding of your copy of Lightroom, which adds a nice touch when using Lightroom to review images with clients.

Customizing View Options

When you are working in either the Library or Develop modules, a View Options item is available from the View menu. For the other three options, this selection doesn't exist. Although the menu selection (View → View Options) is the same for both the Library and Develop modules, the dialog box is different for each one. In other words, choosing this item from the menu will get you a different dialog box depending on whether you're currently in the Library or Develop module.

Library View Options

When you're working in the Library module, the View → View Options menu selection brings up the Library View Options dialog box (Figure 2.22). The dialog box is divided into two tabs, one for each of the views available in the primary display area: Grid View and Loupe View.

Note: You'll notice that the Library View Options dialog box doesn't contain the typical OK and Cancel buttons. That's because the changes you make are applied instantly, enabling you to see the effect of the changes in real time. When you're finished making changes, simply close the dialog box.

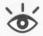

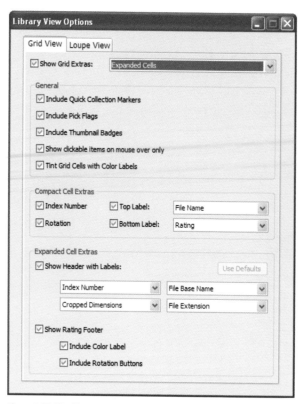

Figure 2.22 The Library View Options dialog box allows you to configure a variety of settings that affect how your images are displayed when you're working in the Library module.

Grid View Options

At the top of the Grid View section of the Library View Options dialog box is a Show Grid Extras check box that serves as a master on/off switch for the many display options available here. Clearing the check box disables all the other controls and turns off the applicable displays.

When the Show Grid Extras check box is selected, you can also select Compact Cells or Expanded Cells from the drop-down list to the right of the check box. The major difference between the two options is that Compact Cells causes the thumbnails to take up less vertical space than with Expanded Cells (Figure 2.23). I recommend using the Compact Cells option in most cases. Because of additional display options I'll discuss later in this chapter, it is possible to configure the Compact Cells display so that all information otherwise available in the Expanded Cells option is shown. The only reason to choose Expanded Cells view is if you feel the information is too "squeezed" otherwise. Expanded Cells causes the cell for each thumbnail to be enlarged vertically, and divides the cell into sections to help keep the information displayed separate from the thumbnail itself.

Figure 2.23 The Compact Cells option (left) minimizes the vertical space used by the cell containing each thumbnail as compared to the Expanded Cells option (right).

General Options

The General section includes several options that affect the display of thumbnails. The Include Quick Collection Markers check box controls whether you'll see a small circle in the top-right corner of the cell containing each thumbnail. An "empty" circle indicates that the image is not part of the quick collection (I'll talk about quick collections in the next chapter), and a filled-in gray circle indicates that the image is part of the quick collection.

The Include Pick Flags check box determines whether a flag indicating the current pick flag status (pick, unflagged, or rejected) will be shown on the thumbnail. This option will be discussed in the next chapter, but I recommend selecting this check box so you'll have quick access to the flag status for your images.

The Include Thumbnail Badges check box controls the display of small badges indicating adjustments that have been applied to an image. These badges also provide quick shortcuts to fine-tuning those adjustments. For example, a badge with a plus and minus symbol on it indicates that tonal or color adjustments have been applied to the image (Figure 2.24). You can double-click that badge to go directly to the Develop module for that image. Similarly, a badge with a 'tag' icon indicates that keywords have been applied to the image, and a double-click will take you directly to the Keyword Tags field for that image.

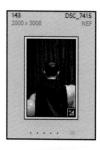

Figure 2.24 The thumbnail badges provide an indication of various properties for your images. For example, the "plus/minus" badge indicates that adjustments have been applied to the image.

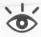

Note: Even if you choose to turn off the badges in the grid view, they are still visible in the filmstrip view.

The next option in the General section is a check box labeled Show Clickable Items On Mouse Over Only. As the name indicates, this setting affects whether the various controls you can click on within the cell for each thumbnail are displayed at all times, or only when you move the mouse pointer over a given cell. My personal preference is to clear this check box so all of the controls are visible at all times, simply because I find it easier to always be able to see the controls I want to adjust as I browse the thumbnails. However, if you prefer to clear up as much clutter in the display as possible, you can select this check box to maintain a clean display for each image until you move your mouse over a given image.

The final check box in this section allows you to "Tint Grid Cells with Color Labels." As you'll see in the next chapter, it is possible to apply a color label to your images, which is most often used to set a "priority" status for processing images. To make these images really stand out, it is helpful to have the cell containing the thumbnail shaded with the color of the label you have applied. I therefore recommend selecting this check box.

Cell Extras Options

The Compact Cell Extras section contains options that determine what information is displayed when you are using the Compact Cells setting. The Index Number places a sequential number in the top-left corner of the cell. Rotation places controls for rotating the image clockwise or counterclockwise in the bottom corners of the cell. As the names indicate, Top Label and Bottom Label allow you to place additional information above and below the thumbnail, respectively. When you select the check box to enable one or both of these displays, the information designated in the drop-down to the right of each check box appears in the appropriate position. There are a wide range of options available, enabling you to see the information that is most important to you. My preference is to have the File Name displayed above the thumbnail, and the Rating below (Figure 2.25). However, you can select any option from either drop-down that is most useful to you. Think about the attributes of your photographs that are most important to you, your clients, the way you work, and the way you tend to search for

your images. That will help you decide which information is most useful for this purpose.

The Expanded Cell Extras section contains options that determine what information is displayed when you are using the Expanded Cells setting. The Show Header With Labels check box determines whether a header section will be included above your thumbnails. This will consume additional space above the thumbnail, but allows you to include more information about each image within the cell. The header can display up to four pieces of data, each of which can be selected from the four drop-downs below the check box. The best settings will be different for each photographer, but with four fields available you can exercise quite a bit of flexibility. Many photographers, for example, might want to include basic exposure information (such as Exposure Time and F-Stop) for these fields. Whenever you change any of the values from the drop-downs, the Use Defaults button becomes active, allowing you to reset the display to the defaults of Index Number, File Base Name, Cropped Dimensions, and File Extension with one click.

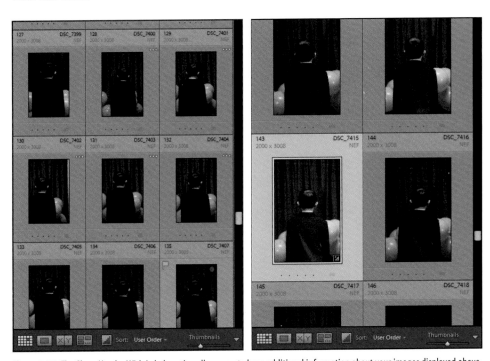

Figure 2.25 The Show Header With Labels option allows you to have additional information about your images displayed above the thumbnail.

The final trio of check boxes in the Expanded Cell Extras section controls whether additional controls are included below the thumbnails when you are in expanded cell view. The Show Rating Footer check box determines whether the star rating control is displayed. If you use star ratings to help organize your images, I definitely recommend keeping this option selected. When the check box is selected, the other two check boxes will be available. The Include Color Label check box allows you to enable a control that will both display the current color label as a small box (color

labels are discussed in the next chapter) and also click to change the color label. The Include Rotation Buttons check box allows you to toggle on or off the display of the rotation buttons (for rotating images) that appear in the bottom corners of the cell.

 Note: Interestingly enough, if you turn off both the Show Header With Labels and Show Rating Footer check boxes, you'll end up with the same display you would have with the Compact Cells option with all of the Compact Cell Extras turned off.

Loupe View Options

The Loupe View section (Figure 2.26) provides settings that determine how images are displayed when using the loupe view (discussed in more detail in the next chapter). At the top of this section is the Show Info Overlay check box, which determines whether information is overlaid on top of your image. All but one of the other options in this section of the Loupe View dialog box relate to that information display.

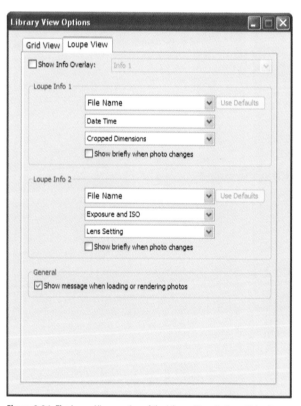

Figure 2.26 The Loupe View section of the Library View Options dialog box provides settings that affect how images are displayed when using the loupe view.

When you have the Show Info Overlay check box selected, a drop-down will be active to the right of this check box, allowing you to choose between Info 1 and Info 2. These two options indicate the information to be displayed as an overlay on your image in the loupe view (Figure 2.27), and you can customize the options in the Loupe Info 1 and Loupe Info 2 sections of the dialog box.

Figure 2.27 The Show Info Overlay option allows you display custom information as an overlay when working in loupe view.

For both Loupe Info 1 and Loupe Info 2 you can select values to display from three drop-down lists. The defaults for Loupe Info 1 are File Name, Date Time, and Cropped Dimensions. These parameters are useful when you're thinking primarily about the files themselves. The defaults for Loupe Info 2 are File Name, Exposure And ISO, and Lens Setting, which are most useful when you're thinking about the photographic properties of the images. Of course, you can adjust any of the values for any of the drop-downs as you see fit. If you've changed any of the values for one of the sets of options, the Use Defaults button will become enabled, allowing you to quickly reset the values to their default options.

Within each of the Loupe Info sections is also a check box labeled Show Briefly When Photo Changes. When selected, the info overlay displays for only a few seconds when you switch photos, rather than being displayed continuously. My preference is to

have the display either always on or always off, rather than having it appear only briefly when I move to a new image, so I don't select these check boxes.

The final check box is in the General section at the bottom of the Loupe View section of the Library View dialog box. It is labeled Show Message When Loading Or Rendering Photos. This check box controls the display of the overlay that indicates Lightroom isn't yet finished rendering the display of the current image. For example, when you click on a new high-resolution image, you will initially see a low-resolution preview, and the word *Loading* will be overlaid at the bottom of the image (Figure 2.28). My recommendation is to keep this check box selected so the text will appear. The text displays only when Lightroom is actually processing your image, and serves as a good reminder that what you're looking at isn't yet the final rendered version (and therefore not the highest quality) of your image.

After you've established the settings that meet your needs in the Library View Options dialog box, simply close it. All the settings that you have adjusted are applied as you modify them.

Figure 2.28 I recommend using the option to display text indicating that Lightroom is still working on your image so you know the display isn't the high-quality final result.

Develop View Options

As mentioned in the previous section, the View → View Options menu option is available when you're working in either the Library or Develop module. However, the actual dialog box that appears depends on which module you're working in. When you are in the Develop module, the Develop View Options dialog box is displayed (Figure 2.29).

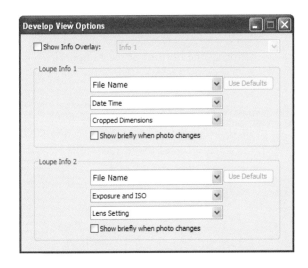

Figure 2.29 The Develop View Options dialog box contains the same Loupe Info options discussed in the previous section, but these settings apply specifically to working in the Develop module.

The Develop View Options dialog box contains exactly the same controls you find for Loupe Info in the Loupe View section of the Library View Options dialog box. In fact, the controls in the Develop View Options dialog box control the exact same settings. Whatever you set for Library View Options will affect the display in the Develop module, and changing the Develop View Options will affect the display in the Library module. I consider this to be a confusing user experience, so I suggest that you ignore the Develop View Options dialog box and instead use the Library View Options dialog box for all of these adjustments.

Having said that, if you're making changes to the settings in the Develop View Options dialog box, they are exactly the same as those discussed previously for the Library View Options. You can most certainly modify the settings here; just keep in mind that you're having an impact on the display in the Library module as well.

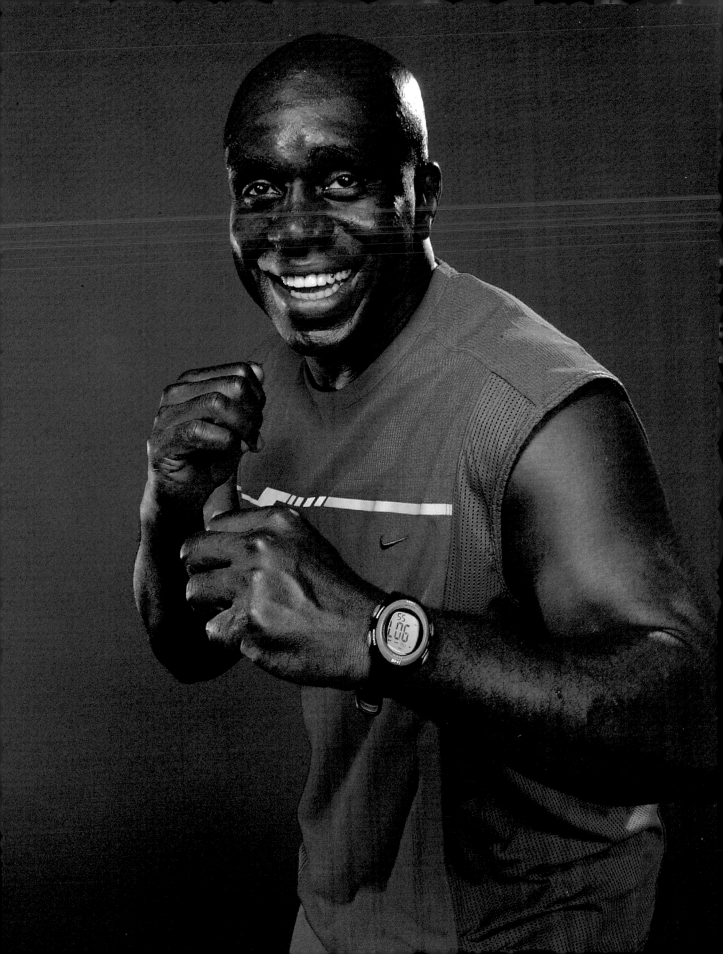

Library

The Library module is, in many ways, the foundation of Lightroom. It provides the tools you need to manage your images, functioning very much like the digital equivalent of the light table you might be familiar with if you have ever photographed with slide film. Of course, as with all things digital, there are many more capabilities than you could ever have with film photography. Learning to work efficiently in the Library module will become the cornerstone of an ideal workflow as you work with your images in Lightroom.

3

Chapter Contents
Importing Images
Reviewing Images
Processing Images
Exporting Images

Importing Images

Before you can work with any images in Lightroom, you need to import them (Figure 3.1). Doing so brings the images into Lightroom so you can actually see them and work with them, and more importantly brings them into the Lightroom database so the adjustments and other work you do with your images can be tracked.

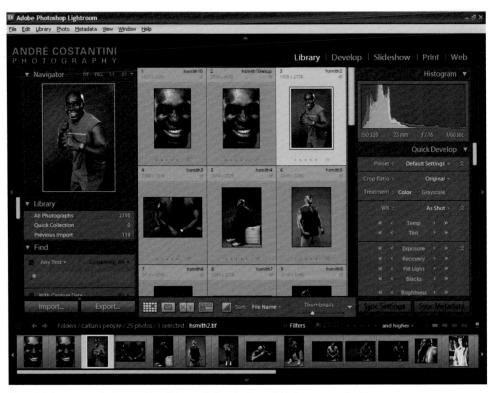

Figure 3.1 Images must be imported into Lightroom before they're available for you to work with.

Importing your images is also the first real step in your workflow within Lightroom. Whenever you have new images to work with, the first step is to bring them into Lightroom so you can continue organizing them in the Library module and then working with them in the other modules.

Note: Photographer André Costantini (www.sillydancing.com) provided all of the beautiful photographic images for this chapter, for which I am very grateful.

Import Process

To get started with the import process, simply click the Import button at the bottom of the left panel in the Library module (or select File → Import from the menu). This brings up the Open dialog box (Figure 3.2), where you can select the images you want to import.

You can select images to import in two ways. If you need to import only specific images (and even folders) within a folder, you can navigate to that folder and then select the images within the folder you want to include. For example, you could click the first image you want to import from a folder, hold the Shift key, and click the last image you want to import from the folder. You could also hold the Ctrl/⌘ key to toggle the selection of individual images on and off. When you have selected the images you want to import, click Open. If you want to import all images within a folder, instead of selecting the individual images, you can navigate to the folder and click it, and then click the Choose Folder button.

After you've clicked Open or Choose Folder, the Import Photos dialog box will appear (Figure 3.3). This dialog box allows you to specify import settings as well as the data that you want to apply to the images during the import process.

Figure 3.2 The Open dialog box allows you to select the images or folders containing images you want to import into Lightroom.

Figure 3.3 The Import Photos dialog box allows you to specify the settings for the images that you are importing into Lightroom.

File Handling

The first option in the Import Photos dialog box is the File Handling option. The drop-down list contains four options (Figure 3.4) for you to choose from.

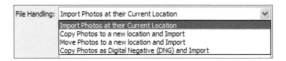

Figure 3.4 The File Handling drop-down contains four options for you to choose from.

The four options are as follows:

Import Photos at Their Current Location This option will leave your original images where they are, and simply reference them from that location. This retains your existing organizational system, while providing the workflow benefits of using Lightroom. The only drawback is the risk of confusing Lightroom if you delete, move, or rename files from outside Lightroom.

Note: If you're using the Import Photos at the Current Location option, you won't want to import directly from your digital memory cards. Instead, you'll want to copy the files from your cards into the file system on your computer before importing.

Copy Photos to a New Location and Import This option will copy the files you import into the Lightroom image store. Depending on where you're importing from, this may result in duplicate copies of files on your system (the exception would be if you are copying from media that won't be permanently available, such as directly from your CompactFlash cards after a photo shoot).

Move Photos to a New Location an Import This option will move the files from the original location into the Lightroom image store. This will change your existing storage method, so this option should be used only if you're committed to using Lightroom for all of your image management work.

Copy Photos As Digital Negative (DNG) and Import This option will create copies of your source images in the Digital Negative (DNG) format, copying the resulting files to the Lightroom image store. This option is an excellent choice for photographers who have adopted DNG as their image storage standard.

Note: Despite the focus on RAW files, you can use the option to Copy Photos As Digital Negative (DNG) for images in all supported file formats.

My personal preference is the first option: Import Photos at Their Current Location. This is because I want to use Lightroom as a tool for managing my images instead

of completely replacing my existing file system. The only drawback to using this option is that if you delete, move, or rename the files from outside Lightroom, then Lightroom won't have any knowledge of the change and you won't be able to work with the image. The image won't disappear, but instead will have a question mark icon indicating that it can't be found. When that is the case, you won't be able to apply any changes to the image or use it for any output. You can resolve this problem by clicking on the question mark icon to bring up the Confirm dialog box. Here you can click the Locate button to access the Locate dialog box and navigate to the image to let Lightroom know where to find it. The way to avoid this problem is to be sure to use Lightroom for all of your file-management tasks, rather than using different tools for that purpose.

Of course, there are four options because different photographers want to deal with their images in different ways. When deciding which option to use, think about how you work with your images and which choice is the best fit for your specific workflow.

If you select any of the other options, a Copy To or Move To reference will be added, with a Choose button to the right. This allows you to specify a folder where the images should be moved or copied, depending on the option you selected. Also added will be an option for how to organize the images. You can organize Into One Folder, By Original Folders, or By Date (with a variety of options for how the folders will be created). I prefer to use "Into One Folder" because when I'm importing images it is generally a single set of images that has a central theme.

Below the File Handling drop-down you will see a list of the folders of images that will be imported. This is based on the folder structure of the source you designated for the photos. If you only want to import part of the full collection of images, you can clear the check box for some of the folders on the list.

Below the list of folders to be imported is a check box to Ignore Suspected Duplicates. Selecting this check box will cause Lightroom to import all images in the designated location, even if they appear to be duplicates. I prefer to select this check box just to be sure no images are omitted in error. You can always remove duplicates from Lightroom later if needed.

The last check box in this section of the Import Photos dialog box allows you to create a backup copy of all images that are being imported. This is particularly helpful if you are importing from removable media or if you're working in the field during a photo trip, but it is always a good idea to back up your images when working with them. If you would like to create a backup copy during the import process select this check box and then click the Choose button to select a location where the backup should be created.

N o t e : After you've chosen an option for File Handling, it is best to consistently use that same option for all imports.

Renaming Files

If you have chosen the option for File Handling to Import Photos at their Current Location, the Rename Files section will be disabled, because in this case Lightroom won't allow you to modify the original image files. However, if you use any of the other three options, the File Naming section will be displayed, and you can use it to rename the image files as you import them (Figure 3.5).

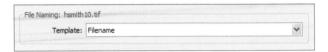

Figure 3.5 The File Naming section in the Import Photos dialog box allows you to rename the images as they are imported.

To apply new names to your files, start by selecting an option from the Template dropdown. While there are many options available, if you want to rename your files my recommendation is to use the "Custom Name – Sequence" option. You can then enter descriptive text in the Custom Text field, and a starting value in the Start Number field, and the images will all be renamed with that structure using sequential numbering.

If the available options don't quite meet your needs, you can define a custom file naming structure by choosing Edit from the dropdown, which will bring up the Filename Template Editor dialog box (Figure 3.6). In this dialog box you can select various options as "building blocks" of a file naming structure. You can choose values from the various dropdown controls in several sections, and then click Insert to add a field to the structure in the text box at the top of the dialog box. This allows you to type specific text and then insert variables as part of the file name. For example, if you wanted to rename a group of images of a boxer while retaining the original filename, you could type "Boxer-", then add the Sequence Number option from the Numbering section, then add a dash (-), then add the Filename option from the Image Name section. This flexibility allows you to utilize an existing file naming system you have already implemented before you started working with Lightroom.

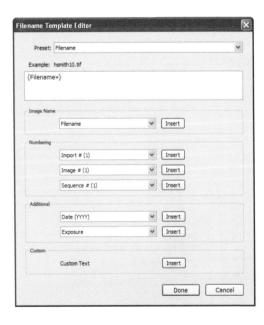

Figure 3.6 The Filename Template Editor dialog box allows you to define a custom structure for file naming to be used during an import.

As you're creating a custom naming structure, keep in mind that when you select a field to be added, it will be inserted where the cursor is currently positioned or at the end of the current structure if the cursor isn't currently in the Name field. Also, it can be helpful to reference the Example text to get a preview of what the final filenames will look like and to make sure they are structured as you want them (Figure 3.7).

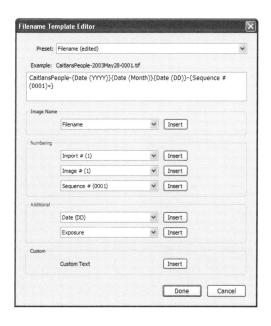

Figure 3.7 A preview is provided of the filename that will result from the structure you've defined.

Information to Apply

The Information to Apply section (Figure 3.8) allows you to apply adjustments or metadata to all images as they are imported.

The Develop Settings drop-down contains the develop presets found on the Presets list in the Develop module (Figure 3.9). You'll learn how to use and edit presets (and create new ones) in the next chapter. The presets included with Lightroom, as well as any new ones you create, are available from this list. This allows you to apply adjustments to the images as you import them. For example, if you want to convert all of the images to a grayscale version as they're being imported, you could select the Grayscale Conversion preset included with Lightroom from the list. I generally prefer not to apply develop settings during import, but there are situations when you want to do exactly that, so this is a nice feature to have available.

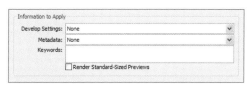

Figure 3.8 The Information to Apply section allows you to apply metadata or image processing to your images as they are imported.

Figure 3.9 The Develop Settings drop-down allows you to apply adjustments to images as they are imported.

The Metadata drop-down list allows you to apply a metadata template to the current import (Figure 3.10). This is helpful for applying values within metadata that you want to affect all images you are importing. A good example of this is copyright information. It is a good idea to add copyright details for all images you import. Those details aren't specific to a particular photo shoot, but rather to all images you capture.

Figure 3.10 The Metadata drop-down allows you to apply a metadata template to the images being imported.

To apply metadata to images during import, you must first define a template. If you haven't already done so, add a new template by selecting New from the drop-down. This will bring up the New Metadata Preset dialog box (Figure 3.11). Start by entering a meaningful name for the preset in the Preset Name field. This may be as simple as entering your name, but it should be something that will make it clear what sort of information you are applying to the images.

Figure 3.11 The New Metadata Preset dialog box allows you to define preset metadata that can be applied to images during import.

Next, enter values for the desired fields. As you do so, the check box to the right of the fields that you have added text to will automatically be selected. If you want to remove a particular value, you can simply clear the check box. You can also toggle complete sections of fields by selecting or clearing the check box for the section name above each section.

As you're entering values, be sure the information you're adding will be applicable to all images you import. For example, I would never add a value for Rating here because I wouldn't want to apply the same rating to all images being imported.

After you've entered all the information you want to be added to the metadata for all imported images, click the Create button. The preset you created will then be

selected on the drop-down in the Import Photos dialog box, and available on the drop-down for all future imports.

Note: The metadata presets you create in the Import Photos dialog box can also be used to apply metadata to images later in the Library module.

The Keywords textbox allows you to assign keywords to all of the images in the shoot. Although you may need to apply individual keywords to the images within the shoot after the import, this option is an efficient way to apply the keywords that are common to all images being imported. To apply keywords, simply enter them in the Keywords text box, separated by commas.

Finally, the Render Standard-Sized Previews check box allows you to have Lightroom create previews for your photos as they are imported. Otherwise only thumbnails and previews included with the original images (if at all) are utilized, and other previews are created as needed. I recommend selecting this check box so previews will be available more quickly as you work with your images in Lightroom, even though this causes the import operation to take a little longer.

The Show Preview check box at the bottom of the Import Photos dialog box will open a new section of the dialog box, providing a preview of the images you are currently importing (Figure 3.12). You can select individual images to import by selecting the check box in the top-left corner for each image. Buttons are also provided at the bottom-left of this new section to Check All or Uncheck All images. Only checked images will be imported. The slider at the bottom-right allows you to adjust the size of the preview images in this section of the dialog box.

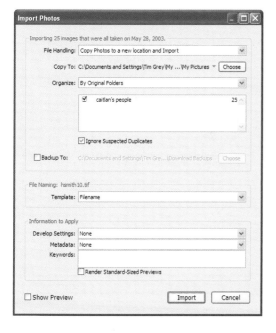

Figure 3.12 When you select the Show Preview check box at the bottom of the Import Photos dialog box (left), a Preview area will be added to the dialog box (top of next page), allowing you to view images and specify which should be imported.

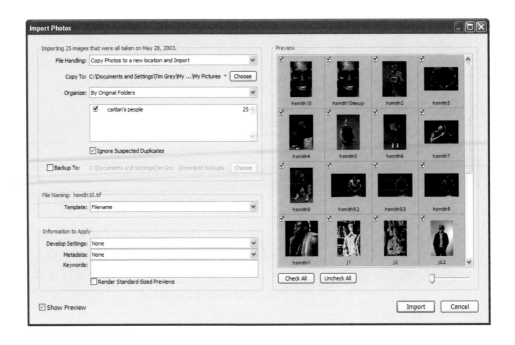

Start Import

After you've established all the desired settings for importing your images, click the Import button to start the process. You'll see a status indicator on the identity plate at the top of the Lightroom interface, showing you the current status (Figure 3.13). You may also notice that the new shoot has been created in the Shoots section of the left panel, and the count showing the number of images increments upward until the process is complete. You can continue to work in Lightroom as the import process operates in the background.

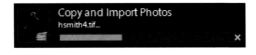

Figure 3.13 A status indicator displays on the identity plate while Lightroom is importing your images.

Note: When you import photos into Lightroom, it will automatically select the Previous Import from the Library section so only the imported files are shown in the primary display area.

Download and Import

Besides simply importing images into Lightroom, you can also download them from your digital memory cards and import all in one process. If you're not already using software for downloading your images that provides other benefits, using Lightroom can improve your efficiency. It is also convenient to utilize both processes in one place at one time.

As you'll recall from Chapter 2, "Configuring Lightroom," there is an option in the Preferences dialog box to have Lightroom automatically show the Import dialog box when you insert a digital media card into a reader on your computer, which saves you a step here. If you prefer not to use that option, you can insert the card and then click the Import button on the left panel in the Library module. Lightroom will recognize there is a media card inserted with images and will present an initial dialog box asking which location you want to import from (Figure 3.14), with a button for the digital media card included. Simply click on that location (or Choose Files if you want to download from a different location or be selective about the files to copy). This will bring up the Import dialog box.

At this point the options in the Import dialog box are exactly the same as those you saw in the prior section. The File Handling option will automatically be set to "Copy Photos to a New Location and Import," which is the setting I strongly recommend using for a download and import operation. The other settings are based on your personal preference.

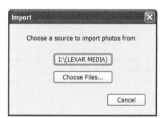

Figure 3.14 When you select the Import option with a digital media card inserted, Lightroom will ask which location you want to import from.

Reviewing Images

After importing images into Lightroom, you're ready to start reviewing them. I think of this process as requiring two basic steps: filtering the images so only those you're currently interested in are displayed, and then evaluating them.

Filtering Images

Lightroom provides a variety of ways for you to filter your images. By using any of the methods available, you can limit the number of images currently being displayed to only those meeting the criteria you've designated. You may initially be a little overwhelmed by all the available options, but I think you'll quickly agree that the large number of options provides tremendous flexibility in filtering your images, and will make it easy for you to find just the images you need quickly and easily.

The options for filtering your images are found on the left panel in the Library module. They include the following sections, each with their own options: Library, Find, Folders, Collections, Keyword Tags, and the Metadata Browser

Library

The Library section (Figure 3.15) is the most simple of the available options for filtering your images. There are only three options, and they are very simple to understand. Simply click one of the options, and the images displayed in Lightroom will be filtered accordingly.

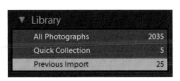

Figure 3.15 The Library section of the left panel provides basic options for filtering your images.

The following options are available:

All Photographs will display all photographs that have been imported into Lightroom.

Quick Collection will display only images that are currently part of the Quick Collection. I'll discuss how to update the Quick Collection in the "Collections" section later in this chapter.

Previous Import will display only images that were added to Lightroom during the preceding import operation.

Note: To the right of each of the options in the Library section is a number indicating how many images are contained in each group. Lightroom provides this information for the options in the Folders, Collections, and Keywords sections as well.

Note: If you have images in the Lightroom library that have been moved or deleted, you'll also see a "Missing Files" option in the Library section that contains those images.

Find

The Find section contains several options that offer some additional flexibility and control over how you filter the images displayed in Lightroom (Figure 3.16).

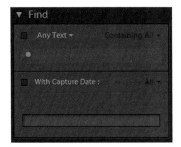

Figure 3.16 The Filters section provides flexibility over how you filter your images, including full-text search capabilities.

The first check box in the Find section is Any Text. When you select this text box, images will be filtered based on the test you type in the field below, regardless of where that text appears (for example, the filename or any metadata field). You can further refine this option with the dropdown to the right of the Any Text check box, which allows you to specify how the images should be filtered based on the text you entered. I normally use the Containing All option so only images containing all of the text you entered are displayed. I also find myself using the Starting With option on occasion.

The With Capture Date option allows you to filter images based on the date they were captured, as reflected in the EXIF metadata for the image. You can choose one of the preset options from the dropdown to the right of the check box (for example, to view images for This Month), or you can specify a custom range. A date range can be defined by dragging the sliders below the date range indicator, or by clicking the beginning or ending date to bring up the Enter Date Range dialog box.

Folders

The Folders section (Figure 3.17) contains the names of all folders you have imported to date. That means the list will be organized by either the folder names from which they were imported or the date the images were taken, depending on which option you used during the import. To view only the images contained in a specific folder, simply click the name of the folder in the list.

Figure 3.17 The Folders section contains all of the shoots you have imported.

Note: For all sections except Find Lightroom will display the number of items currently shown within each of those sections to the right of the section name.

Collections

The Collections section (Figure 3.18) allows you to create groups of images that are organized by methods other than those readily available in Lightroom, and then filter images by collection. To view only the images contained in a specific collection, simply click the name of that collection in the Collections section.

Figure 3.18 The Collections section allows you to create groups of images that are organized by methods other than those readily available in Lightroom.

Note: If you have moved or copied images into the Lightroom Library during import, a collection will have been automatically created called Already In Lightroom.

To create a new collection, click the plus sign to the right of the Collections heading. This will bring up the Create Collection dialog box (Figure 3.19). Enter a name for the collection. If you have already selected the images you want to include in this collection, select the Include Selected Photos check box. Then click Create to create the new collection. You can add images to the collection at any time by selecting them within the Library module and dragging them to the desired collection name in the Collections section.

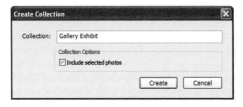

Figure 3.19 The Create Collection dialog box allows you to name the new collection you are creating.

As discussed in the preceding "Library" section, Lightroom also provides a special collection called the Quick Collection. This is an ad hoc collection that contains images you have added to the Quick Collection, but those images won't be a permanent part of the Quick Collection. This is designed to allow you to quickly identify a group of images you want to filter in the short term, but that you don't need to be able to filter in the long term.

As with many tasks in Lightroom, there are a variety of ways that you can add images to the Quick Collection. Start by selecting the images you want to add to the Quick Collection, and then use one of the following methods:

- Choose Photo → Add To Quick Collection from the menu.
- Right-click/Ctrl+click any of the selected images and choose Add To Quick Collection from the pop-up menu.
- Drag the images to the Quick Collection name in the Library section of the left panel.
- Click the small circle marker near the top-right corner of the thumbnail in either the primary display or filmstrip view if the Include Quick Collection Markers option has been set in the Grid View section of the Library View Options (View → View Options) dialog box.

Keyword Tags

The Keyword Tags section (Figure 3.20) lists all keywords that have been applied to any images in Lightroom. At the beginning of this chapter you saw how to apply keywords to images as you import them into Lightroom. Later in this chapter you'll learn how to apply keywords to individual images. To filter images by keyword, simply click the keyword from the list in the Keywords section.

Figure 3.20 The Keywords section lists all keywords that have been applied to any images in Lightroom and allows you to filter images by keyword by simply clicking one from the list.

Note: You can import an existing list of keywords in a standard text file by choosing Library → Import Keywords from the menu and selecting the text file. You can also export the keywords in Lightroom to share with others by selecting Library → Export Keywords. This is most useful if you need to share common keywords with other Lightroom users, or if you have a text list of keywords from a different application you want to use within Lightroom.

Metadata Browser

The Metadata Browser (Figure 3.21) provides a way to filter images based on the metadata stored as part of the photos. The Metadata Broswer is organized into a "tree" view that allows you to navigate through various options with varying degrees of specificity. To filter images, start by clicking the triangle to the left of a section you'd like to expand to see additional options. When you find the metadata value you'd like to use to filter your images, simply click on it.

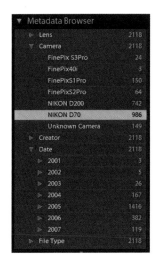

Figure 3.21 The Metadata Browser allows you to filter images based on the contents of their metadata by selecting options from a list.

For example, if you want to see images captured using a particular lens, you could click the arrow to the left of the Lens item to expand the list and then click on the name of the lens you want to filter images based on. The images displayed will then only include those captured using the specified lens.

Evaluating Images

After you are able to filter the images you're looking at in Lightroom, you can start evaluating and processing those images. Lightroom has no shortage of options available to you as you review your images. By becoming familiar with the many ways to view and interact with your images, you'll be better able to work with your images quickly and efficiently.

Note: As you're viewing your images in Lightroom, if you see a question mark icon in the top right of the image, that is an indication that Lightroom can't find the source image. Click the question mark to open the Confirm dialog box. Then click Locate to open the Locate dialog box so you can show Lightroom where the image is located.

View Mode

At the bottom of the primary display in the Library module is a toolbar (Figure 3.22), containing a variety of options (if the toolbar isn't visible, choose View → Show Toolbar from the menu or press T on your keyboard).

Figure 3.22 There are different versions of the toolbar depending on the view you're using, as well as an ability to customize what appears on each version of the toolbar.

At the far left of the toolbar, regardless of which mode you're in, you'll find the options (Figure 3.23) for switching between grid view (thumbnails), loupe view (large image), compare view (for comparing multiple images), and survey view (for narrowing a selection of multiple images). Simply click one of the buttons to change the current view. You can also use the G keyboard shortcut to quickly switch to the grid view, and the E keyboard shortcut to quickly switch to the loupe view (to help remember this shortcut, remember that there's an *e* at the end of *loupe*). The grid and loupe views simply switch between multiple versus single images, with each being useful in particular situations for evaluating your images.

Figure 3.23 The buttons at the far left of the toolbar allow you to quickly switch between grid view, loupe view, and compare view.

The compare view can be especially helpful as you work to process your images. To select the compare view, click the third button at the bottom of the toolbar, or choose View → Compare from the menu, or press the C keyboard shortcut. The currently selected image (or images) will then be shown in the primary display. Use the film-strip to select images you want to see in compare view. Only two of the selected images will be displayed, but the others will be available for review as you move through the comparison process.

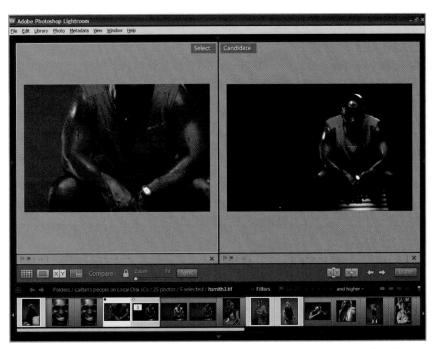

Figure 3.24 As you select images while in compare view, the view will automatically update to reflect all images currently selected.

The Compare view operates on the principle that you will compare a Select image with a Candidate image. The Select image is the current choice, typically your favorite in a group of images. The Candidate image is the one you are currently comparing to the Select image. Initially, the first image you selected will be shown on the left as the Select image, and the first of the other images included in the selection will be shown on the right as the "Candidate" image. You can navigate through the Candidate images to using the arrow buttons at the bottom-right of the primary display area.

To the left of the arrow buttons at the bottom-right of the primary display are two buttons for changing the Select and Candidate images. At first glance they appear to do about the same thing, but there is actually a subtle difference. The first of these buttons swaps the current Select and Candidate images, reversing their positions. This is useful when you decide that the current Candidate image is actually the better

choice than the current Select image, but you still want to be able to evaluate both of these images. The second button will replace the Select image with the current Candidate image, and the next selected image in sequence will replace the Candidate image. In other words, the Swap button will swap the two images and keep both of them as the currently displayed images, while the Make Select button will keep the Candidate as the Select image and replace the Candidate image with a new one. The arrow buttons on the toolbar can also be used to navigate among the selected images (shown on the filmstrip), updating the Candidate image as you click through the previous or next image.

The Survey View (Figure 3.25) takes the Compare view to a new level, allowing you to select multiple images to view at once and gradually narrow your selection down to a single image. This is generally best used when you have a group of images that are very similar, and you want to decide on a single favorite in the group.

Figure 3.25 The Survey View makes it easy to choose between a group of similar images, narrowing down your options as you decide on your favorite.

Note: I usually try to limit my comparisons using the Survey View to no more than six images so each is still large enough to evaluate effectively.

To get started, select multiple images in the Grid display or using the Filmstrip. Then click the Survey View button. All of the selected images will be displayed in the primary display area. In the bottom-right corner of each you'll see an "X" that allows you to remove the image from the view. In this way you can gradually remove images until you narrow your selection down to a single selection.

View Mode Options

The options that appear by default on the toolbar depend on which view you are currently using. The options provided are tailored to providing you the most important capabilities for each view, but you can also change the options shown for the grid, loupe, and survey views (the Compare View options cannot be modified).

You're not able to change the toolbar displayed for the compare view. That view includes controls that affect how the two images are zoomed (Figure 3.26). The "lock" icon acts as a toggle that determines whether the zoom setting for the two images being compared remains fixed. Click the icon to change the status. When the lock is "open" only the Select image will be affected by the Zoom slider to the right of the lock icon. When the lock is "closed" both images will be affected. You can quickly bring both images to the same zoom setting by clicking the Sync button. The other options on this toolbar were discussed earlier in this chapter.

Figure 3.26 The compare view has a toolbar that cannot be modified.

You can change the options shown on the toolbar for a given view (other than survey view) using the dropdown at the far right of the toolbar (Figure 3.27). Items with a checkmark by them will appear on the current toolbar, and those without won't appear. Simply click an item from the list to toggle it on or off.

✔ Sorting
Keyword
Rating
Pick
Color Label
Rotate
Navigate
Slideshow
✔ Thumbnail Size
✔ Info

Figure 3.27 The dropdown at the far right of the toolbar allows you to choose which options will be displayed on the toolbar for the current view.

The following descriptions of the various options available will help you determine if you want to make any changes to the default settings:

Label Survey: This option is only available in the survey view mode, and it is on by default. It simply places the word "Survey" on the toolbar so it will be clear which view you are in.

Sorting Sort: File Name The sorting option is available in the grid, loupe, and survey views, and is included by default in the grid view.

The first button is split between light gray and dark gray, and allows you to toggle between ascending (light gray at the top-left corner) or descending (light gray at the bottom-right corner). To the right of that button is a drop-down that allows you to specify whether which parameter you want to use to sort the images. Each of these is self-explanatory, except perhaps for User Order, which sorts the images based on the order you have defined by dragging the images around. This order will be retained even if you switch to another sort order. Each time you select User Order, the images will return to the order in which you last left them when dragging images around within the grid display.

Keyword The keyword option is only available with the grid view. It provides an additional option for applying keywords to your images. I actually find this option less convenient than simply using the Keywording section on the right panel. However, if you frequently work with the right panel hidden, this can be a helpful option to use.

This keywording tool includes a "rubber stamp" you can use to apply keywords to images, and a text box where you can type keywords. Simply type a value, then click the rubber stamp to access the tool, and click on images to stamp them with the keyword you entered. If multiple images are selected and you click on one of the selected images, all selected images will be stamped with the keyword.

When you're finished using the stamp, be sure to click on the circle to the left of the keyword text box to put the stamp back. Otherwise you might accidentally stamp other images with keywords you didn't intend to apply.

Rating The rating option is available in the grid, loupe, and survey views, and is on by default for the loupe view. It places the star rating control on the toolbar so you can quickly change the rating assigned to a given image.

Pick This option places the pick and rejected flag controls on the toolbar. You can flag images as picks or rejects by selecting images and then clicking the appropriate flag icon.

Color Label The color label option places boxes for each of the available color labels (red, yellow, green, blue, purple) on the toolbar, providing a quick way to apply color labels to your images, typically used for prioritizing images to be processed in some way.

Rotate This option is on by default for the loupe view. It simply places buttons for rotating the image clockwise or counter-clockwise on the toolbar.

Navigate The navigate buttons are on by default for the survey view. They allow you to click left and right arrow buttons to navigate through your images.

Slideshow This option places a "play" button on the toolbar, allowing you to instantly view an impromptu slideshow of the currently selected images.

Thumbnail Size This option is only available for the grid view (since that is the only view that shows thumbnails). It enables a slider for adjusting the size of thumbnails.

Zoom The option is only available for the loupe view. It adds a slider that allows you to quickly resize the image currently being viewed.

Info The info option is on by default for the grid and survey views. It adds an info box to the toolbar that shows the filename of the current image.

Lights Out

Another great option for evaluating images is to use the Lights Out option. The easiest way to activate this display is to press the L keyboard shortcut. The first time you press this key, everything except the currently selected images (or single image in loupe view) will be dimmed to emphasize the images (Figure 3.28). The second time you press this key, everything will go completely black except for the images (Figure 3.29). A third press of the key will bring you back to the normal display.

Note: The Lights Out view option is available in all modules in Lightroom.

Figure 3.28 The first Lights Out option will dim everything but the currently selected images.

Figure 3.29 The second Lights Out option will show only the currently selected images surrounded by black.

Navigator

The Navigator section at the top of the left panel is helpful as you're evaluating images (Figure 3.30). To the right of the Navigator heading are four options that allow you to change the zoom setting of the current image. If you are currently in grid or compare view, clicking one of these options will automatically switch you to loupe view.

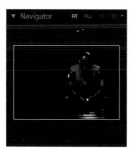

Figure 3.30 The Navigator provides various options for navigating around your image while you're evaluating it.

Note: You can also use keyboard shortcuts to switch between the different zoom views. Hold the Ctrl/⌘ key and press the minus key (-) to move to a smaller view or the equals key (=) to move to a larger view.

The available options are as follows:

Fit will cause the image to be resized so it fits within the available area of the primary display and you are able to see the entire image.

Fill will enlarge the image so it is just big enough to fill the entire primary display area. Unless the image happens to perfectly match the aspect ratio of the currently available display area (which isn't likely), the complete image won't be visible.

1:1 displays the image as "actual pixels," so that one pixel in the image is represented by a single pixel on the monitor display. This is the best option to use for evaluating the sharpness of an image.

Note: When you select the 1:1 view option, Lightroom will generate a 1:1 preview of the image if it hasn't already done so. You can force Lightroom to generate 1:1 previews for all images currently displayed in the Library module, which will allow you to avoid the delay when you click on each individual image. To do so, select Library → Render 1:1 Previews from the menu.

3:1 will enlarge the image so that 3 pixels on the monitor display represent a single pixel in the image. This is useful for examining small details within the image. If you have selected a different zoom setting from the dropdown, that setting will replace 3:1.

Note: When you're viewing a single image in loupe view, clicking an image will toggle between the Fit view and 3:1 view.

When you're viewing the image with the Fill, 1:1, or 3:1 setting, you're seeing only part of the image, unless the image happens to be smaller than the available display resolution of your monitor. The Navigator gives you an indication of which portion of the image is currently visible in the primary display by placing a white box on the image shown in the Navigator (Figure 3.31). You can change which area of the image is currently visible by pointing the mouse to the border of that white box in the Navigator and dragging to specify which area you want to view. If you click on the image in the Navigator but outside the white box, the white box (and thus the view in the primary display) will shift to center on the area you clicked.

Figure 3.31 When the entire image isn't visible in the primary display, the Navigator indicates which area is being shown.

Note: You can also navigate around the image by dragging directly on the image in the primary display when using a zoom setting other than Fit.

Filmstrip

The filmstrip at the bottom of the Lightroom interface (Figure 3.32) is available no matter which module you're using. It always shows the images that would otherwise be displayed in the grid view, even if you aren't currently using the grid view. In other words, it reflects the images as currently filtered based on the options you've set in the Library module. It is therefore very helpful to be familiar with how to work with the filmstrip for all of the work you'll do in Lightroom.

Figure 3.32 The filmstrip at the bottom of the Lightroom interface shows the images that would otherwise be in the grid view even if you aren't currently using that view.

Because the Library module is the foundation of the images displayed on the filmstrip, you'll often want to go back to the Library module from other modules in order to change the filtering of the images currently displayed. Above the thumbnail display on the filmstrip, at the far left, is a small grid button. Clicking that button will immediately take you to the Library module. Although you could just as easily click the Library option on the identity plate, it is faster to use the button on the filmstrip when you're currently working with the filmstrip to select images.

The two arrow buttons to the right of the first button on the filmstrip allow you to navigate through the various modules in the order you last used them. That means the behavior of these buttons varies based on how you've been using Lightroom, which can make it a little confusing. I find it most helpful to use these buttons as a fast short-cut to go back and forth between two modules—for example, when I want to switch between Library and Slideshow while working to identify exactly which images I want to include in a slideshow.

To the right of the arrow buttons is an indication of the current contents of the filmstrip. For example, if you have filtered the images by a folder, the display will indicate Folders, the name of the folder, how many photos are in the folder, how many images are currently selected, and the filename of the currently selected image. If you click this text string, a pop-up menu will allow you to view select the options available from the Library section of the left panel as well as the most recently used criteria for selecting images from the other sections of this panel.

At the far right of the filmstrip are controls that allow you to further filter your images (Figure 3.33) based on several criteria, which I'll show you how to assign to your images in the next section. The first three "flag" buttons allow you to filter the images based on flag status: Picks, Unflagged, and Rejected. Each is a toggle, meaning you can have multiple selected (for example, so you can see images that are flagged as Pick as well as those that are not flagged). To the right of the flag buttons you'll find the option to filter images based on the star rating. Simply select a star rating value and then choose an appropriate option from the dropdown. For example, to view all images rated with four or more stars, click the four star rating and then select "and higher" from the dropdown. The colored buttons to the right of the rating filter allows you to filter images based on the colored label assigned to them. Again, these buttons provide a toggle. When you click on one or more of these buttons, only images labeled with those colors will be shown.

Figure 3.33 The controls at the far right of the filmstrip allow you to filter the images.

The "switch" at the far right of the Filters section on the filmstrip serves as a master control for the filtering of your images. When this switch is on (up) the filters you have selected will limit the images being displayed. When it is off (down), images will not be filtered based on this criteria. Simply click on this button to toggle it on or off.

Note: If you don't see all of the filters discussed here, click the word Filters to expand the list to reveal all options.

As a reminder, you can select images on the filmstrip by clicking a single image to select only that image, clicking one image and Shift+clicking another image to select those two images and all images in between, or by holding the Ctrl/⌘ key and clicking images to toggle their selection.

Histogram

The Histogram display at the top of the right panel (Figure 3.34) in the Library module is just an information display, unlike the more feature-rich histogram in the Develop module, as you'll see in the next chapter. Despite the lack of features, however, the Histogram in the Library module is still very helpful for evaluating images.

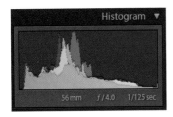

Figure 3.34 The Histogram in the Library module is for information purposes only, but is helpful as you evaluate your images.

A *histogram* is a chart that displays the distribution of tonal values in an image, with darker values to the left and lighter values to the right. The Histogram in the Library module shows individual color overlays, so you can see how the individual channels that compose the full-color image are distributed. Areas shown in shades of gray indicate tonal values that include all channels.

While you are evaluating images in the Library module, the Histogram is most helpful for determining whether shadow or highlight detail is clipped in the image. Clipping is evident if the histogram display is abruptly cut off at the left (shadow detail) or right (highlight detail).

Below the actual histogram chart you'll find additional information about the capture settings for the current image, including ISO, lens focal length, shutter speed, and aperture.

Deleting Outtakes

As you review your images in the Library module, you may find some that you are not happy with and want to delete. You can remove images from Lightroom by selecting them and pressing Backspace/Delete. If you want to delete the source image as well, hold the Ctrl/⌘ as you press Backspace/Delete.

Creating Image Stacks

As you are sorting through your images, you may find at times that you have a number of very similar images that almost seem like duplicates. Sometimes it makes sense to narrow down such a group of images to just one or two of the best, but you may prefer to keep all of them since they are all usable images. At the same time, you may feel it is more challenging to go through your images when you have so many duplicates. Creating image stacks provides an excellent solution for this situation.

A stack is a series of images that you can group together into a stack that can be collapsed or expanded as you see fit. If you've sorted slides on a light table, you can think of this as the process of literally stacking multiple slides that are similar, and then spreading them out when you want to review them in more detail. And of course the images don't necessarily need to be visually similar to be stacked. You can stack any images you'd like to group together and be able to collapse into a single stack so you only see one image at a time.

Creating and working with stacks is very easy. Start by selecting the images within the grid view or filmstrip that you want to stack. Then select Photo → Stacking → Group Into Stack from the menu (or right-click and select Stacking → Group Into Stack). The images will be collapsed into a single "stack" with only one image visible, and a numeric marker indicating the images are stacked and how many images are in that stack (Figure 3.35).

Figure 3.35 When you select a group of images (left) and choose to stack them, the images will be collapsed into a single stack with a visual indication of how many images are included in the stack (right).

When you want to see all the images in a stack, select the stack and choose Photo → Stacking → Expand Stack (or press S on the keyboard). The first image in the group will still have an indicator with the total number of images in the stack, and when you move your mouse over another image in the stack you'll see an indication of its sequence number within the stack (Figure 3.36). When you're done reviewing the images in the stack, you can select Photo → Stacking → Collapse Stack (or press S again) to collapse them again. If you no longer want the images grouped together into a stack, choose Photo → Stacking → Unstack. You can also remove individual images from a stack by selecting a single image (be careful to select a single image, as by default when you expand a stack all images in the stack are selected) and then choosing Photo → Stacking → Remove from Stack.

Figure 3.36 When you expand a stack, the images will still provide an indication they are part of a stack.

Processing Images

Besides the ability to filter and review your images, the Library module also provides various options for processing your images. These include various options for identifying images, the Quick Develop settings for adjusting images, the Applied Keywords section for viewing and changing the keywords assigned to specific images, and Metadata settings for adjusting the data stored within your images.

Flags, Stars, and Labels

As you get further into reviewing your images and are ready to start doing some more active processing of those images, it can be helpful to take advantage of the several ways Lightroom allows you to identify your images. These include Flags, Star Ratings, and Color Labels.

Flags

I find the Flags option to be particularly helpful as I'm just getting started with evaluating a new set of images or as I'm trying to identify images for a particular project. There are three options available for flagging your images: Pick, Rejected, and Unflagged. I think of these as "yes," "no," and "maybe," respectively.

If you have set the Include Pick Flags in the View Options for the Grid View, you'll see a flag icon near the top-left corner of each thumbnail image when the mouse is over it. You can click on this flag to mark the image as a Pick, and click again to unflag the image. While there are also options on the Photo menu for setting all three flag options, I recommend using the shortcut keys for this:

- To flag an image as a pick, press P.
- To flag it as a rejected image, press X.
- And to remove the flag altogether, press U for unflag.

As discussed earlier in this chapter, you can then filter images based on their flag setting, making this a very helpful way to quickly identify images you want to work with (or not work with) for a particular project.

Star Ratings

I find star ratings to be particularly helpful for sorting images and finding just the right one for a particular need. Instead of a general "yes or no" approach, star ratings allow you to apply a more subjective value to your images.

I actually tend to only apply star ratings at a value of three stars or more. The reason for this is that I don't feel it is worth the investment to apply star ratings to images I think are only worthy of one or two stars. However, you can most certainly apply star ratings to all images if you prefer.

You can apply star ratings in a number of ways, but one of the easiest is to simply click on the star rating control below the thumbnail in the grid view, or in the toolbar below the image in loupe view. When an image hasn't yet been rated you'll see five dots. Simply click on the dot that corresponds to the rating you wish to apply. To remove a rating, you can simply click on the star for the rating that has already been applied (for example, if you've rated an image as three stars, click on the third star to remove the rating).

If you prefer to use keyboard shortcuts, you can select an image and then press a number on the keyboard that corresponds to the number of stars you want to assign (1 for one star, etc.), or press 0 to assign no stars (effectively removing the rating).

Color Labels

Lightroom also supports the ability to assign a color label to images, which can be helpful for organizing your workflow. The color labels can be thought of as assigning a priority code to the images, because the colors range from what might be perceived as lower priority (blue and purple) to higher priority (red and yellow) with green being in between.

For example, you might use these color labels to identify the priority for processing specific images, assigning a red label to images that need to be optimized and added to a web gallery immediately, and green for those that need to be processed but without a sense of urgency. You could also define a completely different system for these color labels, identifying them with tasks or categories. For example, you might specify that red identifies images to be included in your latest big project (perhaps a book or calendar, for example) and yellow identifies images you want to present to clients. The problem with this type of approach is that you can only assign a single color label to each image, and often images may fit in more than one category. I therefore recommend that you use color labels as a priority code.

To assign a color label to one or more images, first select the images and then choose Photo → Set Color Label and then the desired color from the menu (the same options can be found by right-clicking on the image and selecting Set Color Label).

Quick Develop

The Quick Develop section of the right panel contains a series of basic adjustments you can apply while evaluating images in the Library module (Figure 3.37). I generally prefer to wait until I get to the Develop module to apply changes to images, but at times as you're evaluating images you'll want to apply a quick adjustment to get better sense of the quality of the image (for example, lightening an image that is a little dark so you can get a better idea of how much noise is hiding in the shadow areas).

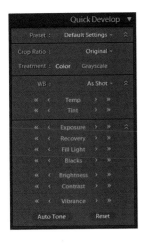

Figure 3.37 The Quick Develop section of the right panel provides basic adjustments you can use while reviewing images.

At the top of the Quick Develop section, to the left of the heading, is a drop-down that allows you to choose a preset to the images. You'll learn about presets in Chapter 4, "Develop," but you can use this drop-down to apply changes to the currently selected image (or images) based on a "formula" defined in the Develop module.

Note: The various sections of Quick Develop controls can be expanded or collapsed by using the double chevron button at the right side of each sub-section within Quick Develop.

The Crop Ratio dropdown allows you to crop images to a specific aspect ratio by selecting it from the dropdown. I suggest waiting until you're working with the Crop view in the Develop module for applying any cropping.

The Treatment option allows you to quickly choose between a Color and Grayscale version of your image. Simply click on the desired option and the image will be updated immediately. Because Lightroom uses non-destructive editing for all operations, you can switch back and forth between these as desired.

The White Balance (WB) controls allow you to correct the color in your images. The drop-down to the right allows you to select a white balance preset. Especially in the Library module, I generally prefer not to use this adjustment. Instead, I'll use the Temp and Tint controls to adjust the image between warmer or cooler values. This control (as with many of them in the Quick Develop section) consists of five buttons. The double arrows at the outer positions will adjust the control with a significant change, while the single arrows on the inside positions will make a more modest adjustment. The text label between these buttons will reset the control to its default value.

Note: In the Quick Develop section there is no visual indication of the current setting for any of the adjustments.

Below the Settings buttons are adjustments for Exposure (midtones), Recovery (highlights), Fill Light (shadows), Blacks (darkest tones), Brightness (overall brightness), Contrast (overall contrast), and Vibrance (a variation on saturation). The same set of five buttons that are used for the White Balance adjustment for are used for each of these adjustments. I'll discuss these controls in more detail in Chapter 4.

The are two additional buttons at the bottom of the Quick Develop section: Auto Tone and Reset. The Auto Tone button will cause Lightroom to attempt to adjust the tonality of the image for you to produce a better result. The Reset button will return all Quick Develop settings to their default values.

Keywording

As you've already seen, keywords are a great way to filter images in the Library module to help you find exactly the image (or images) you're looking for. The Keywording section (Figure 3.38) of the right panel in the Library module provides a quick and easy way to view and modify the keywords for the currently selected images.

Figure 3.38 The Keywording section provides an easy way to view and modify the keywords for the currently selected images.

Whenever you select images to which keywords have been applied, those keywords will be listed in the Keyword Tags section. Any keywords that have an asterisk after them have been applied to only some (not all) of the currently selected images.

To modify the keywords applied to the currently selected images, simply make changes to the text in the Keywording section, separating all keywords by a comma.

The next section provides quick shortcuts to keywords you can add to the Keyword Tags automatically. The default setting for the Set option is to show Recent Keywords. You can also change this to reflect other keywords you want ready access to. For example, presets are included for Outdoor Photographer, Portrait Photography, and Wedding Photography. Once you've selected an option from the dropdown, you can click on any of the words shown below to add them to the Keyword Tags. The text will appear as white for keywords that have been added to the currently selected images, and gray for those that have not. To edit the list of keywords available in the current set, click the Edit button at the right to bring up the Edit Keyword Set dialog box where you can change the list of keywords to be displayed (Figure 3.39).

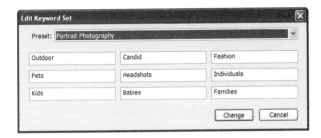

Metadata

The Metadata section of the right panel allows you to view and modify the metadata applied to the currently selected images (Figure 3.40). This can be incredibly helpful when filtering images by using the Filters section of the left panel.

Figure 3.40 The Metadata section allows you to view a wide range of metadata about your images and provides the ability to modify many of the values.

The drop-down to the left of the Metadata heading allows you to specify which subsets of metadata you want to display in this section. This allows you to reduce clutter on the display by viewing only the types of metadata you are interested in. The available options are as follows:

All will display all available metadata.

Default will display a subset of metadata based on what Adobe apparently felt was most useful within Lightroom, including basic file and capture data about the image.

EXIF displays only the EXIF capture metadata recorded by your digital camera.

IPTC displays only the International Press Telecommunications Council (IPTC) metadata fields, which include a wide range of information about the photographer and photograph.

Minimal displays only the filename, rating, caption, and copyright information.

Quick Describe displays only basic information about the file, rating, image attributes, and a handful of fields from the IPTC metadata.

For purposes of getting familiar with all of the available options, I suggest using the All option as you explore the Metadata section of the right panel.

The Preset drop-down at the top of the Metadata section allows you to apply (or create) metadata presets for your images. I discussed these metadata presets at the beginning of this chapter when discussing their use while importing images. You can also apply metadata presets after importing from the Metadata section. The same options you saw before are available in this drop-down, and they work in exactly the same way, except that they are applied immediately when you select the option rather than not applying until you actually initiate the import.

The File Name and File Path fields are for your information only and cannot be modified. The arrow button to the right of the File Path and Shoot fields will open a separate window showing you the specified folder.

The Rating field allows you to view and change the rating for an image. To change the rating, simply click the dot that represents the number of stars you want to assign as a rating for the currently selected images. To set the rating to No Rating, click the star for the currently applied rating. Besides changing the rating for an image in the Metadata section, you can also change it in a variety of other ways. If you have enabled the Rating display below the thumbnails in the grid view, you can use that display below each thumbnail in exactly the same way you use the control in the Metadata section. You can also press the numbers 0 through 5 on your keyboard to apply a rating to the selected images, with the number reflecting how many stars the rating should be (0 equals No Rating).

The Title, Caption, and Copyright fields are self-explanatory, and each of these can be modified by entering (or changing) the desired value in the appropriate field.

The EXIF section contains details about the capture recorded by the camera. These values are read-only, meaning you can review them but you aren't able to modify them in Lightroom, with the exception of the Date Time field. This field includes an arrow button to the right of it that will bring up the Edit Capture Time dialog box. To change the capture date and time for the currently selected images, enter a new date and time. You can click the drop-down for this control to display a calendar control from which you can select the date. Click the Change button to apply the change, but be aware that this adjustment cannot be undone. You can always change the date and time again later, but there is no way to restore the original information as recorded by your camera. Note that this adjustment is really intended to correct for situations where the date, time, or time zone was not set properly for your camera when the images were originally captured.

The Photographer Info and IPTC sections contain fields that allow you to enter additional information about the photographer and photograph for the currently selected images. Click any field to access it and add or change a value.

If you have selected multiple images, you will likely see that some of the fields are set to < mixed >, indicating that there are different values for the images you have currently selected (Figure 3.41). If you change this value to something else, the new value will replace whatever value had been applied to that field for all currently selected images.

Figure 3.41 If any fields in the Metadata section have a value of < mixed >, this indicates that different values have been applied to the selected images. Changing this value will replace the existing values for all selected images with the value you enter.

Exporting Images

After using the many options available in Lightroom to filter, review, and process your images, you may want to package them up to share with clients or others. Lightroom provides an option to export your images for exactly that type of purpose.

The first option simply places copies of all of the currently selected images into a new folder so you can copy them onto other media and share them with others. To export, select the images you want to export and then choose File → Export from the menu. This brings up the Export dialog box, where you can specify the settings for the images to be exported (Figure 3.42).

Figure 3.42 The Export dialog box allows you to specify the settings you want to use when exporting images from Lightroom.

The first section allows you to specify which folder the images should be placed in. Click the Choose button to bring up the Browse For Folder dialog box (Figure 3.43) and select a folder (or make a new folder), and then click OK. Select the Put In Subfolder check box if you would like the images to be placed in a subfolder within the folder you selected, and enter a name for that folder if you do want to use this option.

Figure 3.43 The Browse For Folder dialog box allows you to select a folder (or make a new one) where you want the exported images placed.

You can rename the files when they are exported if desired. Just remember that doing so can make it more difficult to reference the original images when the client contacts you about the images you sent them via export. The File Naming controls are the same as those found in the Import Photos dialog box covered at the beginning of this chapter.

The File Settings section contains options allowing you to control the details of the files resulting from the export process. The File Format drop-down allows you to choose which type of file you want to provide (I suggest using JPEG for basic image review, and TIFF when the images will need to be printed by the recipient).

The Image Settings section will contain controls appropriate to the file type you have selected. For JPEG, that will be a Quality slider, allowing you to balance image quality with file size. For PSD files, the only setting is for Bit Depth (8 or 16). For TIFF images, you can specify Bit Depth as well as a compression method for the files (I prefer to use None to ensure maximum compatibility, even though it results in larger file sizes). The Color Space drop-down allows you to choose the profile to be used as a color space for the images. I recommend Adobe RGB for most situations. You can use sRGB if the images are going to be used only on the Web, and ProPhotoRGB if you are sending images at a Bit Depth setting of 16. If you want to limit the size of the images (either so they can't be reproduced very large or just so the file sizes won't be as large), you can select the Constrain Size check box and then enter maximum values for width and height. A drop-down to the right of both fields allows you to specify the unit of measure to be used. Below this section is a Resolution field you can use to set the output resolution of the exported files.

Finally, the Post-processing section at the bottom of the dialog box allows you to specify an action that you want to be taken after the export is complete (Figure 3.42).

Figure 3.44 The Post-processing options allow you to choose what action should be taken after the export is complete.

The available options are as follows:

Do Nothing Do nothing after the export.

Show in Explorer/Show in Finder Open the images in an Explorer window after export so you can review them.

Burn the exported images to a disc Start the process of burning a CD or DVD with the images. If you use this option, refer to the next section for details on how to configure the burning of the disc.

Open in Adobe Photoshop Open the images in Photoshop. Note that if there are a large number of images being exported, this can be a time-consuming task.

Note: There is also a "Go to Export Actions Folder Now" option that when selected will bring up a window showing you the contents of the folder where actions are saved.

After you've established all the settings as desired, click the Export button to begin the process. The images will then be processed based on your settings so you can share them with others.

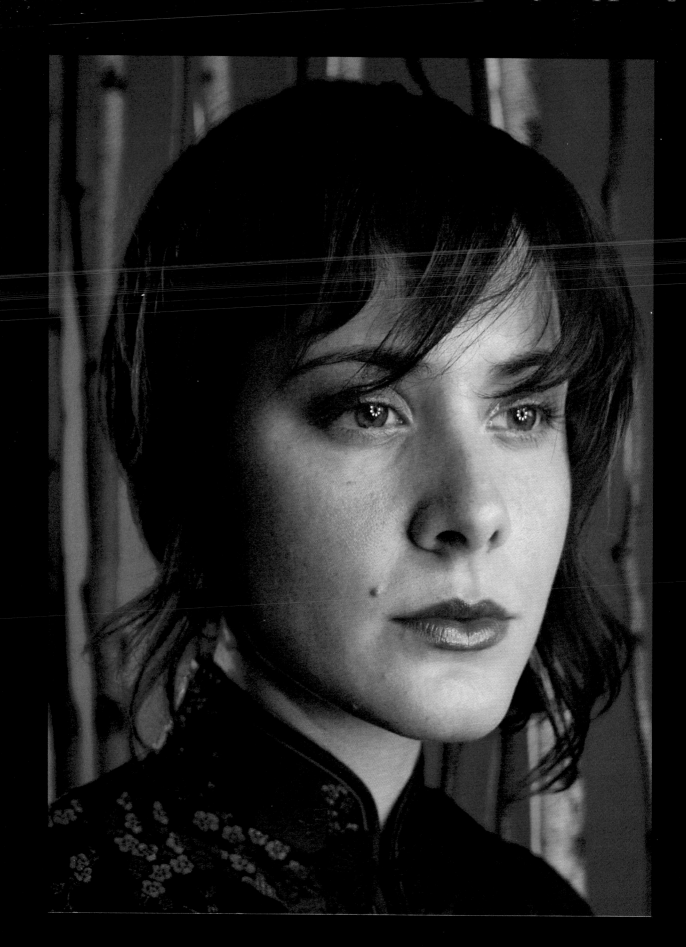

Develop

Making adjustments to an image in order to optimize its appearance and best fulfill the vision you had when you clicked the shutter release is at the heart of digital photography. In Lightroom it is also at the heart of the workflow. The Develop module provides most of the tools that most photographers will need for most of their images. Understanding how the various tools work will enable you to produce the very best results possible for your images.

4

Chapter Contents

Developing the Image

The Develop module in Lightroom is completely focused on allowing you to optimize your images to perfection. One of the most important aspects of the Develop module is that all adjustments are nondestructive. This means that the original pixel values are never modified in the file. Instead, the adjustments you make are stored separately as instructions, and Lightroom renders the result on the fly by combining the original image with the adjustments you've applied. You can therefore feel free to experiment with a wide range of adjustments without any concern that you'll damage the original capture data.

One of the common questions I get about Lightroom is whether it replaces Photoshop. Because Photoshop revolves around image optimization, the Develop module is a good test for whether you could indeed do without Photoshop. In this chapter you'll see that the Develop module contains the vast majority of adjustments you'll need for your images, so there are only a few cases (targeted adjustments for example) where you'll need a more powerful photo-editing tool such as Photoshop.

As you've seen by now, the first step is to find the image you want to work on (I'll talk about applying adjustments to multiple images at once toward the end of this chapter). After you've located the image you want to work on in the Library module, you can start optimizing the image in the Develop module by selecting it from the top panel. You can always switch to a different image by using the filmstrip while in the Develop module.

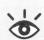 **Note:** As soon as you've selected the image you'll be optimizing, I recommend hiding the identity plate and filmstrip to maximize the space available for your image.

Navigating the Image

More than likely you focused some energy on a close review of your images while you were working in the Library module, covered in the previous chapter. As you switch to the Develop module to start adjusting your images, you'll use the same basic methods to evaluate the image as you make your adjustments, helping you decide when you've achieved the optimal results. Lightroom provides a variety of ways to view and navigate around your image while you're working on it in the Develop module.

Navigator

As you saw in Chapter 3, "Library," the Navigator provides several ways for you to zoom in or out and navigate within your image to view different areas. When working in the Library module, these features are used primarily for evaluating images to determine image quality and perhaps to update metadata. In the Develop module these tools are similarly useful, this time for evaluating the adjustments you need to make and confirming that the adjustments are optimal after you've made them.

All of the controls in the Navigator function exactly as they do when working in the Library module, so if you need to refresh your memory on how to use the Navigator, go back to Chapter 3 and review.

When it comes to the Navigator in the Develop module, I tend to use the Fit and 1:1 options most frequently (Figure 4.1). I use Fit when I want to get an overview of the entire image to evaluate tone and color, and 1:1 when I want to evaluate specific areas to ensure that I'm applying an appropriate adjustment and not introducing any problems into the image. Occasionally I'll use the 3:1 option (or one of the other zoom settings available from the accompanying dropdown list) to get a really close look at an area I'm concerned about, such as when fixing fringing (discussed later in this chapter).

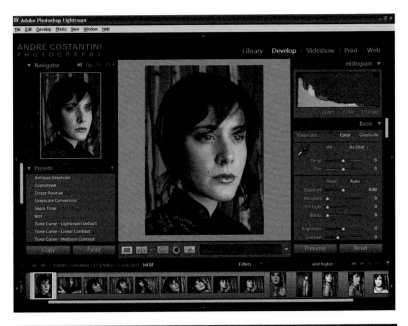

Figure 4.1 When working in the Develop module, I tend to use the Fit (top) and 1:1 (bottom) views most frequently.

Note: When you use the cropping view covered in the next section, the image will always be sized to fit the available space regardless of the option set in the Navigator.

View Options

The primary display area is where you'll focus most of your attention during the process of optimizing your images in Lightroom, and there are various view and navigation options available for this display. In some cases the options match those available in the Navigator, providing multiple ways to accomplish the same goal. However, there are also additional views within this display. The three views available are loupe view, and before-and-after view (with four different options for this), and cropping view. Each is accessible via one of three buttons at the bottom-left corner of the primary display, on a toolbar that appears there (Figure 4.2).

Figure 4.2 The toolbar along the bottom of the primary display allows you to switch between the three views in the Develop module.

Note: The images in this chapter were generously provided by photographer André Costantini (www.sillydancing.com). I can assure you I had a very difficult time finding images from him that needed much adjustment at all.

Note: The toolbar that contains the controls discussed in this section can be toggled between hidden and visible by pressing the T key on your keyboard.

Loupe View

The loupe view is the default view for your image in the Develop module (Figure 4.3). It simply displays the image to fill the available area, with the zooming set based on the current Navigator settings. To switch back to the loupe view after you have activated a different view, click the first button below the bottom-left corner of the image in the primary display ▣.

The loupe view also includes the ability to zoom and navigate around your image in a manner similar to what is available with the Navigator. If the image is zoomed so it more than fills the available display (in other words, some of the image extends outside the visible display), you can point your mouse at the image and click and drag to move the image around within the display area.

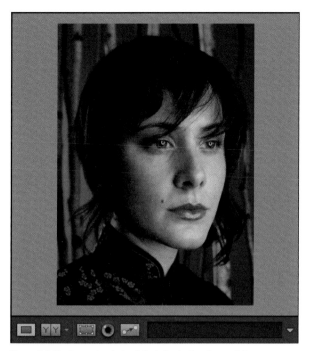

Figure 4.3 The loupe view is the default for the Develop module.

A single click on the image will toggle between the Fit view (with the image fitting the available space, so you can see the full image) and the 1:1 view (in which one pixel on the display represents a single pixel in the image). When you click to switch to 1:1 view, the image will be centered on the area you clicked. This provides an excellent way to quickly evaluate the effect of an adjustment on a specific area of an image. Just click on an area to zoom in and evaluate it, and then click again to see the whole image again. Repeat as needed for evaluating various areas of the image up close.

Note: Remember you can also select an area of the image to review by dragging the box within the Navigator.

Before-and-After View

The before-and-after view is available only in the Develop module, which makes perfect sense because this is where you'll be making adjustments to your images and therefore want to see the "before" and "after" versions. It can be helpful to compare the image before and after an adjustment to get a better sense of whether that adjustment is optimal (Figure 4.4). In fact, you can continue applying adjustments after applying this view so you can see the comparison even as you're adjusting the appearance of the after version of the image.

To enable the before-and-after view, click the second button below the bottom-left corner of the image in the primary display [Y|Y]. The default view places the before version of the image on the left and the after version on the right. However, there are actually four view options to choose from. You can select the desired view by clicking the down-arrow to the right of the button you used to enable the before-and-after view, or by simply clicking multiple times on the button to cycle through the view options. The available options are as follows:

Before/After Left/Right places the before version on the left and the after version on the right. Both views will always show the same portion of the image, so as you drag one, the other will follow.

Before/After Left/Right Split places the before version on the left and the after version on the right, but as a single view of the image split in half. The left half of the image will show the before version while the right half of the image will show the after version. As you drag the image, the split remains in the center as the image moves around.

Before/After Top/Bottom places the before version on the top and the after version on the bottom. Both views will always show the same portion of the image, so as you drag one, the other will follow.

Before/After Top/Bottom Split places the before version on the top and the after version on the bottom, but as a single view of the image split in half. The top half of the image will show the before version while the bottom half of the image will show the after version. As you drag the image, the split remains in the center as the image moves around.

The before-and-after view is helpful for evaluating the adjustments you are applying to the image in the context of the original appearance, but it also offers some additional functionality. You may have noticed that clicking the button to enable the before-and-after view causes two additional buttons to appear to the right of that button. Those buttons allow you to apply the settings from one view to another. This

ability means that you aren't always looking at the original image compared to the adjusted image, but rather can be comparing two different adjusted versions of the image. This gives you tremendous flexibility as you're deciding on precisely how you want to adjust an image.

To apply settings from one version to another, simply click one of the two buttons that appear when you're in before-and-after view:

- The left button ⊞ applies the settings for the before image to the after image (Figure 4.5). You can think of this as reverting your adjustments, but it doesn't necessarily mean you'll be going back to the original image because you could have applied the adjusted after version to the before image.

- The right button ⊞ applies the settings for the after image to the before image. Think of this as making one of the images look like the other, and you'll probably find it much easier to work with this feature.

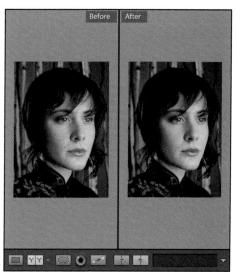

Figure 4.5 Clicking one of the apply settings buttons will apply the settings for one view of the image (left) to the other view (right).

One way you might use this capability is to compare a relatively modest adjustment to a stronger adjustment to help you decide on the final adjustment. You could apply relatively modest adjustments to the image, and then switch to before-and-after view. Click the right button to apply the after version to the before, and then make further adjustments to the after version. This will show you a comparison between the intermediate and final adjustments you applied so you can make a decision about what settings to keep.

Another way to use this capability is to compare two completely different versions of an image to decide which you like better. For example, you could produce an optimized color version of your image and then switch to before-and-after view and apply those settings to the before image. You could then create a grayscale version of the after image (for example, using presets as discussed later in this chapter) and compare the two to decide which you like better.

After you've decided on the settings you want to keep for your image, be sure to apply those settings to the after version if necessary. In other words, if the before image is the one you want to keep, apply those settings to the after version with the left button so that the after image represents your final version. You can then switch back to the loupe view if you want to continue your work.

Cropping View

It may seem odd for the cropping view to be discussed as a view mode rather than a tool, especially if you're accustomed to using the Crop tool in Photoshop. Keep in mind that Lightroom takes a very different approach to optimizing your images compared to Photoshop, maintaining a nondestructive workflow throughout. Your image is never permanently cropped. Instead—as with all adjustments in Lightroom—the settings you used are remembered and the cropped result is displayed, even though the pixels weren't eliminated in the crop. The only exception to this is when you're actually in the cropping view where you can see the full image.

As such, the cropping view really is a way to look at (and crop, of course) your image. After you've applied a crop when using Lightroom, the normal and compare views will show the cropped version of the image (Figure 4.6). However, the cropping view will always show the full image, with a crop box indicating where the image has been cropped. You can then adjust the cropping and even rotate as desired. To display cropping view, click the third button below the bottom-left corner of the image in the primary display.

Figure 4.6 The cropping view shows the complete image with a cropping box to indicate how it has been cropped.

If you've read my book *Photoshop Workflow*, you know I generally prefer to apply cropping late in the workflow. In fact, I often save it for just before preparing the image for final output. However, with Lightroom I don't feel there is a need to delay cropping because it is always nondestructive. Because I have the confidence of knowing that I can always come back and refine my crop, or even restore the original uncropped image, I now tend to apply cropping in the normal process of optimizing the image.

Once you enable cropping view, the image will be sized to fit the available area and a box with "handles" placed around the image so you can adjust the cropping (Figure 4.7). Before you start adjusting the crop box, however, consider whether you want to constrain the aspect ratio to maintain the relationship between width and height in the image. By default, the crop tool is set to "Original" for the aspect ratio, meaning the aspect ratio of your image will be retained. You can also select an option from the drop-down menu to the right of the "lock" button on the toolbar below the primary display area (Figure 4.8). Options are included for Original (the original aspect ratio of your image), various relationships between width and height (such as 1×1 for a square cropping), and Enter Custom, which allows you to enter specific values you want to use for an aspect ratio (to match the aspect ratio of a custom frame, for example).

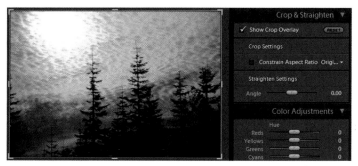

Figure 4.7 When you select the Show Crop Overlay check box, the image is displayed in the cropping view.

Figure 4.8 There are a variety of aspect ratio options you can choose from when cropping your image, including an Enter Custom option that lets you set any aspect ratio you like.

To actually crop the image, move the mouse to the edge of the box placed around the image and drag. The cropping box cannot be placed outside the image, so you never have to worry about "extra" pixels being added around the image because you set the crop larger than the image itself.

> **Note:** You don't have to use one of the handles to adjust the cropping box. You can point the mouse anywhere along an edge—or a corner to adjust two sides at once—to adjust the cropping of your image.

After you have resized the crop box, you'll see that part of the image lies outside that box. If you'd like to fine-tune the position of the image within the cropped area,

you can point the mouse over the image and drag to move the image into a new position (Figure 4.9). I find this less intuitive than if you were able to move the cropping box around, but you can think of this as moving the image to position it as desired through a window (the cropping box) to achieve the result you're looking for.

Figure 4.9 You can click and drag on the image to move it around within the cropping box.

The rightmost control on the toolbar in cropping view is Straighten. This includes a slider to adjust the rotation angle of the image. The range is from −45° to 45°. Naturally, 0° represent no rotation at all and is the default value. You can rotate the image by moving the slider left or right, and as you do a grid will appear within the cropping box to help you achieve proper alignment (Figure 4.10).

Figure 4.10 When you're adjusting the Angle for rotating the image, a grid appears within the cropping box to assist you with proper alignment.

Besides using the slider, you can also rotate the image directly within the primary display area. To do so, position the mouse pointer within the primary display area but outside the current crop. The mouse pointer will change into a double-headed curved arrow. Click and drag to rotate the image. The grid will again appear within the cropping box to assist you with proper alignment as you rotate. You'll also see that you are

still limited to 45° in either direction, because using this method is simply an alternate way to adjust the Angle slider.

In some cases, especially where precision is necessary in rotation, you may find that the two methods that I've mentioned don't give you the control you need. In that case you can use the Straighten tool to achieve a more precise result. To access the Straighten tool, click the ruler icon on the toolbar below the primary display area. When you then put your mouse over the image, you'll see it is a crosshair. Click and drag along an edge in your image that should be perfectly horizontal or vertical. You'll see that an anchor point is placed where you first clicked, and another follows your mouse, with a line drawn in between (Figure 4.11). Position the mouse so the line between those two anchor points is perfectly aligned with the reference line in the image, and then release the mouse. The image will be rotated so the line you defined becomes perfectly horizontal or vertical, with the orientation set depending upon whether the line you drew is closer to vertical or horizontal.

Figure 4.11 The Straighten tool allows you to draw a line to define an edge that should be perfectly horizontal or vertical, and Lightroom will then rotate the image automatically.

Regardless of which of these methods you use to straighten your image, the image will automatically be resized within the cropping area so none of the cropped area appears outside the actual image (Figure 4.12). This ensures that you won't have any pixels added around the outside of the image. No matter how you crop and rotate in Lightroom, you'll always end up with a result that shows only the pixels within the image, and nothing else.

Figure 4.12 As you rotate a cropped image, the image will automatically be resized within the cropping box to ensure that none of the cropped area falls outside the actual image.

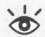

RGB Values

As you're working with the view options in the primary display, you may have noticed the numeric RGB values displayed below the bottom-right of the image in the primary display. This area shows you the red, green, and blue (RGB) values for the pixel currently under your mouse pointer in the primary display (Figure 4.13).

| R | 52.9 | G | 57.8 | B | 95.6 % |

Figure 4.13 As you move the mouse over your image, the RGB values are displayed on the toolbar below the primary display.

The RGB values display can be helpful for evaluating areas of your image more critically or getting a sense of what color cast exits in a particular area. Simply move your mouse over the image and you'll see the values change to reflect what's under the mouse at any given moment.

The values are displayed as percentages, which is different from the default settings you may be accustomed to in Photoshop. However, using percentages removes the need to remember what the maximum values are for images of varying bit depths. It is easier to remember that 100% is the maximum value than it is to remember that 255 is the maximum for 8-bit per channel images and 65,535 is the maximum for 16-bit per channel images. If the value for any of the channels is 100%, it indicates that detail was likely lost for that channel (unless it just happened to reach the maximum without going over). If all three values are at 100%, it indicates that area has become pure white, and detail is also probably lost. In general you want to avoid values going to 100%, especially for large areas of the image, because those details will lack some (or any) detail. The same holds true for black (0%), though it isn't as significant a problem since a lack of shadow detail isn't as problematic for an image as are blown highlights.

When evaluating color casts, look to see how the values relate to each other. A neutral area will have all three values matching (or very nearly matching). If there's a color cast, the values will likely not be very close to each other. Determining whether there is a color cast from these values is difficult, because you don't know what the values should be for a given color appearance. However, if an area doesn't quite look right, you can use the RGB values to help you determine what the color cast may be. Simply look to see which value is furthest from the other values, or which value doesn't seem appropriate for the color of the area. For example, in a blue sky a high red value would indicate a possible color problem. By comparing the RGB values and what they indicate to what you would expect for a given color area, you can get a better sense of what sort of adjustment might be necessary.

Note: Evaluating RGB values requires at least a basic understanding of the relationship between colors (Figure 4.14). Remember that red is the opposite of cyan, so a high value means more red and a low value means more cyan. Similarly, green is the opposite of magenta, and blue is the opposite of yellow.

Figure 4.14 Understanding the relationships between colors can be very helpful as you're applying color adjustments to your images.

Using Presets, Snapshots, and History

Besides the Navigator, the left panel in the Develop module contains the Presets, Snapshots, and History sections (Figure 4.15).

Figure 4.15 The Presets, Snapshots, and History sections are below the Navigator on the left panel.

Presets

Presets provide a way to quickly apply a set of saved adjustments to an image, producing a consistent effect for a given preset on any image you apply it to. For example, Lightroom includes presets to produce a grayscale (black-and-white) image, sepia-toned

image, and several others. You can add your own presets based on settings you've applied on the right panel (discussed later in this chapter).

Applying a preset to an image is as simple as clicking on one in the list of presets. You don't need to know what each preset name really means, because you can see a preview in the Navigator as you move the mouse over a preset name (Figure 4.16), and the effect is applied immediately in the primary display when you click on a preset from the list (Figure 4.17). If you don't like the result, you can always choose a different preset or undo the application of the preset in the History section, which I'll cover shortly.

Figure 4.16 When you mouse over a name on the Presets list, the Navigator shows a preview of the effect.

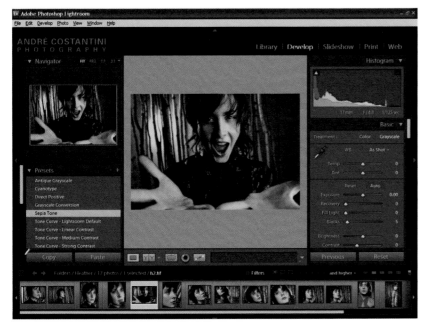

Figure 4.17 When you click on a preset from the list, the effect is applied immediately to the image.

Keep in mind that you can also compare two presets by using the before-and-after view. To do so, apply a preset to your image. Then switch to before-and-after view and apply the appearance of the after view to the before view. Finally, click another preset and you can see the two compared next to each other (Figure 4.18).

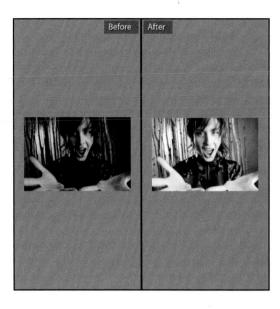

Figure 4.18 You can use the before-and-after view to compare the effect of two presets on your image.

After you've applied a preset to an image, you can still fine-tune all the adjustments in the right panel to produce exactly the result you're after. I talk about all the adjustments on the right panel later in this chapter.

Adding and Removing Presets

As you start to get a sense of the power of presets, and as you get more familiar with the adjustments you can make to your images, you'll likely find other presets you'd like to create. Doing so is quite simple.

Start by making adjustments to your image to produce the effect you want, using any of the controls available to you. When you have the image looking exactly as you want it, click the "plus" button to the right of the Presets label on the left panel. In the New Develop Preset dialog box that appears (Figure 4.19), enter a name in the Preset Name field that is meaningful to you and describes the results you will achieve by using this preset. Note that you can choose which adjustments you actually want the preset to apply to your images. My recommendation is to have all of the check boxes selected, because you made the adjustments based on the way you wanted the image to appear and therefore probably want to include all of the adjustments as part of the preset. However, if there are specific aspects of the adjustments you've applied that you don't want included in the preset, you can clear the check boxes for those items. After you've configured the settings for the preset, click the Create button to save the preset to the list. From that point forward it will be available for you to apply to your images by selecting it in the Presets section.

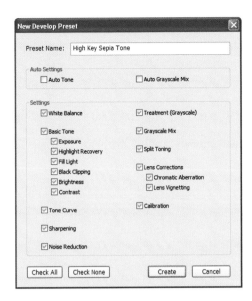

Figure 4.19 When you click Add in the Presets section, the New Develop Preset dialog box appears, allowing you to specify which adjustments should be included in the preset.

Note: It is best to use presets for special effects rather than more-typical tonal and color adjustments, because typical adjustments can vary significantly from one image to another.

If you find you have a preset you no longer need or created by accident, you can remove it by first clicking on the preset and then clicking the "minus" button to the right of the Presets label on the left panel. Note that because you need to select the preset before you can remove it, the adjustments included in that preset will be applied to the image. You can remove the effect by using the History feature, which I cover in the next section.

Snapshots

Snapshots provide a way for you to literally take a snapshot of your image at a particular moment in time so you can return to that appearance later quickly and easily. This is particularly useful when you want to create multiple versions of an image, such as when you create a color and a black-and-white version of the same image. It is also helpful as you are working on your image and making relatively significant adjustments so you can easily go back to a point that you were happy with an image.

The way I recommend thinking about snapshots is to take one any time you feel you've achieved a good result with an image but plan to go further with your adjustments. This will give you the ability to go back to that point at any time by simply clicking the name of the snapshot you created.

To add a snapshot, adjust the image to the point you're happy with it (or the point where you want to capture a snapshot) and then click the "plus" button to the right of the Snapshot label on the left panel. A new snapshot called "Untitled Snapshot" will be created, with the text in edit mode. Simply start typing to apply a more meaningful name to the image. Ideally you want to apply a name that will indicate to you immediately what the image will look like if you choose that snapshot.

If at any time you decide you don't need a snapshot you have created for an image, simply select it and then click the "minus" button to the right of the Snapshots label on the left panel.

 Note: Snapshots don't replace the History option discussed next, but rather supplement it by providing you with a way to encapsulate multiple adjustments into a single history state as a snapshot.

History

The History section of the left panel serves two purposes. The first is to display a history of what you've done to an image (Figure 4.20). This history can be helpful for a variety of reasons—for example, you may want to see the order in which you applied adjustments or to see whether you already applied a particular adjustment. Just as evaluating metadata for your images can be helpful in capturing better images in the future, evaluating your history for an image can be helpful in producing the best results when optimizing your images.

Figure 4.20 The History section displays a list of everything you've done to an image, and provides the ability to step back to any point in the process of making adjustments.

Although seeing what you've done is helpful, the biggest value comes from being able to undo something you've done when you're not happy with the results. If you've used Photoshop for any period of time, you're likely familiar with the History palette there. Lightroom takes that concept to a higher level.

To really appreciate the value of the History feature in Lightroom, it is important to understand what's going on behind the scenes. First, it is helpful to remember that Lightroom is a nondestructive editor, which means that it never alters the original pixel values in your images. Instead, it remembers what changes you want applied, and then shows you the effects of those changes on the fly. What you're seeing is a translation of the changes you've applied to your image, not a modified version of the original. That's an important distinction because it means you will always have the original pixel values preserved. As an additional benefit, it is easy for Lightroom to keep track of a large number of changes you've applied to your images. They're all simply instructions that require very little storage space to remember, as compared to the huge amount of space that would be required to save multiple versions of your image so you could step back to any version at any time.

The History feature in Lightroom shows you a list of what you've done to your image and gives you the opportunity to step back in time to any point, effectively undoing anything that had been done after that step. However, because Lightroom remembers all of the things you've done, stepping backward in History is never a permanent action. You can bounce back and forth as you see fit (Figure 4.21).

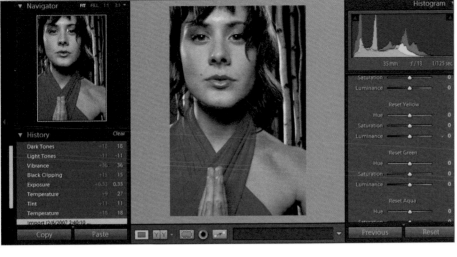

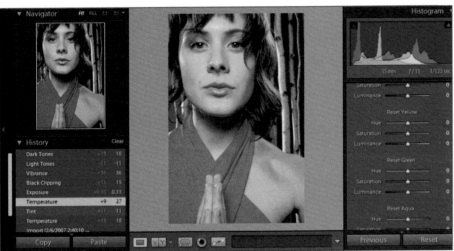

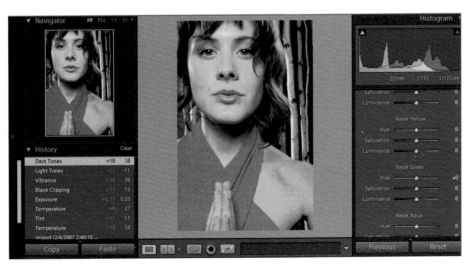

Figure 4.21 Lightroom's History feature allows you to bounce around between various states of an image as you see fit, always remembering everything you've done to an image.

For example, if you've adjusted a color image to improve saturation, then applied a grayscale effect, and then applied a color tint, each of those steps will be remembered in History. You can then click on any of the steps in History to go back to the version of the image as it was at a particular moment in time. You can go back to the color version, then come back to the grayscale version, and shift back and forth between any of the versions in this manner. The version of the image you see depends on which step you've selected in History.

What this means is that you never lose any version of your image in Lightroom. You can always switch between versions, effectively undoing and redoing any of the adjustments you've applied along the way.

Note: The History is available only in the Develop module, meaning tasks you perform in other modules can't be undone by using History.

The most common way to work with History is to undo something you didn't intend to do or aren't happy with. When such a situation exists, scroll through the History list to find the last step you want to keep applied to your image, and click on it. You'll see the image updated to reflect the way it appeared when that step was applied to the image. Because you're able to click on any step in History to see what the image looked like at that point, and because all History states are retained for the life of an image in Lightroom, you don't have to worry about experimenting to find the appropriate step to click on. You can just click on the step you think is right, and then click on others until you find just the right one.

Note: You can clear the History by clicking the Clear link to the right of the History label on the left panel, but this isn't something I recommend.

Making Adjustments

The real focus of the Develop module is the right panel, which contains a wide range of options that enable you to exercise tremendous control over tonal and color adjustments for your images (Figure 4.22). One of the things I like most about these adjustment controls in Lightroom is that they operate the same for all images, whether they are RAW captures that need to be processed in the background to produce an actual image or standard image file formats such as JPEG. You don't have to learn two different processes for two different types of images, but rather can use all of the same adjustments on all photos, regardless of their source.

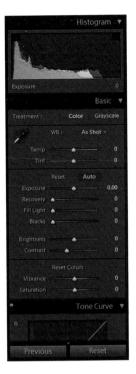

Figure 4.22 The right panel in the Develop module contains a wide range of adjustments that allow you to optimize your image. In fact, there are so many that you'll need to scroll down to see them all.

Note: When you're not using the left panel, I recommend hiding it so you can see more of your image as you're optimizing it.

If you've read any of my books on Photoshop (such as my *Photoshop Workflow;* a new edition will be published by Sybex in spring 2007), you know that I recommend performing adjustments in a particular order. I still prefer to work in a specific order, and I'm happy with the order in which the controls appear in Lightroom, so I generally work from top to bottom. However, because Lightroom is always doing nondestructive edits on your image, it isn't especially critical that you work in a particular order. Although I work through the controls from the top of the panel to the bottom in most cases, feel free to move around between various controls if an image demonstrates a need for a particular adjustment first or you simply have a preference to perform the adjustments in a different order.

Note: You might want to hide the right panel while you're adjusting your images, so you can see as much of the image as possible for evaluation. The panel can be brought quickly back into view by moving your mouse over the bar on the right side of the Lightroom window.

Remove Redeye Tool

Redeye (that devilish red glow in the pupils of the eyes you've certainly seen in many snapshots) can generally be avoided by keeping the flash relatively far from the lens axis, but when it does occur Lightroom makes it easy to fix. The Remove Redeye tool ▣ is found on the toolbar below the primary display area, with a button that looks appropriately enough like an eye.

Before you get started using this tool, it is helpful to zoom in on the first eye in the image that needs to have redeye removed. I try to zoom in close enough that the eye nearly fills the screen, just to make it easier to work (Figure 4.23). Then click on the Remove Redeye button and you're ready to get started. Click and drag to draw a box around the eye that needs to be fixed. Make sure you draw a box that encompasses the entire area exhibiting redeye, but don't include too much of the image outside that area. Lightroom will automatically apply a dark circle over the area to eliminate the redeye (Figure 4.24).

Figure 4.23 When working with the Remove Redeye tool, it is best to zoom in on the area that requires correction.

Figure 4.24 Click and drag to define a box with the Remove Redeye tool that encompasses the area that requires adjustment.

The two sliders that appear on the toolbar when you have the Remove Redeye tool active enable you to fine-tune the effect. The Pupil Size slider allows you to adjust the size of the area being corrected (Figure 4.25). I recommend that you enlarge this setting so the correction covers the entire pupil of the subject, producing a more uniform result. You can then adjust the Darken slider to adjust how dark the pupil will become (Figure 4.26). Be careful not to darken the pupil so much that it looks artificial.

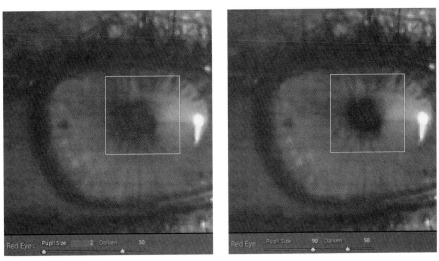

Figure 4.25 Use the Pupil Size slider to adjust the size of the area to which you need to apply a redeye correction.

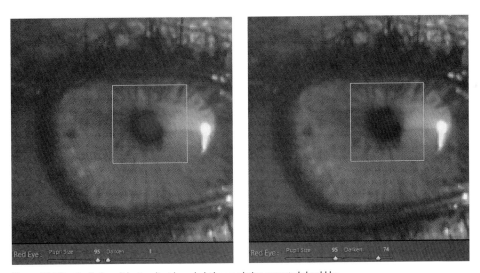

Figure 4.26 Use the Darken slider to adjust how dark the area being corrected should be.

If you have one eye in the photo that requires a fix with the Remove Redeye tool, chances are there is at least one more, and possible several more depending on how many people are in the photo. Use the Navigator to move within the image to the next eye that needs fixing, and draw another box. When you're all done with this tool, simply click it again to disable it.

At the far right of the toolbar is a Clear button that allows you to remove the redeye correction. Be aware that clicking this button will remove all redeye repairs for the current image, so only use it if you're sure you want to start over again (or simply cancel all redeye corrections).

Remove Spots Tool

The Remove Spots tool ▦ provides the basic functionality of the Clone Stamp and Healing Brush tools you may already be familiar with from Photoshop. This allows you to cleanup various spots and blemishes within an image with ease.

To get started, zoom in on the area that requires cleanup. Then click the Remove Spots button on the toolbar. Move your mouse out onto the image again, over an area that needs to be cleaned. You want the brush size to be just big enough to cover the area that requires cleanup (Figure 4.27), so adjust as needed. You can use the Spot Size slider on the toolbar, and a preview of the brush size will appear near the slider. However, I prefer to adjust the brush size as I compare it to the actual area to be cleaned, so instead I keep the mouse over that area and use the left and right square bracket keys ([and]) to reduce and enlarge the brush size, respectively.

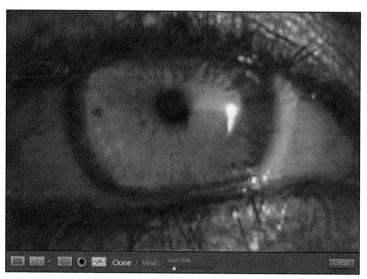

Figure 4.27 Adjust the size of the brush for the Remove Spots tool so it is just big enough to cover the area that needs to be repaired.

Next, decide whether you want the tool to behave in Clone mode (completely replacing an area with pixels from another) or Heal mode (replacing pixels but blending them into the new surroundings). In most cases I recommend using the Heal option, reverting to Clone only when you find the blending of the Heal mode is causing problems. To choose one or the other, simply click the appropriate word next to the Remove Spots tool button.

Note: You can switch back and forth between Clone and Heal as often as needed while working with the Remove Spots tool.

To remove a spot or other blemish, simply move the mouse over the area that requires repair and click. A pink circle will identify the area you clicked on as the area to be cleaned (Figure 4.28). A corresponding green circle will also appear to identify the source Lightroom has chosen as a possible good match to repair the target area. You can adjust the location of both the target and source areas by pointing to the appropriate circle and dragging it around the image. You can also adjust the size of the circles by clicking and dragging on the edge of either circle.

Figure 4.28 When you click to cleanup an area with the Remove Spots tool, circles will identify the source and destination areas, which can be dragged around the image as needed and even resized.

If you find you have repaired an area that didn't need it, or you aren't happy with the repair that you have applied, click on the circle for that repair and press the Delete/Backspace key. You can also click the Clear button on the toolbar to remove the corrections, but keep in mind this will cause all spots you have fixed to be removed.

Histogram

At the top of the right panel you'll see the Histogram, which provides a way to review and evaluate the overall tonality of your image (Figure 4.29). You are probably familiar with the histogram from your digital camera and Photoshop. It charts the distribution of tonal values within your image, so you can get a general sense of the relative brightness and contrast of an image. The chart starts with black on the far left and white on the far right. If the image is relatively dark, the histogram will be weighted toward the left. If the image is relatively bright, the histogram will be weighted toward the right.

A histogram that is relatively tall on the outer ends and not very tall in the middle has higher contrast, whereas one that is not very tall on the outer ends but tall in the middle has lower contrast.

Figure 4.29 The Histogram provides a graphical indication of the distribution of tonal values within your image.

Of course, most of us make those evaluations by looking at the image itself, and don't want to spend time trying to evaluate a chart when we can simply look at the image. However, a histogram can be useful for confirming whether any information is clipped, and is therefore an important tool to utilize when evaluating and optimizing your images.

Clipping occurs when detail is lost in the shadows and/or highlights of an image, either because the image was exposed too dark, exposed too bright, or the scene contained too broad a contrast range to capture all detail. Because a histogram charts the relative number of pixels at a given tonal value, you can determine if clipping occurred in your image by seeing whether the histogram chart is abruptly cut off at the edge of the display area for the histogram (Figure 4.30). If the histogram is cut off in this manner, detail has been lost. With a RAW capture you may be able to make adjustments (discussed later) to recover this lost detail—but if not, there will be areas within the shadows and/or highlights with no texture or visible detail.

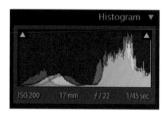

Figure 4.30 A histogram that is cut off at the end (in this case highlights) indicates that detail has been lost (clipped).

The Histogram display in Lightroom also shows you detail about the individual color channels within the image. Instead of simply showing a chart based on tonal values, the individual color channels are represented, displayed in the color of that channel. You'll therefore see that the Histogram display has various areas of color. Wherever you see a color, one or more channels are being represented, depending on the color shown. When you see a neutral value (shades of gray through white), it indicates that all of the channels are being represented in that area. One of the reasons this is important (and helpful) is that the Histogram is able to show you if just a single color is clipped so you can focus your efforts on that color range rather than the overall tonality.

Below the Histogram display you'll see that some basic capture data is shown, including ISO setting, lens focal length, exposure time, and aperture setting. These help you to have context around what you're seeing in the Histogram itself for a given image.

So far I've been talking about how to "read" the Histogram display, but in Lightroom the Histogram is actually interactive. One is the ability to turn on or off the clipping preview display individually for highlights and shadows. When you turn on one or both of these options, you'll see a color overlay on your image showing you where detail has been lost because of clipping. This can be easier than evaluating the Histogram itself, and is more informative in any event because it shows you exactly which area of the image is being affected.

The clipping preview display is toggled by clicking the small triangle that appears at the top-left and top-right corners of the Histogram. The top-left box controls the shadow clipping preview display, and the top-right box controls the highlight clipping preview display. To toggle the display on or off, simply click the box. A white border will be displayed around the box when the option is enabled. If there are actually clipped areas of the image, the highlight box will also be filled with white. Both appear gray with a gray border when disabled. When enabled, the clipping preview will place a color over the image (blue for shadows, red for highlights) in areas that are clipped (Figure 4.31).

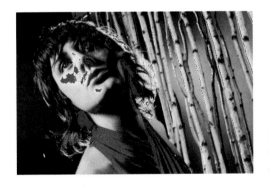

Figure 4.31 When you enable clipping preview with the boxes in the Histogram, a color overlay indicates which areas of your image have clipped highlight or shadow detail.

As you move your mouse over the Histogram, you might also note that areas "light up"(Figure 4.32). Specifically, the Histogram is divided into four zones that relate to specific ranges of tonal values. The darkest shadows at the left are identified as Blacks, the medium shadow areas are identified as Fill Light, the middle-through-bright range is Exposure, and the brightest highlights are labeled Highlight Recovery. These might not strike you as the most obvious names for tonal ranges within the image, but there's a good reason they have these names. Those names correspond directly to the names of controls you'll be able to adjust in the Basic section of the panel. In fact, you can adjust those controls directly on the Histogram. When you mouse over the image and an area becomes highlighted, you can click and drag left or right to adjust the slider relating to that area, just as though you were adjusting the slider itself. I'll discuss these controls shortly, but for now just be aware that the His-togram provides an alternate way to make those adjustments that enables you to better think about what tonal range within the image you're affecting. As you mouse over an

area or drag to adjust, you'll also notice that a value is displayed in the bottom-right corner of the Histogram. That value corresponds to the value for the sliders I'll discuss shortly.

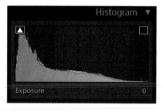

Figure 4.32 When you move your mouse over the Histogram, you'll see a visual indication of the tonal range you're passing over.

Note: Remember that each section of the panel can be collapsed by clicking on its label or the triangle near its label. This allows you to minimize the space for controls you don't use often, to reduce the need to scroll up and down through the controls.

Basic

The Basic section provides the core color and tonal adjustments you need (Figure 4.33). For some images these may be the only adjustments you need, whereas for others you'll want to apply more-advanced adjustments. In either case, the Basic section is the best place to start when optimizing an image.

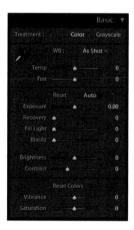

Figure 4.33 The Basic section of adjustments provides all the core color and tonal adjustments.

The first option in the Basic section allows you to switch the mode for an image between Color and Grayscale (these are labled "Treatment"). Unlike in Photoshop, choosing Grayscale doesn't permanently remove the color data from your image, because Lightroom always applies nondestructive edits to your images. You can therefore feel comfortable switching the image to Grayscale mode even if you're not sure you want to produce a monochromatic result. To switch between the modes, simply click the Color or Grayscale label at the top of the Basic section.

Note: If you import a grayscale image into Lightroom, the Color mode will still be available, but the color adjustments (except for Split Toning) won't have any effect.

Note: If you'd like to produce an image that is effectively grayscale with a color tint applied (such as with a sepia tone image), select Grayscale and then use the Split Toning controls discussed later in this chapter to produce the final effect.

Color Temperature

The next options relate to the white balance in your image. These controls allow you to apply compensation for the color of light (color temperature) under which the image was captured, producing more-accurate (or desirable) color.

The first option is the "WB" (for white balance) drop-down list, which allows you to choose a white balance preset. Click the drop-down to see a list of available options (Figure 4.34), and select an option to apply it to your image. The available options are the same as (or similar to) those available in your digital camera for RAW captures (for other image files, the only options are As Shot, Auto, and Custom). They are named for the lighting conditions for which they apply compensation. If you know what the lighting was, you can select it from the list.

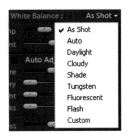

Figure 4.34 The white balance drop-down allows you to choose a preset to apply to your image.

You can also force a compensation that produces a more pleasing result. For example, you could choose Cloudy even if the image was captured under clear skies, to apply a warming effect to the image (in this example compensating for cool light even though cool light didn't exist). I prefer not to use these options because they are not as precise as simply moving the sliders, and even when I select one of the available options from the drop-down, I end up fine-tuning the sliders anyway.

Note: As you're making adjustments in the Develop module, keep in mind that any slider can be reset to its default value by double-clicking it.

The next option is the eyedropper tool. This tool allows you to click on a pixel within your image and have Lightroom apply an automatic adjustment that will make that pixel appear neutral, shifting the color of the entire image accordingly. Lightroom offers a big advantage over the eyedropper feature in Photoshop because it provides a zoomed view of the area you're about to click on so you can be precise in the color of pixel you choose to click (Figure 4.35). This zoomed preview shows a grid of 25 pixels (a 5×5 grid) around the pixel directly under your mouse pointer, and RGB values are included below the grid display. Simply move the mouse over the image to find the area that you want to be sure is neutral and click to see the result.

Figure 4.35 The eyedropper tool in Lightroom includes a zoomed preview display to help you select the best pixel to click on.

Note: When using the eyedropper tool, any color overlay from the clipping preview display will appear in the zoomed view, which can be distracting. I therefore prefer to turn off the clipping preview display when using the eyedropper.

My biggest frustration with the eyedropper tool is that after you click with it, the eyedropper tool returns to its place on the right panel and you need to select it again to click again. Even with the zoomed preview, it is very common that you'll click a pixel in your image only to decide you need to click a different pixel to get the desired result. You therefore need to move your mouse back to the right panel, click the eyedropper, and move your mouse back over the image to find another pixel to click. This may not sound like a significant inconvenience, but when you need to click several areas of the image before you find the right spot, it can be a major annoyance.

Whether or not you've selected one of the white balance presets or used the eyedropper, the next step is to adjust the Temp and Tint sliders. I actually prefer to go directly to these sliders, skipping the preset and eyedropper options.

The Temp slider allows you to adjust the color temperature (measured in degrees Kelvin) that identifies the color of light under which the image was captured. Rather than getting caught up in the science behind the adjustment, I recommend that you simply think of the slider as providing the ability to create a cooler (more blue) image by sliding to the left, or a warmer (more yellow) image by sliding to the right.

The Tint slider provides a similar control, shifting color between green to the left and magenta to the right. Think of this as a way to fine-tune the color temperature adjustment. Start with the Temp slider, and then adjust the Tint slider to get the best color.

Tonal Adjustments

The next section of the Basic group of controls affects overall tonal adjustments for your image. The first option is the Auto Adjust Tonality check box. If you select this check box, Lightroom will attempt to automatically optimize the tonality of your image (Figure 4.36). Although it generally does a pretty good job of this, my preference is to adjust the four sliders in this section manually instead. However, if you have an image that you just can't figure out how to adjust, you can select this check box to get an improved starting point, and then fine-tune the sliders from there.

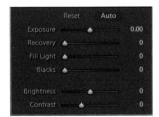 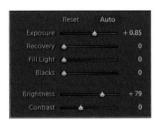

Figure 4.36 If you select the Auto Adjust Tonality check box, Lightroom will automatically apply adjustments to the Exposure, Recovery, Fill Light, and Blacks controls.

The primary options for adjusting tonality in your image are Exposure, Recovery, Fill Light, and Blacks. Each of these is adjusted with a slider, and focuses the adjustment on a specific tonal range within the image. This doesn't mean that each control will be limited to affecting only tonal values within a particular range, but rather that the adjustment will emphasize that range with a lesser effect on other tonal values within the image.

Exposure is a form of brightness adjustment that emphasizes its effect on the midtones to highlights in the image. You can think of it as having a very similar effect of increasing or decreasing exposure in the camera. In fact, the unit of measure for this control is exposure value, or EV. This control should be used primarily for setting the white point. For images that should have an area of white within them, the idea is to set this to a value that produces a true white without any clipping.

For such images, my recommendation is to use the clipping preview that is available for this control. To enable this preview, hold the Alt/Option key as you move the slider. The image will become pure black except where clipping occurs, which will be shown in a color indicating which channel or channels are being clipped (Figure 4.37). In general you'll want to adjust the slider to the right until you start to see clipping, and then back off until there isn't any clipping. For images that don't call for any bright white values, you can adjust this control visually.

Figure 4.37 The clipping preview display, enabled by holding Alt/Option while adjusting Exposure, is helpful in finding the optimal setting.

In some cases you may find that reducing the Exposure value until there isn't any clipping produces an image that is far too dark. In those cases the Recovery slider can be helpful. Start by setting the Exposure slider to a value that produces a more pleasing image in terms of overall tonality, even though some highlight detail is being lost. Then adjust the Recovery slider to bring back highlight detail (Figure 4.38). Move the slider to the right to recover highlights (prevent clipping) and to the left to reduce the strength of this effect (but not to the point of reintroducing clipping). The Recovery slider is also helpful for situations where highlight detail has been lost in the original capture and you're trying to make the best of it. The clipping preview display is also available for the Recovery slider by holding the Alt/Option key, and I strongly recommend using this feature to get the most-accurate adjustment possible. When recovering highlight detail, the best approach is to use only as much adjustment as is necessary to bring back the detail, without recovering so much that the highlights start to look muddy.

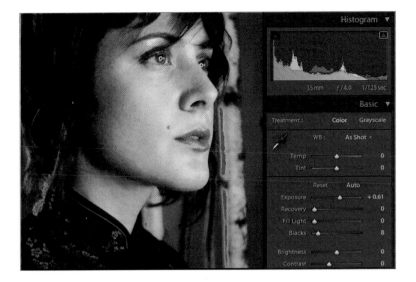

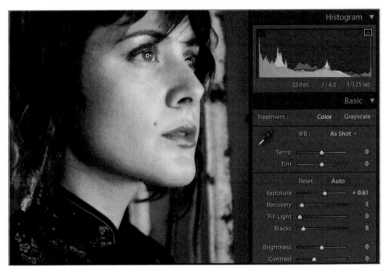

Figure 4.38 When you need to use an Exposure setting that causes a loss of detail in highlights (top) in order to achieve appropriate overall brightness in the image, the Recovery slider can help restore detail in those areas (bottom).

The Fill Light adjustment lightens up the shadow areas of your images, and is useful for bringing out detail that exists but isn't visible (Figure 4.39). Because this adjustment is focused on the dark areas but doesn't affect the black point, the image won't get severely washed out by using this control. However, you can create an artificial look by lightening up shadow areas too much, so it is important not to use a setting that is too extreme. There is no clipping preview available for this adjustment because it doesn't affect the black or white point in the image, so you'll need to judge the adjustment required by a visual review of the image.

Figure 4.39 The Fill Light adjustment allows you to bring out detail in the darker areas of your image.

The Blacks slider controls the black point in the image. When you move the slider to the right, you are defining a new black point in the image, which can cause a loss of detail if taken too far. The clipping preview is available for this adjustment, so I recommend holding Alt/Option as you adjust the slider to find the value that works best. In general I try to avoid clipping shadow detail, but in some cases you may actually want to cause a loss of detail. For example, when producing a silhouette image, you don't want to have any (or at least much) detail in the subject being silhouetted. When you use the clipping preview, the image will appear white except for areas that are clipped (Figure 4.40). The clipped areas will appear in a color representing the channels being clipped, or black if the area has been clipped to pure black. If data was clipped in the capture, even at the minimum setting you'll still have clipping in the image.

Figure 4.40 When you use the clipping preview display for the Blacks slider, the image will appear white except where clipping occurs.

The Brightness and Contrast sliders provide a more basic tonal adjustment than the four sliders just covered (and the Tone Curve control discussed later in this chapter), and I prefer not to use them. The Brightness control is similar to the Exposure control, and I recommend using the Exposure control for this purpose. The Contrast slider allows you to adjust contrast by shifting the value of shadows and highlights in your image, but it does so with an equal effect on shadows and highlights rather than giving you individual control over each, so I recommend against the use of this control.

Vibrance and Saturation

The Vibrance and Saturation sliders both affect the saturation of the image, but in slightly different ways. Both are useful, but I highly recommend using the Vibrance control as your primary tool for saturation. Use the Saturation slider only when you're not able to get the desired effect with Vibrance.

The Vibrance control is indeed a saturation adjustment, but it is a "smart" one. It applies a nonlinear boost of saturation, which means it doesn't affect all colors in a uniform way. It will apply a greater boost to colors with low saturation than it does to colors with high saturation, helping to boost the overall appearance of saturation in your image while minimizing the risk of posterization (overly abrupt transitions between colors in the image) or colors that look artificial (Figure 4.41). It also takes measures to protect skin tones so they don't get a saturation boost. I recommend that you start with Vibrance for saturation adjustments, and use Saturation only when necessary.

The Saturation control is not as sophisticated as the Vibrance control, but it does provide a stronger effect that can be helpful in some situations. If you find Vibrance isn't giving you the boost you need, reduce the Vibrance setting back to a neutral value, and then increase the Saturation slider to give the image a "bump." Then go back to the Vibrance slider to produce the final effect for the image.

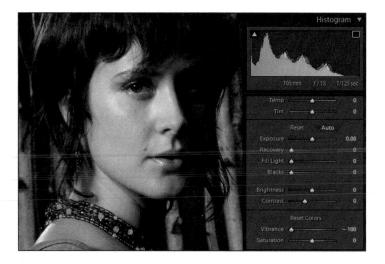

Figure 4.41 The Vibrance adjustment doesn't apply extreme adjustments, even at minimum (top) and maximum (bottom) values, which helps to produce a more natural adjustment than the Saturation slider.

Note: Although the Saturation slider can be set to 0 in order to create a grayscale version of the image, I don't recommend doing this because it doesn't offer an adequate amount of control over the result. Instead, set the mode to Grayscale at the top of the Basic section of adjustments, and then use the Grayscale Mixer section to fine-tune the effect.

Tone Curve

The Tone Curve control in Lightroom is a variation on the Curves adjustment available in Photoshop (Figure 4.42). The simple fact that *Curve* is in the name of this control may cause many photographers to feel uncomfortable using it, but I assure you in this

case that the control is easy to learn and use. It offers many of the advanced tonal adjustment capabilities of Curves, while providing a much simpler user experience. In short, this is a tool you'll absolutely want to use for your tonal adjustments within Lightroom.

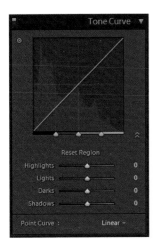

Figure 4.42 The Tone Curve adjustment is a variation on the Curves control you may be familiar with from Photoshop.

Understanding the Tone Curve

The main display in the Tone Curve section is a box with a grid overlay and a curve (though it starts as a straight line) running from the bottom-left to top-right corner of the box. A faint Histogram display appears in the background of the box, helping you get a better sense of the tonal distribution of the image as you're making adjustments.

As you move your mouse over this display, you'll see a variety of information appear (Figure 4.43). This information updates depending on which tonal value is represented by the position of your cursor (black is at the far left, white is at the far right, and all other tonal values transition in a gradient between them). In the top-left corner you'll see percentages displayed, which are the before (left) and after (right) values for the tonal value currently under the mouse.

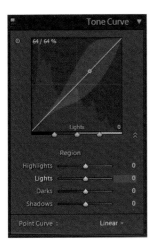

Figure 4.43 When you move your mouse over the Tone Curve display, you'll see a variety of information appear.

You'll also see an indication of which of the four tonal ranges the curve is divided into is represented by the position of your mouse. These ranges are those for which the sliders below the Tone Curve display apply. These are Highlights (the brightest values), Lights (the brighter midtones), Darks (the darker midtones), and Shadows (the darkest values). As you move your mouse between these zones, you'll see several things happen. The slider label and value below will be highlighted, the range of the curve that is affected by this range will be highlighted, and the name of this range will appear as a label at the bottom of the Tone Curve box. You'll also see the current value for the slider displayed in the bottom-right corner of the box. In addition, the "before" and "after" tonal values are displayed as percentages in the top-left corner of the Tone Curve display for the tonal value represented by the position of your mouse on the curve.

Near the bottom-right corner of the Tone Curve box you'll see a double chevron symbol. This allows you to hide or reveal the adjustment sliders. My preference is to keep them visible, but if you find that you're using the Tone Curve box itself to make all your adjustments, you might want to hide the sliders so they don't consume additional space on the panel.

Directly below the Tone Curve box you'll see three sliders. These define the "border" of each tonal value within the Tone Curve. That doesn't mean one slider will stop affecting pixels with a tonal value on the "other side" of one of these sliders, but rather that the adjustment will be focused on one side of the slider with a gradual transition through the tonal values on the other side of the slider.

Below the sliders you'll see a drop-down for ACR (Adobe Camera Raw) Curve. The default is Linear, but options are available for Medium Contrast or Strong Contrast (Figure 4.44).

Figure 4.44 The ACR Curve drop-down includes several options to change the starting adjustment for the Tone Curve.

Making Tone Curve Adjustments

Now that you have an understanding of the elements of the Tone Curve control, you're ready to start making adjustments. I suggest that you first decide whether you're going to adjust the Point Curve setting at the bottom, because that will create a good starting point for you. My preference is to leave this control at the default Linear value, and then adjust the settings directly with Tone Curve. However, if you prefer a bump in contrast, you might want to set this to Medium Contrast before you get started with your adjustments. I recommend against Strong Contrast in most cases because it tends to be a bit too harsh for most photos.

Note: As you start making adjustments with the Tone Curve sliders, you might want to switch the display to the before-and-after view to help you better evaluate the adjustments as you're making them.

As you're getting started with Lightroom, I suggest simply adjusting the four sliders below the Tone Curve display, which will actually produce a change in the curve itself (Figure 4.45). I generally prefer to start with the Highlights slider to set the brightest values. This is because I feel getting the highlights right can be most critical to the overall tonal adjustment for your image, with the least amount of tolerance for an inappropriate adjustment. Move the slider to the right to brighten highlights and to the left to darken highlights.

Figure 4.45 As you make adjustments to the sliders, the appropriate section of the curve will move.

Note: It can be helpful to make sure the clipping preview display is turned on in the Histogram control when adjusting Highlights and Shadows in Tone Curve.

Next I like to adjust the Shadows slider. Moving the slider to the left darkens the darkest pixel values in the image, and moving it to the right lightens those values. You can probably get away with darkening the shadow areas of your images with a relatively strong adjustment (Figure 4.46) because we don't expect to see too much shadow detail and this adjustment will taper through the slightly lighter values to produce a natural transition. Still, use caution not to create unwanted clipping or an artificial appearance in the shadow areas. The more common problem to be avoided is excessive lightening of the shadows. You may be trying to pull out detail from an underexposed image, but this is more likely to create an artificial appearance as well as bring out noise and other image quality problems that may have been hidden in the shadows. If a strong adjustment is required, take a close look at the dark areas of your image to be sure they look their best.

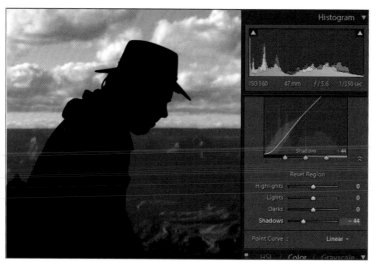

Figure 4.46 The Shadows adjustment allows you to set the black point in your image, which can be used to darken the shadows to produce a silhouette, among other things.

Note: Lightroom restricts the adjustments you can make with Tone Curve to help ensure that you won't create problems in your images. Therefore, you'll likely not see any serious negative effects from Tone Curve adjustments unless the image was poorly exposed from the start.

After the Highlights and Shadows adjustments are made, I like to move on to the midtone adjustments. These are made via the Lights and Darks sliders, which affect the lighter and darker midtones, respectively. Which you start with is largely a matter of preference, but I recommend starting with the range that seems more prevalent in your image. Therefore, with a darker image I'd adjust the Darks first, and with a lighter image I'd adjust the Lights first. However, you'll find that you probably move back and forth between these two sliders as you make your adjustments, so which you start with isn't too critical.

Both the Lights and Darks sliders lighten the image when moved to the right and darken when moved to the left. The difference is just the tonal range on which the adjustment is focused for each. In general you'll likely want to increase midtone contrast, so you will probably slightly lighten the Lights (move the slider to the right) and darken the Darks (move the slider to the left). This will produce an *S* shape in the middle range of the tone curve, producing increased contrast in the image without losing highlight or shadow detail.

Besides adjusting the sliders, you can also produce the same effect by dragging directly on the Tone Curve display. As previously discussed, when you move your mouse over the tone curve, a label appears at the bottom of the box to indicate which tonal range is represented by the current position of the mouse. To make adjustments directly on the tone curve, move the mouse into the region you want to adjust and then click and drag up or down to adjust the curve. You'll notice that as you do so,

the corresponding slider below is updated. The effect is exactly the same, with the only difference being how you prefer to make the actual adjustment.

Yet another way to adjust the Tone Curve sliders includes a direct reference to the image. When you move your mouse over the image while in the Develop module and while the Tone Curve section is visible, you'll see that the sections get highlighted based on the tonal value below the mouse within the image—just as they do when you move the mouse over the Tone Curve box itself. To make an adjustment by referencing the image itself, move the mouse over the area you want to adjust, and then use the up and down arrow keys on your keyboard to apply an adjustment. If the Tone Curve section is visible while you do this, you can see that the corresponding slider moves as you make this adjustment.

Another way to fine-tune the adjustments you're making with the Tone Curve control is to change the tonal range defined by each of the four regions represented by the four sliders. For example, the Shadows adjustment by default focuses its effect on the darkest 25% of tonal values. However, you can change this by moving the sliders below the Tone Curve box. The leftmost slider controls the transition point between Shadows and Darks, the middle slider controls the transition point between Darks and Lights, and the rightmost slider controls the transition point between Lights and Highlights. To move any of these sliders, just click it and drag left or right. As you drag the slider, you'll see a vertical line and number indicating the tonal value at which the transition will occur.

I use the ability to redefine tonal ranges most often when I'm trying to make an adjustment while protecting a certain range of tonal values. For example, if I want to protect most of the shadow values as I increase contrast by darkening the Darks and lightening the Lights, I might move the leftmost slider to the right a little bit (Figure 4.47). Similarly, if I want to have that midtone contrast affect a broader range of tonal values and I'm not worried about protecting as much of the Shadows range, I might move the leftmost slider to the left. As you move these sliders, you'll see the effect they have on your adjustments so you can get a better sense of how far you want to move them.

Figure 4.47 You can move the split between Shadows and Darks on the Tone Curve by moving the leftmost slider below the curve from its starting position (left) to a new position (right), changing the range of tonal values affected by each slider.

Color and Grayscale Adjustments

The next section (Figure 4.48) contains three options to change the controls that are available. HSL provides many options, allowing you to adjust the hue, saturation, and lightness for all of the color components in your image individually. The Color option provides the same basic controls, but organizes them differently so the hue, saturation,

and luminance sliders are shown together for a single component color, with sliders for only a single color at a time shown by default. The Grayscale option includes controls for refining the appearance of your image when you've chosen to produce a black and white version.

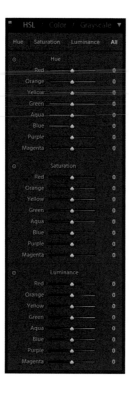

Figure 4.48 The Color Adjustments section contains 18 sliders that enable you to adjust the hue, saturation, and lightness of individual colors within the image.

The HSL section has sliders for Hue, Saturation, and Lightness, and you'll notice that Lightroom divides the 18 sliders into these three groups. The Hue/Saturation adjustment in Photoshop also includes an Edit drop-down, where you can choose a specific color value to adjust. Lightroom contains the same capability, but provides sliders for each rather than a combination of drop-down and slider to offer the same adjustments. The advantage is that in Lightroom it is much easier to move between similar adjustments (for example, Hue) for different color values within the image.

I think it is important to understand what I feel is the proper perspective for using these controls. You may have noticed that Lightroom doesn't contain a Color Balance adjustment. Instead, color adjustments are handled by the Temp and Tint sliders that affect white balance, found in the Basic section of the panel. Also, recall that you have already had the opportunity to adjust the saturation of your image through Vibrance and Saturation sliders in the Basic section. The HSL section really provides a way to fine-tune color, especially through targeting adjustments to specific color ranges in your image. I recommend that you think of this section as a tool for fine-tuning the colors in your image, not for doing your primary color adjustments.

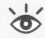

The Hue sliders allow you to adjust the color appearance of individual colors in your image, with sliders for each of the additive (red, green, blue) and subtractive (cyan, magenta, yellow) primary colors. The sliders give you a visual indication of the effect they'll have on the color in question. For example, moving the Reds slider to the left will make the reds in your image more magenta (pink), and moving it to the right will make them more orange or yellow (Figure 4.49). Think of these sliders as providing a color balance adjustment for individual color values within your image and you'll better understand the approach I recommend taking. Evaluate the image, and if any colors aren't quite what you feel they should be, choose the appropriate slider and move it to shift the applicable color values.

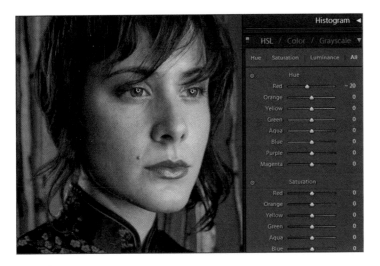

Figure 4.49 Moving the Hue slider for Red will shift the value of reds in the image. The other Hue sliders operate in the same manner with different colors.

Note: When using the Hue sliders, I find it helpful to start by moving the sliders through the extreme minimum and maximum values to get a sense of the effects. Then I bring the slider back toward the range that seems most appropriate for that color.

The Saturation sliders allow you to increase or decrease the vibrancy of specific color ranges within the image. For example, if you have an image with a magenta tint in the sky and no other magenta values, you can quickly solve the problem by moving the Magentas slider in the Saturation section to the left. You might even move it all the way to the left to eliminate the appearance of any magenta in your image if the only magenta that appears is problematic.

Conversely, you can boost the saturation of individual color ranges. For example, if you have a photograph of a model and you want to boost only the saturation of the blue background without affecting the model, you could adjust the Blues slider (Figure 4.50).

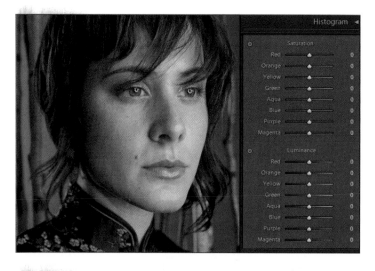

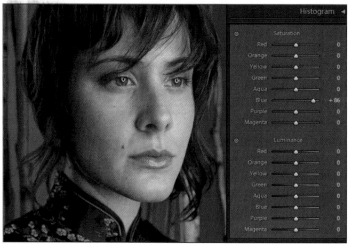

Figure 4.50 You can use the Saturation sliders to boost the vibrancy of a single range of colors within the image.

Finally, you can adjust the brightness of a particular color range by using the Luminance sliders. I typically use these controls when a particular color range appears a bit washed out in the image (Figure 4.51). Move the slider for a given color range to the left to darken those colors in the image, and to the right to brighten them.

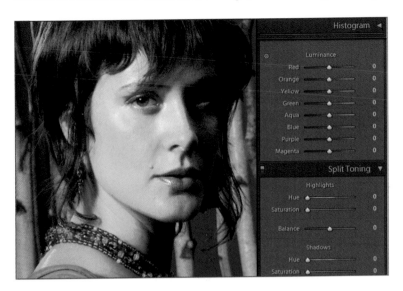

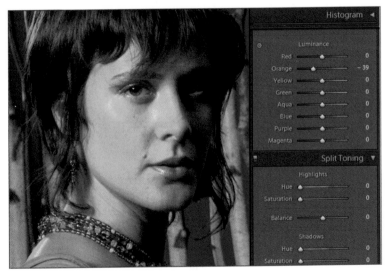

Figure 4.51 The Luminance sliders allow you to change the relative brightness of a range of colors within the image—for example, to darken colors that appear washed out.

The Color option (accessed by clicking the Color link at the top of this section) provides the same set of controls, but organizes them differently. By default, only a single color is shown at a time, with Hue, Saturation, and Luminance sliders for that color (Figure 4.52). These are the exact same controls found in the HSL section discussed above, just organized differently. You can click on one of the color boxes to change the color the controls will apply to, or click All to see all 18 sliders divided into sections based on color.

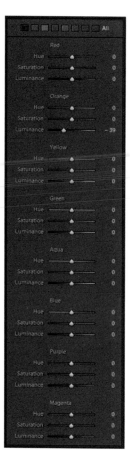

Figure 4.52 The Color section provides the same controls as the HSL section, but organized differently. By default you'll only see Hue, Saturation, and Luminance sliders for a single color.

Grayscale

When you select the Grayscale option (Figure 4.53), you'll have controls that provide an excellent way to use all the information in a color image to produce the best possible grayscale image. It allows you to adjust the brightness values of individual colors within the image, all of which are displayed as shades of gray. The result is a high degree of control over the final grayscale appearance of the image.

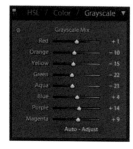

Figure 4.53 When you select the Grayscale mode for an image, the Grayscale Mixer section becomes available.

After seeing the color version of the image, you probably have a pretty good sense of which color areas you want to emphasize in the grayscale version. However, even if you know that information, you may not know which sliders you want to adjust in which direction. You can get a good indication of which sliders to focus on by switching to the before-and-after view so you can see the original color version along with the grayscale version. For example, if you want to darken the red areas of the image, you'll know to adjust the Reds slider in the Grayscale Mixer section. I realize this may seem obvious, but in some cases you might not know what color is dominant in a particular area of your image, which is why the before-and-after view can be so helpful (Figure 4.54).

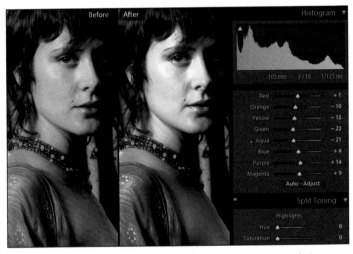

Figure 4.54 The before-and-after view can be particularly helpful as you're producing a grayscale adjustment for your image.

Even after knowing which sliders need your attention, you might not necessarily be able to formulate a plan for those adjustments. My recommendation is to work with all the sliders, moving them through their extremes to get a sense of how the adjustment will affect various areas of the image, and then settling on the best final setting. After working with all six sliders, perhaps revisiting each of them more than once, you'll be able to produce an optimal grayscale image from the color original.

Split Toning

The Split Toning adjustments allow you to apply a color cast to the image, with individual adjustments for the highlights and shadows. These adjustments are available for all images whether they're in Color or Grayscale mode, but in general you'll find them most useful for grayscale images. You can use Split Toning adjustments to produce a result that looks like a grayscale image that uses a color instead of black to produce the various tonal values, such as you would see in a sepia-toned print.

The individual adjustments for Highlights and Shadows provide a bit more control, which enables several possibilities. If you're looking to have an image comprising a single color value, the split between controls for highlights and shadows enables you to adjust the intensity individually for each. For example, you may need to use a lower Saturation setting for the Shadows as compared to Highlights to produce a consistent appearance throughout the image. You may also want to get more creative with your image, applying one color to the highlights and a different color to the shadows.

The general approach I take with Split Toning is to start with the Saturation for Highlights set to about 50 or so and then move the Hue slider for Highlights through the full range to find the color that works best for the image (Figure 4.55). After you find the right color value with the Hue slider, you can refine the Saturation adjustment for the best effect. Then either set the Hue slider for Shadows to the same value as you used for Highlights or a completely different color if you're trying to achieve a more radical special effect, and adjust the Saturation to the desired level for both Highlights and Shadows.

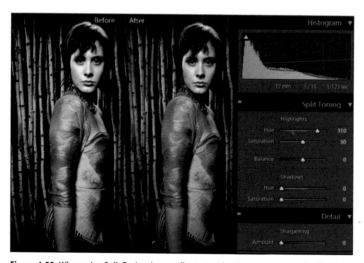

Figure 4.55 When using Split Toning, I generally start with a Saturation setting for Highlights of about 50, adjust the Hue slider to find the desired color, and then revise the Saturation adjustment as needed.

Note: Don't forget that you can reset an individual adjustment to its default value by double-clicking on the slider handle for that control. I find this particularly helpful for adjustments, such as Split Toning, that tend to require a bit more experimentation for the adjustment to be made.

Detail

The Detail section provides three sliders to help optimize the overall appearance of your images. These include Sharpening, Luminance Noise Reduction, and Color Noise Reduction (Figure 4.56).

Figure 4.56 The Detail section includes adjustments for Sharpen, Smooth, and De-Noise.

The Amount slider for Sharpening applies a sharpening effect to your image (Figure 4.57). Although it doesn't offer the full control afforded by sharpening tools such as Unsharp Mask found in Photoshop, it does provide a good and simple sharpening solution. I recommend setting the image to the 1:1 view size so 1 pixel on the monitor represents 1 pixel in the image. Then adjust the Sharpen slider for the desired level of sharpening in the image. Remember that this is still a nondestructive edit, as with all adjustments in Lightroom, so you can always reduce or eliminate the sharpening later by moving the slider again.

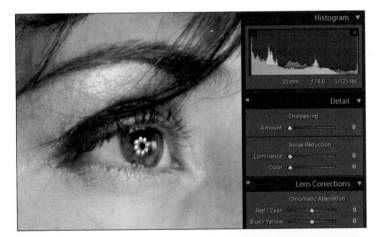

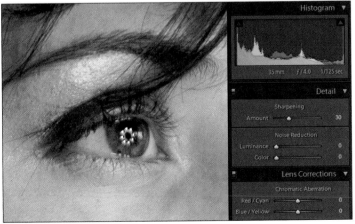

Figure 4.57 The Sharpening control provides a simple way to apply a sharpening effect to your image.

The Luminance and Color sliders for Noise Reduction can be helpful in removing noise from your images, most often caused by capturing at a relatively high ISO setting. When using this adjustment, I recommend zooming in to the 3:1 zoom setting so you can see the noise more clearly. Navigate to an area of the image that exhibits the most noise, and then adjust the Luminance and Color sliders (Figure 4.58) based on whether the noise is mostly exhibited by tonal variations or color variations (color variations are most common). When the noise has been eliminated, navigate around to other areas of the image to confirm that you haven't reduced overall saturation too much by neutralizing the noise. Fine-tune the adjustment as needed for the best result.

Figure 4.58 The Luminance and Color sliders provide a way to minimize noise in images, which is most often caused by capturing images at a high ISO setting.

Lens Corrections

The Lens Corrections section (Figure 4.59) provides sliders that allow you to compensate for two problems generally caused by lens issues: Chromatic Aberration (the appearance of color fringing along high contrast edges in your images) and Lens Vignetting.

Figure 4.59 The Lens Corrections section contains adjustments for Reduce Fringe and Lens Vignetting.

If you have colored fringing (color along the higher contrast edges in the image) in your image, the Chromatic Aberation adjustments will likely enable you to eliminate it, or at least minimize it. To use this adjustment, set the zoom to 3:1 and zoom in on a high-contrast area that exhibits fringing. Then choose the slider that seems most appropriate for the color of fringing you're seeing (if you can't decide, just start with Red/Cyan and then move to Blue/Yellow). I recommend shifting the sliders through their extreme values and then narrowing in on the setting that eliminates (or minimizes) the fringing (Figure 4.60). Adjust both the Red/Cyan and Blue/Yellow sliders, and then adjust both of them a second time to ensure that you're getting the optimal effect.

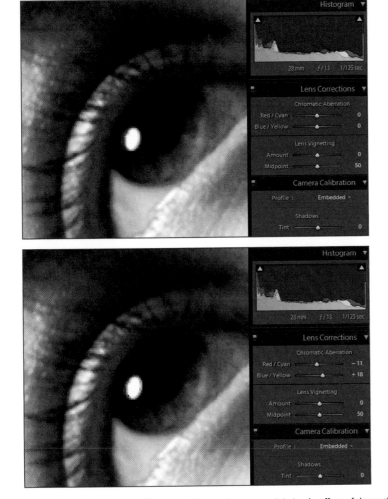

Figure 4.60 Use the Chromatic Abberation sliders to eliminate or minimize the effects of chromatic aberrations in your images, which are most often found in high-contrast areas.

The Lens Vignetting adjustments can be used to compensate for vignetting (darkening of the corners of an image) caused by the lens or to add vignetting for effect (Figure 4.61). The Amount slider adjusts the strength of the adjustment. A lower value darkens the edges of the image, whereas a higher value lightens the edges. The Midpoint slider affects how far toward the center of the image the compensation applies. For the Lens Vignetting adjustments, I recommend switching between both sliders as you make adjustments and work toward the best settings to either eliminate vignetting or add a vignetting effect.

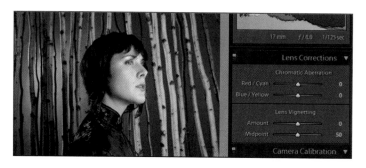

Figure 4.61 The Lens Vignetting adjustment allows you to compensate for vignetting in your image (or add it if you like).

Camera Calibration

The Camera Calibration section (Figure 4.62) is designed to allow you to compensate for a generic digital camera profile in Lightroom that is inaccurate. My experience with Lightroom has been that the included profiles are quite accurate. Furthermore, manipulating these controls requires a good eye, attention to detail, and an understanding of the specifics of the adjustments. In short, I don't recommend using these controls unless you are familiar with the behavior of your digital camera and understand how the controls in this section work.

Each digital camera model will have a particular bias for the color recorded for shadow areas relative to other tonal values. The Shadows Tint slider allows you to compensate for this behavior if the generic camera profile isn't accurate. Moving the slider to the left shifts the shadows toward green, whereas moving it to the right shifts the shadows toward magenta.

Figure 4.62 The Camera Calibration section allows you to compensate for a generic digital camera profile within Lightroom that is inaccurate.

The remaining six sliders provide Hue and Saturation adjustments for each of the primary colors (red, green, and blue). Hue shifts the basic color value for each of those colors, and Saturation adjusts the intensity of that color. If you're going to adjust these controls, use very small adjustments and evaluate several images carefully with the same settings.

I've not yet found a need to touch the Camera Calibration controls, and I suspect you won't either. They are offered as a means to exercise a high degree of control over the results you are getting with Lightroom, but because Adobe has been careful to ensure highly accurate generic camera profiles, the adjustments should frankly not be necessary for most users.

Control Buttons

There are four control buttons found in the Develop module that affect how adjustments are applied to images (Figure 4.63).

Figure 4.63 The Copy and Paste control buttons are found on the left panel, and Previous/Sync and Reset buttons are found on the right.

On the left panel you'll find the Copy and Paste buttons. These allow you to apply adjustments you've made for one image to another image (or group of images). For example, if you find an image that was captured under conditions that were similar for another photo, the same adjustments might be suitable for both (at least as a starting point). To apply adjustments from one image to another in this manner, select the image from the filmstrip that has the adjustments applied to it, and click the Copy button. In the Copy Settings dialog box (Figure 4.64) select the check boxes for the adjustments you want to copy to another image (by all except Spot Removal and the Crop options are selected, and this is generally the best approach). Then select the image (or images) on the filmstrip you want to apply the same adjustments to and click the Paste button.

The first button at the bottom of the right panel provides a similar ability to apply adjustments from one image to another, but it operates with two different scenar-

ios. The first is to simply apply the same settings you used for the most recently adjusted image to the current image. To apply those adjustments, simply click the Previous button with the image to which you want the adjustments applied selected. This can be a helpful control provided you actually remember which adjustments you applied most recently to another image.

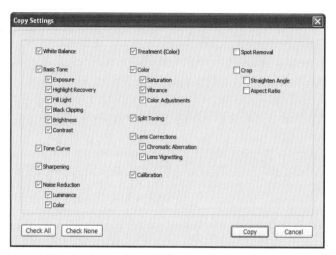

Figure 4.64 The Copy Settings dialog box allows you to select which adjustments you want to copy for use with other images.

The Previous button actually takes on different behavior if you select multiple images. With multiple images selected the button itself changes to the Sync. When you click this button, the Synchronize Settings dialog box will appear. This is actually the exact same dialog box as the Copy Settings dialog box seen above, with a different name. Select which adjustments you want to apply to the group of images and click Synchronize. The settings from the first of the selected images (based on the options you selected) will be applied to all selected images (Figure 4.65).

Figure 4.65 You can use the Sync button to apply settings you've used for one image to a group of selected images.

You don't actually have to adjust the first image in the selection before you use the Sync option. In fact, I generally prefer to make the selection of images first, then apply adjustments, and then synchronize the adjustments because it more closely matches the way I tend to think about this process. In effect, I look at a group of images and realize they would all benefit from similar adjustments. I select those images and then apply adjustments (the first of the selected images will be the one you're adjusting). Finally, click Sync and apply the desired adjustments to the full group.

Note: After applying the same adjustments to a group of images with the Sync option you can still go back and fine-tune the adjustments for each individual image.

The final control button is the simplest of the four. It is the Reset button, and it will simply revert the current image to its original state with no adjustments applied.

Sync

The Sync button doesn't exactly grab your attention at the bottom of the panel, but it enables you to apply settings from one image to a large group of images, providing a tremendous workflow advantage. If you have a series of images from a given photo shoot captured under similar conditions, you can quickly adjust all of them with the same settings.

Start by selecting multiple images in the Library module (or on the filmstrip), and then switch to the Develop module. The first selected image will be displayed in the primary display area. Make your adjustments to this image, and then click the Sync button. This brings up the Synchronize Settings dialog box (Figure 4.66), where you can choose which settings should be applied to the selected images. Unless you have a reason to exclude some of the settings, I recommend keeping all of the check boxes selected and clicking Synchronize. The settings you've applied to the first image will be applied to all selected images (Figure 4.67). This provides a form of batch processing that can allow you to work with remarkable speed on large groups of images.

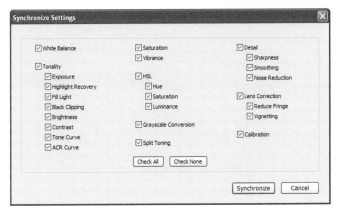

Figure 4.66 The Synchronize Settings dialog box allows you to choose which settings should be applied to the selected images.

Figure 4.67 After you've adjusted a single image while multiple images were selected (top), the Sync option allows you to apply the adjustments to all of the selected images (bottom).

Note: After you click Sync, it may take some time for all of the thumbnails for the selected images to be updated.

Reset

The Reset button simply reverts all adjustments to their default values. If you've gotten so far into adjustments for an image that you want to simply start over, click this button and you'll be back to your starting point. Because this functions as just another adjustment applied to your image, the Reset Settings step will be recorded in the History along with everything you had done prior, so there is an easy way to return to the image as it was before resetting the adjustments.

Note: Clicking the Reset button produces the same effect as choosing the Zero'd preset, putting all adjustments back to their neutral values.

Using an External Editor

As powerful as Lightroom is for optimizing your images in the Develop module, you'll no doubt find that at times you need to make more-sophisticated adjustments. The most common situations for needing something else (most likely Photoshop) will occur when you need to make targeted adjustments or need to perform image cleanup (neither of these are available in the current version of Lightroom). Fortunately, Lightroom allows you to easily open any image into another editor.

If you have Photoshop installed on your machine, Lightroom will recognize that and provide an option to Edit In Adobe Photoshop from the Photo menu. If you want to use a different editor, you can choose Photo → Edit In Another Application from the menu and locate the executable for the program you wish to use.

When you choose to edit an image with an external editor, the Edit Photo dialog box will appear (Figure 4.68), allowing you to select how you want to work with the photo. The following three options are available:

Edit Original allows you to work on the original image file in the external editor, but the adjustments you have made in Lightroom will not be reflected in the image.

Edit A Copy allows you to work on a copy of the image from Lightroom so you don't overwrite the original, but you still won't be able to see the Lightroom adjustments.

Edit A Copy With Lightroom Adjustments causes a copy of the image to be created and then opened in the editor you selected. This copy will have the Lightroom adjustments applied to it.

Figure 4.68 The Edit Photo dialog box lets you specify how you want the image handled by the external editor you've chosen.

I recommend using the Edit A Copy With Lightroom Adjustments option so the image you see in your editor matches what you've produced thus far in Lightroom. You can then save the final image in the editor of your choice, and the changes you've applied will be reflected in Lightroom.

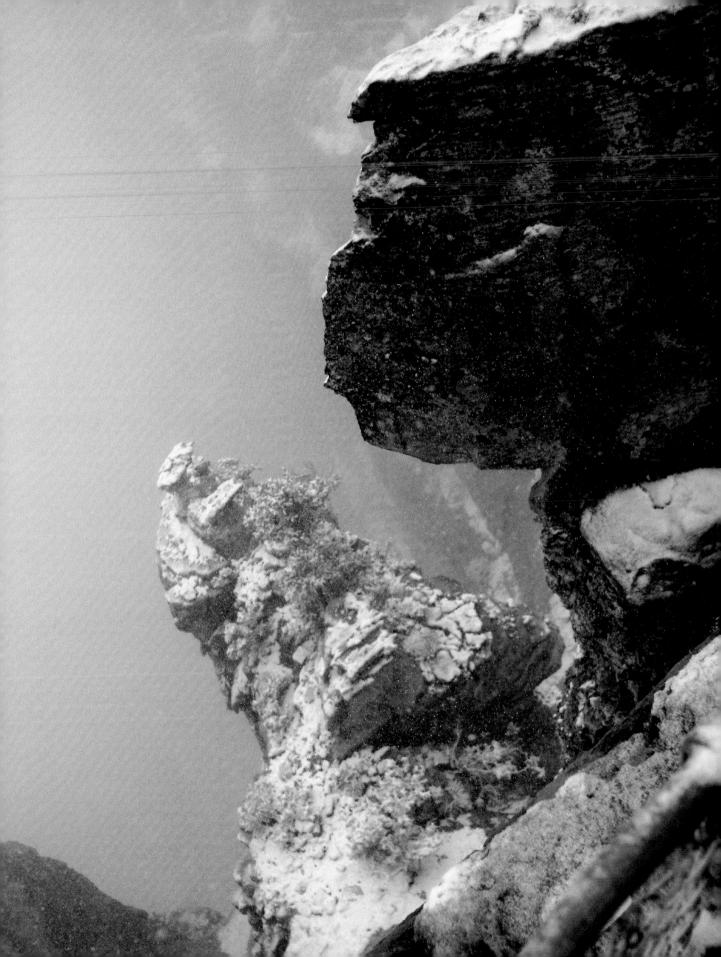

Slideshow

5

Slideshows have long been a popular way to share photographic images. They provide a dynamic and creative way for you to share images with clients or other audiences, and even provide a great way for you to simply review a collection of images. Whatever your needs, a slideshow provides a great way to share your best images. In the Slideshow module in Lightroom you can configure a basic slideshow that will enable you to present your images in a professional manner to any audience.

Chapter Contents
Building Lightroom Slideshows
Configuring the Slideshow
Previewing, Playing, and Exporting

Building Lightroom Slideshows

The Slideshow module within Lightroom—at least in this release—certainly won't replace your favorite digital slideshow application. It isn't intended as a solution for creating incredible artistic slideshows, but rather as a relatively quick and easy way to prepare a professional and elegant slideshow (Figure 5.1). I see two primary ways in which you might use the Slideshow module in Lightroom. The first is for simple review of your images. Although you can certainly view your images within the Library module, and even view them in something of a slideshow display by hiding the panels and using the Lights Out display, a slideshow is in many ways better suited for such a review.

Figure 5.1 The Slideshow module provides a solution for quickly and easily creating simple but elegant slideshows for a professional presentation of your images.

Note: Whenever I'm making a presentation about digital photography I wish my images were as good as those provided by photographer André Costantini (www.sillydancing.com) for me to use throughout this chapter.

The other way you'll likely use the Slideshow module is to share images with clients or others. Whether it is a simple review to show the clients the photos from a particular project, or a slideshow for a broader audience, you can create simple and yet powerful slideshows by using Lightroom.

The first step in creating a slideshow is selecting the images you want included in the presentation. Whichever images are currently selected will be included in the slideshow—either by virtue of some form of filter, or by having the images actually selected within the Library or filmstrip displays.

Selecting Images in the Library

As you saw in Chapter 3, "Library," the Library module provides a variety of ways for you to locate, filter, and select a group of images. The panel on the left provides a number of options for quickly filtering your images to a specific group (Figure 5.2).

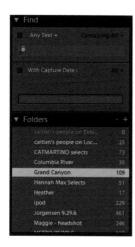

Figure 5.2 The Library module provides a variety of options for selecting images to include in a slideshow, including several options on the left panel.

By way of review from Chapter 3, the available options include the following:

Library allows you to quickly view a specific group of images to serve as the source that the other settings will apply to. It is important to realize that this option defines only the source of the images, and other settings can further limit which specific images will be shown. For example, the All Photographs option within the Library section of this panel will show only those images that fit the settings you have assigned in the Filters section of the filmstrip or through other means to filter your images.

> **Note:** Keep in mind that the number to the right of each option—which indicates the number of photos included in that option—also reflects other settings. For example, the number of photos shown for a given collection will change based on the Filters settings or other methods for filtering your images.

Filters on the Filmstrip provides options to narrow the scope of images available. There is a control at the far right of the Filters controls that enables you to quickly turn the filters on or off, and a set of options allows you to customize the group of photos to be included based on flags, star ratings, and color labels.

Collections enables you to select images that you have defined as being part of a given collection. Collections provide a way to group images that otherwise don't have a common theme, such as images you included in a book project that span a number of different Folders.

Keywords lists all of the keywords for all of the images in your Lightroom library. This section allows you to select a keyword so you can see only those images that include that keyword in their metadata.

N o t e : The Library, Folders, Collections, and Keywords sections are mutually exclusive. If you select an option in Folders, for example, that option will override an already selected option in Library. You are choosing to view images that are part of a given photo shoot, or part of an option in the Library section, for example. Filters, on the other hand, apply to the current group of images regardless of what you selected in the other sections.

The approach I recommend is to look at the Library, Folders, Collections, and Keywords sections to see which contains the option that best defines the general group of images you're looking for. Then use the Find settings to narrow the range of images to be included in the final slideshow. For example, if you are preparing a free-form slideshow, you may want to select All Photographs in the Library section, turn off Filters, and then select images manually (Figure 5.3). If you're working with images from a particular project, you may want to select an option from Folders or Collections, and then use the settings in Filters to further narrow the selection of images as needed.

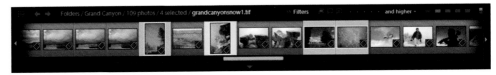

Figure 5.3 If you're creating a free-form slideshow, you may want to display all images and then select the specific ones you want to include from the filmstrip.

Selecting Images in the Filmstrip

As you're working with the various options in the panel on the left side of the Library display, you'll notice that the filmstrip—if visible—is constantly being updated to reflect the current selection of images. If you filter the range of images available by using any of the options in the various sections of the panel, the thumbnails in the filmstrip view will change to reflect that. Furthermore, if you select images within the primary display while working in the Library module, those selections will be reflected in the filmstrip as well. The filmstrip is therefore primarily an alternate way to create a selection of images.

Because the panel provides more options than the filmstrip, I recommend starting with the panel to narrow the group of images, and then fine-tune your selection on the filmstrip if you find it easier to work with. There are two basic methods I recommend using to make the most of the filmstrip.

The first is to use the Filters options found at the top-right corner of the filmstrip display (Figure 5.4). This provides quick access to the options you find in the Preset drop-down of the Filters section and can be a quicker way to narrow the group of images you're working with, especially if you prefer working with the filmstrip. To apply a filter to your images, simply click the Filters pop-up menu and choose the appropriate option. For example, after selecting one of your photo folders from the Folders section of the panel, you can choose 5 Stars from the pop-up menu.

Figure 5.4 The Filters options on the filmstrip display provides a way to quickly reduce the number of images displayed on the filmstrip to those matching specific criteria.

Note: One of the advantages to using the filmstrip to define which images should be included in your slideshow is that the filmstrip can still be seen while you're in the Slideshow module. In contrast, the left panel no longer reflects the options found in the Library module.

The other way to fine-tune a group of images in the filmstrip display is to select the images you want to include. To select your first image, simply click it in the filmstrip view. Then hold the Ctrl/⌘ key and click additional images to add them to the selection (Figure 5.5). Each selected image will be highlighted in both the filmstrip and the primary display of the Library module.

Figure 5.5 You can select multiple images from the filmstrip by selecting one and then holding Ctrl/⌘ and selecting others.

If the selection of images you want to include in a slideshow can't be readily defined using the options on the left panel in the Library module, you'll need to add the images to a collection in order to use them in a slideshow. In other words, if you have done all you can to limit the range of images using the Library module and then need to further refine by selecting images on the filmstrip, you'll need to put the selected images into a collection. You can use the Quick Collection option, but I actually recommend using a completely new Collection. To do so, click the Plus icon to the right of the Collections label and add a collection, then drag the selected images onto that collection. You can then click on the collection to ensure the slideshow will include only those images.

Configuring the Slideshow

After you've selected which images should be included in the slideshow, you're ready to start configuring that show to your liking. Lightroom provides a wide range of options for customizing the slideshow to your personal tastes and optimizing the way the images are presented. The basic process I recommend using as you create a slideshow is to choose a template from the left panel, adjust any settings you like in the right panel, preview the show, fine-tune any settings you'd like to change, and then play or export the slideshow depending on how you want to present it.

Selecting a Template

The panel on the left side of the Slideshow module revolves around templates you can use (and define) to quickly set the style of your slideshow. The Preview section at the top of the panel isn't something I find particularly useful (Figure 5.6). It does play a version of the preview slideshow (discussed later), but it doesn't include the transitions, so it isn't a true preview of the final result. It also provides a preview of the overall lay-out for a given template when you move the mouse over the name of a template in the Template Browser section of the panel. I don't bother to collapse the Preview section because I don't tend to have a large number of templates listed, so there is plenty of room for it. But I don't reference it very often.

Figure 5.6 The Preview section of the left panel is primarily used for getting a preview of the overall appearance of the slideshow templates.

The Template Browser allows you to select a template for your slideshow (Figure 5.7). Templates are simply saved settings based on the options available to you on the panel on the right side of the Slideshow module. As I mentioned, you can move your mouse over the name of a template to get an idea of what the slideshow will look like in the Preview section. To apply a template, simply click on it. Doing so will cause all the settings in the right panel to reflect the saved settings for the template.

Figure 5.7 The Template Browser provides quick access to the saved slideshow settings you want to use for the current slideshow.

Adding and Removing Templates

In the next section I'll talk about how to configure the many available settings for your slideshow on the right panel in the Slideshow module, but while we're looking at the Template Browser it makes sense to talk about the ability to add and remove templates.

As I mentioned, a template simply reflects saved settings from the various options on the right panel (with the exception of the Layout section, because that section relates only to the working environment in Lightroom, not the actual slideshow display). If you want to define a new template, the first step is to adjust the settings to your liking. After the slideshow is exactly as you want it, click the Add button at the bottom of the left panel; a text field opens, allowing you to enter a name for the template (Figure 5.8). Give it a descriptive name that is meaningful to you so you'll know exactly what it means when you are selecting the template from the list.

Figure 5.8 The Template Browser allows you to provide a name for the template you are saving.

If you've saved a template by accident or find that you simply don't use a given template anymore, you can select the template from the list and click the Remove button to remove it from the list. Because you have to click a template in order to remove it, the settings will still be active after you have removed it—so you'll want to click on another template or manually change the settings if you don't want the current slideshow to reflect those settings.

N o t e : After you've chosen a template from the left panel, I recommend hiding the left panel, filmstrip, and top panel to maximize the space available for the primary display and the panel on the right with all your slideshow settings.

Adjusting Settings

After you've selected a template, you have a complete slideshow ready to play. Of course, many times you'll want to fine-tune the settings to customize the show to your liking. You can then save the final settings as a template to use for future shows. Just as you probably have your own unique photographic style that influences how you capture images and in some cases may result in a number of images that have a similar look to them, you may find that you want to have a consistent presentation style for your slideshows, customized to your preferences.

The panel on the right side of the screen includes a variety of settings that allow you to change the appearance of your slideshow, as well as a few settings that affect how you work within the Slideshow module. The various settings are divided into sections on the right panel.

Options

The Options section contains settings that affect the overall appearance of the images included in your slideshow (Figure 5.9).

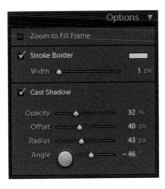

Figure 5.9 The Options section of the right panel contains settings that affect the overall appearance of images in the slideshow.

The Zoom to Fill Frame check box determines whether each image should automatically be made as large as possible to fill the available space. That means the image may be cropped if it doesn't match the aspect ratio of the overall presentation (Figure 5.10). In other words, vertical images will be cropped to horizontal for a standard slideshow. In my experience most photographers do not like to have their images cropped in this way, so you'll probably want to leave this option turned off unless you want to ensure that no background area is visible behind your images. Of course, the Layout section (discussed in the following section) allows you to further crop the image even if Zoom to Fill Frame is selected, so the image won't necessarily fill the entire screen simply because you selected this check box.

The Stroke Border option allows you to place a small border around the outside of your images to help define their edge (Figure 5.11). Many photographers prefer not to use this option because they feel it distracts from the image. It does add an element to your image that you didn't intend at the time of capture, so this is a reasonable perspective. However, at times a stroke can be helpful in defining the bounds of an image. For example, if you have an image that is particularly dark (or with some dark areas near the edges) and you prefer to present your images on a dark background, it may not be clear where the image ends and the background begins. In that type of situation you might want to use a light-colored stroke around the edge of the image to help define its bounds. Of course, because the stroke settings apply to all images in your slideshow (which is actually good from the perspective of having a consistent display of your images), you can't customize the setting on a per-image basis.

To enable the stroke, select the Stroke Border check box. Then click the colored box (it defaults to white) to the right of this check box. This opens the Color dialog box, where you can choose a color to use. Then click OK.

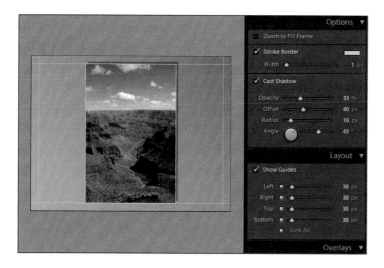

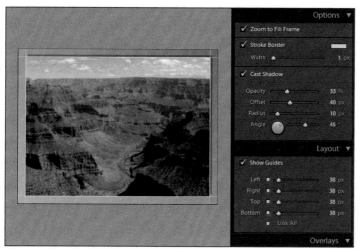

Figure 5.10 The Zoom to Fill Frame option ensures that there won't be any blank space around your images, which could mean the image will be cropped.

Figure 5.11 Many photographers find a border around the images to be distracting, but it does help define the edge of the image.

The Cast Shadow option and related settings determine whether a drop shadow will be used for your images, creating the perception that your photo is floating above the background (Figure 5.12). Selecting the check box allows you to turn on drop shadows and enable the settings below it so you can fine-tune the appearance of the drop shadow.

Figure 5.12 The Cast Shadow options allow you to create a drop shadow that creates the effect that the image is floating above a background.

The Opacity setting determines how strong the shadow effect will be. A value of 100% means the shadow will appear completely opaque and black, whereas a value of 0% means the shadow will not be visible at all. Somewhere in between will allow the background color or image to show through to some degree. My general rule for shadow effects is that if you notice it, the shadow is probably too strong, so I recommend a relatively low setting for Opacity. Start with a value of around 10% to 15% and adjust from there based on your preference.

Note: You can't set the color of the shadow being cast, so it will always appear as a shade of gray. Shadows won't be visible on a black background, and dark values may require a higher setting for the shadow to be visible.

The Offset setting allows you to adjust how far away from the image the shadow should appear. This gives you the ability to adjust how far from the background the image appears to be floating. The best value depends in part on the size of the images relative to the background, the resolution at which you're displaying the slideshow, and your own tastes. For most slideshows I recommend starting at a value of around 50 pixels and then adjusting based on what looks good to you.

The Radius setting can be thought of as allowing you to round the corners and soften the edges of the shadow being cast. The actual adjustment defines the distance in pixels of the transition of the edge. I usually prefer the edges to be at least a little soft, so I generally set this to a value of 25 pixels or higher.

The Angle setting enables you to specify the direction in which the shadow should be cast, which can also be thought of as controlling the position of the light source creating the shadow. The values range from –180° to 180°, with both of those

values placing the light source to the right (shadow to the left). The shadow will be to the top with a setting of 90°, to the right with a setting of 0°, and to the bottom with a setting of –90°. I consider this layout to be a bit confusing, so I simply ignore the value and look at the preview area as I move the slider to place the shadow where desired. Most often the shadow is placed toward the bottom-right of the image, but you can place it in any direction you like.

Layout

If you simply look at the controls in the Layout section (Figure 5.13), you might assume that they enable you to only view the position of guides on the preview display. In fact, the guides determine how large the images in your slideshow will be displayed, so their impact is more than you may realize. When you adjust the position of the guides, you're adjusting the size of the images, because those images will fit within the bounds of the guides.

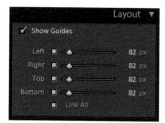

Figure 5.13 The Layout section contains controls that affect where and at what size your images will appear in the slideshow.

The Show Guides check box determines whether the guides are visible in the preview area (Figure 5.14), but even if you disable this check box, the hidden guides still affect the size of the display area for your images. The Show Guides setting determines only whether the guides will be displayed. I don't like the clutter of the guides on my images, so I prefer to keep them turned off. However, when I'm adjusting the size and positioning of the display area for the images, it is very helpful to have them turned on. In fact, in some cases the edge of the image won't correspond with a guide, making it difficult to make the adjustment. Therefore, I prefer to keep the guides turned off except when I'm adjusting their position.

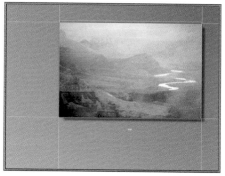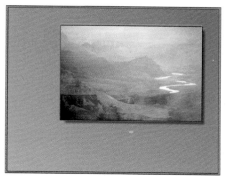

Figure 5.14 The Show Guides check box determines whether the guides will be visible (left), but even if they aren't (right), they will affect the size and position of the images.

Regardless of whether the guides are visible, the easiest way to adjust the area within which the images will be displayed is to simply click and drag along the edges of the image box in the preview area. When you point your mouse at an edge, the insertion point turns into a double arrow to let you know that dragging will move that edge and resize the display box. You can also drag a corner to adjust two edges at the same time. Adjusting the guides also causes the images to be resized to fit the box you've defined, unless the image was partially cropped. If that's the case, moving the guides will first reveal the rest of the image before starting to resize it.

Besides manually adjusting the edges of the box in which the images are displayed, you can also adjust the Left, Right, Top, and Bottom sliders in the Layout section of the panel on the right. Each of these sliders allows you to specify how far from the edge of the available area the applicable edge of the display box will appear. I find this to be rather nonintuitive, which is why I recommend simply dragging the sides of the box in the preview area.

Note: It may seem odd that you would want to adjust the size of the displayed images versus having them fill the available space. One instance where you'll want to do this is when you're using a background image, which is discussed later in this chapter.

Whether you're defining the area in which your images will be displayed by dragging the edges of the display box or adjusting the sliders on the panel, you can link some or all of the sides. This causes all linked sides to move when you adjust one of the linked sides. For example, if you link the left and right sides, whether you drag the left side or adjust it with the slider, the right side will move in the same manner (Figure 5.15). This can be helpful when you have defined a sizing relationship (such as a specific aspect ratio) between the sides but then want to adjust the overall size of the displayed image.

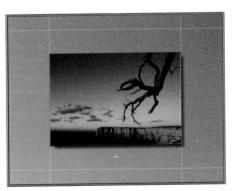
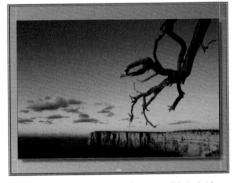

Figure 5.15 If you link two or more sides, such as the left and right shown here, adjusting one side causes all linked sides to move in a similar manner.

To link multiple sides together, simply select the check box to the right of the label for the desired sides (Figure 5.16). For example, if you want the top and left to always be the same distance from the edge of the slideshow display, you can link those

two so an adjustment to one will have a similar effect on the other. To lock all sides, select the Link All check box.

> **Note:** At times you may find yourself adjusting more sides than you had intended. For example, you might drag the top-left edge and be surprised to see the right edge moving as well. In a situation like that, the link between sides on the panel is the cause.

There is an interaction between resizing the guides and the Zoom to Fill Frame setting, which is important to understand. Both can affect the size as well as the visible area of your images. The guides define the bounding box in which the image should appear, while the Zoom to Fill Frame option determines whether any blank space should be allowed around your images. When Zoom to Fill Frame is selected, there won't be any blank space, even if the guides define an area with a different aspect ratio than the image. In other words, if you use the Zoom to Fill Frame option and then adjust the guides, you may be cropping the image. For example, you can fill the frame with a horizontal image, but then adjust the guides to crop it to a vertical with only part of the image displayed (Figure 5.17). The only problem with this approach is that it affects all of the images in your slideshow in the same way, which I consider to be a major limitation of the Slideshow module in Lightroom. In light of this limitation, I try to avoid any extreme cropping when adjusting the guides.

If you're using the Zoom to Fill Frame option and have adjusted the guides, the images will be cropped within the frame defined by the guides if the aspect ratio of that frame doesn't match the aspect ratio of an image. In that situation, you may find that for certain images the positioning within the frame isn't optimal. You can adjust the position of each image in the slideshow individually to ensure that the key subject area is visible within the display area (Figure 5.18). Start by selecting an image from the filmstrip display. Then click on the image itself and drag to move it. If you can't move the image in a particular direction, you've reached the edge of the image. For example, if the frame is the same height as the image, you won't be able to move the image vertically. After positioning one image within the frame, you can choose the next image from the filmstrip and adjust its position. Continue for all of the images in the slideshow that need to be adjusted.

> **Note:** Dragging your mouse inside the box defined by the guides will move the image within that box, not the box itself. You can change the position of the display area only by moving the guides directly.

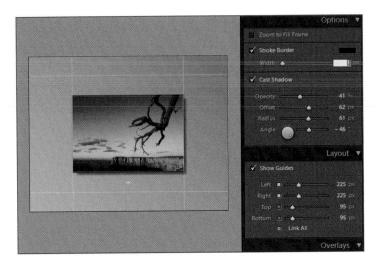

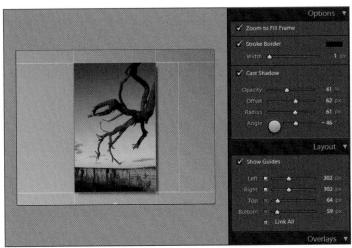

Figure 5.17 By using the Zoom to Fill Frame setting in conjunction with adjusting the position of the guides, you can crop the images in your slideshow—for example, from horizontal to vertical.

Figure 5.18 If an image extends beyond its frame, you can adjust the position of the image by simply dragging it to a new position within the frame.

Overlays

The Overlays section (Figure 5.19) allows you to place text over your images in the slideshow. The first set of controls allows you to include rating stars as part of the display (Figure 5.20). This is helpful when you want to use a slideshow as a way to review your images and see what ratings you gave them, as discussed in Chapter 3 "Library." Just keep in mind that you can't adjust the ratings for your images during the slideshow.

Figure 5.19 The Overlays section offers options that allow you to place text over your images in the slideshow.

Figure 5.20 Rating Stars is one of the available display options for your slideshow in the Overlays section of the right panel.

The Identity Plate check box allows you to include the identity plate you have used to "brand" your version of Lightroom as part of your slideshow. This is obviously most useful when you have actually put a logo or business name in the Identity Plate area. Whatever is set as the Identity Plate will be shown in the preview below the check box. You can click the dropdown to select Edit if you would like to change your Identity Plate settings.

If you are using a text identity plate, the Override Color option will be enabled. Selecting this check box will cause the color you select with the picker to the right of the check box instead of the settings you have used in Identity Plate Setup.

The Opacity slider allows you to adjust whether the identity overlay will be partially transparent. The Scale slider allows you to resize the identity overlay as needed.

The Rating Stars check box determines whether the stars will be displayed at all. To enable this display for your slideshow, just select the check box. To the right is a box that defines the color you want to use for the display. Click the box to bring up the Color dialog box, where you can select a different color. Finally, the Scale slider sets the relative size of the stars displayed on your images. I generally prefer making them as small as possible while still being adequately visible. Remember that you are working on the slideshow at a size smaller than it is likely to be displayed later (perhaps much smaller if you'll be using a digital projector) so you can make them smaller within Lightroom than you think is actually appropriate.

Besides the settings available in the Overlays section, you can also adjust the position of the rating stars display. To do so, just point your mouse at the stars in the primary display and then click and drag to a new position within the frame (Figure 5.21).

Lightroom allows you to display text labels with your images for a slideshow. To enable this option, select the Text Overlays check box in the Overlays section of the panel. This turns on the display, but you still need to define text for it to appear over your images. To define the text you want to display, click the ABC button at the bottom-center of the primary display area. This will enable a text box to the right, where you can enter the text you want to place in the slideshow.

Figure 5.21 You can drag and drop the star rating in the primary display to move it to a new position.

Besides entering your own text into the box, you can select a metadata field to have text specific to each image displayed. To do so, click the ABC button to add text and then click the dropdown that has the default setting of Custom Text at the bottom-right of the primary display area. From the pop-up menu, select the metadata item you'd like to include. The field will be inserted, and the appropriate text will be displayed during the slideshow (Figure 5.22).

Custom Text ▾ Grand Canyon

Figure 5.22 The Custom Text field allows you to enter text to be used for the text overlay.

Note: You can change the options presented on the popup menu by selecting Edit at the bottom of the list and changing the settings in the Text Template Editor dialog box.

The appearance of the text you have added can be adjusted in the Text Overlays section on the right panel. Select the text object in the primary display area, and then adjust the Opacity, Font, and Face options to create the desired appearance.

You can then click and drag the text to reposition it within the slideshow display. Because the text appears in the same position for all images in the slideshow, you'll want to choose the position carefully if it is important to you that the text not cover a key subject area for any of the images. Besides adjusting the position of the text, you can also resize the text by dragging any of the sizing boxes around the bounding box while the text is selected.

If you need to revise the text, click on the text to select it and then click the Edit button at the bottom-left of the primary display area. This brings up the Edit Text Adornment dialog box so you can refine the settings as needed.

Backdrop

In some cases you may want to display your images over a backdrop rather than having them fill the frame or being displayed over a black background. The Backdrop section provides several options to add a creative background for your slideshow (Figure 5.23).

Figure 5.23 The Backdrop section of the right panel contains several options that affect what appears behind your images in the slideshow.

The Color Wash check box enables a gradient display on the backdrop for your slideshow (Figure 5.24). Select the check box to enable the display, and then click the colored box to the right to bring up the Color dialog box and select a color. The Opacity slider allows you to adjust the strength of the color wash effect. The ideal setting depends on your personal preferences as well as the colors involved. For example, if you are using a background image (discussed in a moment), you'll likely want to use a very low Opacity setting (perhaps around 10% to 20%), whereas with a solid color

background you might want to use a value of 90% to 100%. Adjust for the aesthetic effect you're looking for. You can also adjust the direction of the gradient by changing the Angle setting. The circular control provides both a visual indication of the angle selected as well as a way to adjust the setting (by clicking or dragging the circle). You can also adjust this setting by using the slider to the right of the circular control.

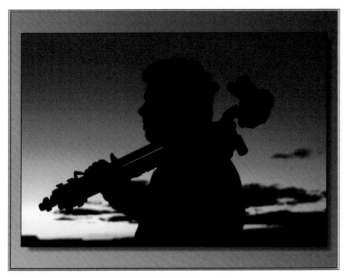

Figure 5.24 The Color Wash option allows you to place a gradient display behind your images.

To display a background image behind all of the other images within the slide-show (Figure 5.25), select the Background Image check box and then drag an image from the filmstrip to the thumbnail area below the check box. Use the Opacity slider to determine the degree to which you want the image to be translucent. I recommend a setting of around 50% (the actual value will depend on the background color behind the image) so this background image doesn't compete with the images in your slideshow.

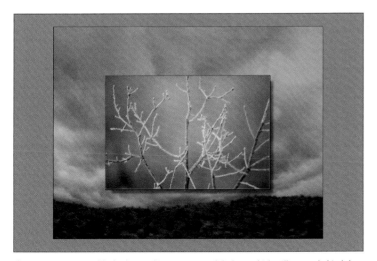

Figure 5.25 You can add a background image to your slideshow, which will appear behind the images being displayed.

If you'd like to use a simple colored background behind the images in your slideshow (Figure 5.26), select the Background Color check box. Then click the colored box to the right of the check box to bring up the Color dialog box. Select a color and click OK to apply the effect.

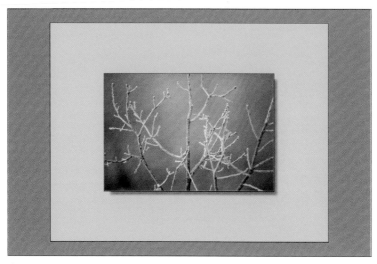

Figure 5.26 You can choose a simple colored background by using the Background Color option.

Keep in mind that you can use more than one of the Backdrop options at the same time. You can even have all of them active. For example, if you set a background color of blue and then include a background image with a reduced opacity, you'll see the background color showing through. You can then also have a color wash displayed as a gradient at a reduced opacity across the image and colored background. Just keep in mind that too much in the way of effects can distract from the slideshow itself (Figure 5.27). I suggest using all of these settings in moderation, and that you err on the side of subtlety when adjusting the settings.

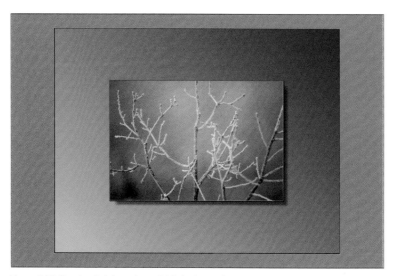

Figure 5.27 Keep in mind that using multiple background settings can create a distracting result for your slideshow.

Playback

The Playback section (Figure 5.28) provides a few settings that affect the final playback of your slideshow.

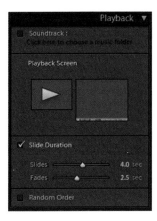

Figure 5.28 The Playback section includes settings affecting the timing and order of your images, as well as the option for background music.

As you might expect, the Soundtrack check box allows you to enable music (or other audio) that will play during your slideshow. The only option is to point to a folder that contains music (rather than an individual audio file), and there aren't any timing controls you can adjust. If you want to add music, select the Soundtrack check box, and then click the text link (or folder name if you've previously set a folder) to bring up the Browse For Folder dialog box (Figure 5.29). Navigate to the desired folder, click on it, and then click OK. The music in that folder will play when you play the slideshow.

Figure 5.29 The Browse For Folder dialog box allows you to select a folder containing the music you want to have play during your slideshow.

The Playback Screen section provides a graphical indication of the monitors available to you, allowing you to select which monitor you'd like to use for playback if multiple monitors are available. A right-pointing triangle (a "play" symbol) will appear on the monitor that is currently selected. Simply click to select a different monitor.

The Duration check box enables the actual transition between images (if you clear this checkbox you'll need to advance the slideshow manually using the left and

right arrow keys). You can then adjust a slider for Slides to determine how long each image should be displayed, and Fades to determine how long the transitions should be between images. The Fades setting is a portion of the Slides setting, meaning the transition will be part of the overall display time for each image. Therefore, be sure to use a Slides setting that is longer than the Fades setting. If, for example, they were the same, the images would constantly be in transition without any time for actually viewing the images. The ideal duration will depend on your circumstances and preference, but I usually find that a setting of 3 to 4 seconds for Slides and around 1 second for Fades creates a good pace. You might start there and then adjust as desired.

The Random Order check box causes the image order to be randomized for your slideshow. If you don't select this check box, the images will display in the slideshow in the order that they appear in the filmstrip view. If you select the check box, the order will be different every time you play the slideshow.

 Note: After you've configured the slideshow just the way you want it, don't forget to save the settings as a template that you can use later for other slideshows.

Playing and Exporting

After establishing the settings to create the desired slideshow, you're ready to review and present your show. The Export and Play buttons at the bottom of the panel on the right of the Lightroom window allow you to do just that (Figure 5.30).

Figure 5.30 The Export and Play buttons allow you to review and present your slideshow.

Playing the Slideshow

If you click the Play button, Lightroom will play the image full-screen. This is the option you'll want to use when you are playing the slideshow for clients or utilizing a digital projector.

Exporting the Slideshow

Although you can share your Lightroom slideshows very easily with those in your presence, either by having them look at your monitor or by connecting a digital projector to your computer, at times you'll want to share slideshows over greater distances. In those situations, you can export a slideshow from Lightroom into PDF format.

To get started, click the Export button at the bottom of the right panel or choose Slideshow → Export Slideshow from the menu. This brings up a dialog box where you can define the export settings (Figure 5.31).

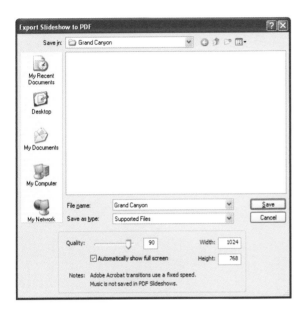

Figure 5.31 The Export Slideshow to PDF dialog box allows you to choose settings related to the export of your slideshow.

Select (or create) a folder where you want to save the PDF slideshow to be exported, and then enter a name in the File Name textbox. The Quality slider makes it possible to reduce the quality of images in your slideshow in order to minimize the size of the final file. I prefer to keep the quality at the maximum value of 100 unless I need to share the file with others via the Web or email. In that case I'll set the value down to about 75 and then check the file size of the final result. If it is still too big, you can export the slideshow again using a lower value. If the file size is still relatively small, you can export again with a larger setting. In general, you want to use the highest-quality setting possible that still results in a file small enough to transmit in the manner required by those with whom you're sharing the slideshow.

The Width and Height fields allow you to adjust the output size of the final result. Set this based on the output resolution at which the slideshow will be displayed. For most digital projectors today that will be a Width of 1024 and Height of 768, which are good values to use if you don't know what is best for your situation.

The Automatically Show Full Screen check box, as the name indicates, will cause the final slideshow to take up the entire screen display. If you turn off this option, the slideshow will play within a window. I recommend keeping this check box selected.

After you've established the desired settings, click the OK button and Lightroom will process the slideshow and write the resulting file to disk. You can then provide that file to others so they can view this slideshow of your images.

Print

Printing has long been the way most photographic images are shared with a wide audience. Even with the new options for sharing images digitally, such as via digital slideshows and web galleries, printing continues to be a popular way to share photographic images. The Print module in Lightroom initially gives the impression that it is aimed primarily at producing contact sheets from a group of images. However, after you delve into its capabilities, you'll discover that the Print module is actually quite powerful, enabling you to print single or multiple images quickly and easily in a variety of formats.

Chapter Contents

Selecting Photos

By now you're probably an old pro at selecting images in Lightroom. As you've seen in Chapter 4, "Develop," and Chapter 5, "Slideshow," selecting the images you want to work with in Lightroom is always the first step before you get started working on your images in a module. That selection process starts in the Library module, which as you've already seen—especially in Chapter 3, "Library"— provides a variety of ways for you to select the images you want to work with.

The way I generally approach printing in Lightroom is to first filter the images in the Library module by selecting a shoot or collection, or by using the Keywords or Find sections on the left panel to narrow the list of images to the group that contains the images I want to print (Figure 6.1). Which approach I take depends on how I'm thinking about the images I want to print. For example, if I need to print contact sheets for a client from a particular photo shoot, I would naturally start by choosing the folder containing the images from that shoot from the Folders section. If I'm submitting images that fit a particular concept for a project, I might start by selecting a particular keyword. Again, there are many ways to approach this process depending on how you're trying to filter your images, and a review of Chapter 3 will help you find the best way to do that when you need to print specific images.

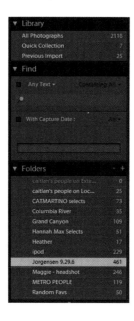

Figure 6.1 Filtering the images in the Library module by folder, collection, keywords, or any of the other options is the first step in creating a print job.

Note: Thanks to photographer André Costantini (www.sillydancing.com) for providing the many photographic images used to beautify this chapter.

Note: To quickly select all of the images on the filmstrip, choose Edit → Select All from the menu.

After I've filtered the list of images in this manner, the next step is to choose the specific images I want to put on paper by using the filmstrip (Figure 6.2). Click the first image you want to include in the print job. You can then hold Shift and click another image to select the contiguous range of images between those two images. In addition, you can hold the Ctrl/⌘ key and click individual images to toggle them between selected and not selected. After you have selected the images you want to print, you're ready to start configuring the print settings.

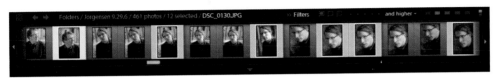

Figure 6.2 Use the filmstrip to select the specific images that will be included in your print job.

Note: Don't forget about the additional filter options available at the top-right of the filmstrip. These options can be helpful as you narrow the list of images you want to print.

Using Templates

A template in the Print module can be thought of as a definition of the page layout for your print job. It is defined with a series of settings I'll discuss later in this chapter. A template enables you to quickly select a layout for the images you want to print, and you can also create new templates defined by the settings you establish for the print job.

Selecting a Template

The left panel in the Print module contains the Preview and Template Browser sections (Figure 6.3), which work together to allow you to define the layout for your print job. The Preview section at the top allows you to get an idea of what the layout for a given template looks like, while the Template Browser allows you to select (and add and remove) templates.

The Template Browser is a simple list of the available templates, which includes those created by default in Lightroom as well as any additional templates you save (I'll talk about saving templates later in this section). You can scroll through this list to find the template for your current print needs. When you move the mouse over the name of a template in the Template Browser, a visual representation of the layout for that template is displayed in the Preview section at the top of the left panel (Figure 6.4). This provides a basic idea of what the final printed output will look like, by providing a visual indication of the size and positioning of the cells that will contain each image on the page. When you click on a template, its layout is shown in the Preview section while you work in the Print module. However, if you move your mouse over a different template in the Template Browser, that template's layout will be shown.

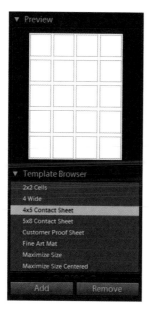

Figure 6.3 The Preview and Template Browser options on the left panel help you set the template for the print layout that you want to produce.

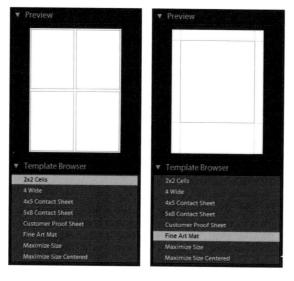

Figure 6.4 When you move your mouse over different templates in the Template Browser, the Preview section updates to reflect the layout for that template.

If this seems remarkably simple, that's because it is. When an existing template meets your needs for the current print job, simply select the images you need to print, choose the desired template, and start printing. Of course, in many cases you may want to fine-tune the layout for printing, which I'll discuss in detail in the next section.

Note: You may find after choosing a template for your printed output that you want to change the images you've selected. Keep in mind that you can maintain flexibility in your workflow, moving back and forth between image selection and configuring settings as needed.

Adding and Removing Templates

At the bottom of the Template Browser are Add and Remove buttons (Figure 6.5). These are used to add or remove (as you might expect) templates from the Template Browser. The basic process for adding a template is to first select a template that most closely matches the result you're looking for. Then adjust the settings on the right panel (covered later in this chapter) to produce exactly the layout you want. After the settings are established exactly as you want them, click the Add button at the bottom of the left panel. In the text field that appears (Figure 6.6), enter a name that describes the template and press Return.

Figure 6.5 The Add and Remove buttons are found at the bottom of the Template Browser.

Figure 6.6 The Template Browser allows you to name the template you are adding.

Note: When naming a template, I recommend using a name that describes the layout or intended use, such as *3×4 Grid* or *Customer Proof Sheet*.

If there is a template listed in the Template Browser that you don't need, you can select the template and click the Remove button to permanently remove it.

Navigating Pages

Depending on the number of images you selected for printing and the layout of the template you selected, the result may require more than one page. The toolbar at the bottom of the primary display area indicates how many pages are included in the current print job by showing the current page number and total number of pages in the job (Figure 6.7). For example, if there are two pages required based on the current settings and you are currently looking at the first page, the display will show *Page 1 of 2.*

Figure 6.7 The toolbar at the bottom of the primary display area provides information about the current and total page numbers as well as the capability to navigate to lower or higher page numbers.

You can navigate through the pages of your current print job by using the toolbar below the primary display or the options on the menu bar. The left-most button (a rectangle) will take you to the first page of the current print job. To the right are left and right arrow buttons, which will take you to the previous and next pages, respectively.

To navigate among pages from the menu, select Print and choose one of the available options to navigate. These include Go To First Page, Go To Previous Page, Go To Next Page, and Go To Last Page (Figure 6.8).

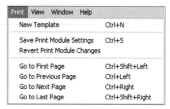

Figure 6.8 The Print menu contains four options for navigating through the pages in your current print job.

Determining Print Layout

Most of the settings on the right panel relate to the actual layout of the printed output you'll be producing (Figure 6.9). The settings related to the print layout are divided into three sections: Image Settings, Layout, and Overlays.

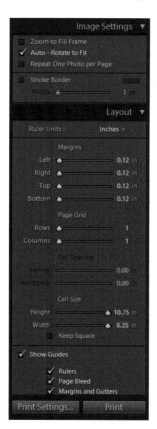

Figure 6.9 The right panel contains sections that relate to the actual layout of the printed output you'll be producing.

Image Settings

The Image Settings section on the right panel provides settings affecting how the images appear on the page. It contains a set of simple controls (Figure 6.10), but the results they produce have a fairly significant effect on the final output.

Figure 6.10 The Image Settings section on the right panel contains a set of simple controls that affect how images are used on the page.

Each image in your print layout will be sized by default to fill each cell on the page, without cropping the image. For example, if the cells are vertical but a horizontal image is inside the cell, that image will be sized to fill the width of the cell with empty space above and below the image (Figure 6.11).

Figure 6.11 By default, images will fill as much space within the cell as possible without cropping the image.

If you select the Zoom to Fill Frame check box, the image will be resized so that it completely fills the cell (Figure 6.12). If the image is the same orientation as the cell but a different aspect ratio, that means the image will be enlarged to completely fill the cell with some minor cropping resulting. When the orientation of the image doesn't match the orientation of the cell, using this option will result in more-significant cropping of the image. For example, for vertical cells and horizontal images, the image will fill the cell completely, which will result in the horizontal image being cropped to appear vertical. This setting is most useful when your focus is on the layout of the page rather than showing the entire image. You can adjust the position of each image within the cell by clicking and dragging the image directly within the cell (Figure 6.13).

Figure 6.12 If you select the Zoom to Fill Frames option, the image will be enlarged to completely fill the cell, resulting in some cropping of the image depending on its aspect ratio.

Figure 6.13 When using the Zoom to Fill Frames option, you can move the image within the cell by clicking and dragging to change its position.

Note: When using the Zoom to Fill Frames check box, you will be able to move the image either horizontally or vertically within the cell, but not both, because the image has been enlarged only as much as is needed to fill the cell.

The Auto-Rotate To Fit check box will cause images to be automatically rotated to match the orientation of the cell that contains it (Figure 6.14). By default all images will be oriented so "up" in the image is toward the top of the page, meaning that all images will appear right side up on the page. When you select the Auto-Rotate To Fit check box, some images will appear right side up and others will appear sideways. For

example, on a page layout consisting of vertical cells, the default behavior is for all images to appear right side up, so that verticals nearly fill the frame and horizontal images are smaller, but still oriented right side up. When you select this check box, those horizontal images will be rotated to vertical so they match the orientation of the cell. This setting is most useful when you want to produce a group of prints that are all the exact same size, but want to place multiple images on the same printed page for efficiency. It is obviously not ideal to view images with different orientations on the same page, so you wouldn't generally use this option if your images would be presented in this way.

Figure 6.14 The Auto-Rotate To Fit option (shown at right) causes images to be rotated as needed to match the orientation of the cells containing them.

> **N o t e :** If you want all images on the page to be the same orientation, but you don't want to have images with different orientations on the same page, the best approach is to work with the horizontal and vertical images individually, producing output for one set and then going back and producing similar output for the second set.

The next check box is Repeat One Photo Per Page. Typically, one image is placed within each cell in a template—so if there are multiple cells in the template that you're using, there will be multiple images on the page. As the name of this check box indicates, a single image will be placed in all cells on the page when this check box is selected (Figure 6.15). This means that you'll get multiple copies of each image (assuming the template has multiple cells on the page), and that more pages will be required for the complete print job. This setting is obviously most useful when you need to produce multiple sets of prints for a group of images. For example, if a portrait client wants multiple copies of the images they've selected, this option allows you to produce that output quickly and easily.

Figure 6.15 The Repeat One Photo Per Page option fills each page with multiple copies of the same image.

The final check box in the Image Settings section is Stroke Border. This will cause a border to be printed around the edge of each image on the page. When you select this option, the color box to the right will be enabled, which you can click to bring up the Color dialog box to select a color. The slider below allows you to set the width of the stroke in pixels. When a stroke is desired, I recommend using a stroke of just one or two pixels to help define the edge of your images without being overbearing.

Layout

The Layout section of the right panel contains many options for adjusting the layout of the printed page (Figure 6.16). This is the section that allows you to define how many images will appear on the page, how they will be spaced, and how the information will be shown within the primary display in Lightroom.

Figure 6.16 The Layout section contains options for adjusting the actual layout of the printed page.

The first option in this section allows you to set the unit of measure for the rulers shown to the top and left of the primary display area if the rulers are turned on (to turn on the rulers, select View → Show Rulers from the menu). Because the templates don't reference a specific paper size, it can be very helpful to have the rulers turned on so you always have an indication of how large the printed output will be with the current settings, and how large each image will appear on the page (Figure 6.17). To change the unit of measure displayed on the rulers click the drop-down list to the right of the Ruler Units label. Available options include inches, centimeters, millimeters, points, or picas. The default is Inches.

Figure 6.17 The Show Rulers option allows you to display rulers at the top and left of the primary display area.

Note: Changing the unit of measure for the rulers will also change the unit of measure for all of the controls in the Layout section that relate to size.

The Margins controls allow you to determine how close to the edge of the page the images can be printed (Figure 6.18). Four sliders are provided so you can adjust all four sides of the page individually: Left, Right, Top, and Bottom. The minimum value for each is determined by the capabilities of the currently selected printer and the settings for that printer (I'll address changing these settings in the "Output Settings" section later in this chapter). The maximum value is based on the paper size and current settings, which means it is possible to set the left margin so far to the right that no image will be printed. You can adjust each of these sliders based on a specific value you want to use, or based on a review of the primary display with reference to the rulers so you can adjust the size and positioning of all images on the page as desired.

Note: If your printer supports borderless printing, you'll need to enable this feature in the printer properties before the Margins sliders can be adjusted to a zero value.

Figure 6.18 The Margins controls allow you to adjust how close to the edge of the page the images can be printed.

The Page Grid controls include sliders for Rows and Columns so you can specify the number of images that should appear on the page (Figure 6.19). The minimum value for each is 1, because it would be pointless to have less than a single image on the page. The maximum is 15 for both Rows and Columns, resulting in a maximum of 225 images per page (Figure 6.20). That should be more than adequate for virtually any output size, and in fact is way too many for most page sizes. I recommend using the rulers for reference as you adjust these settings to get a sense of how large each image will be, and whether the setting is appropriate for the output you're attempting to produce. Be sure that you use settings for each that result in an appropriate aspect ratio for each image. If you're printing a group of images with a normal aspect ratio, you don't want to create cells on the page that are too tall and skinny, for example.

Figure 6.19 The Page Grid controls allow you to specify how many images appear on the page.

Figure 6.20 The maximum number of images per page is 225, with 15 rows and 15 columns.

The next set of sliders is for Cell Spacing, which allows you to specify the amount of space that should exist between each individual cell on the page (Figure 6.21). Sliders are provided for Vertical and Horizontal so you can adjust them individually. The minimum value is zero, which means the images may be printed with no space between them in the final output. The maximum value will vary depending on the paper size and Page Grid settings.

Figure 6.21 The Cell Spacing adjustments determine how much space will appear between individual cells on the page.

Note: The Cell Spacing sliders determine the space between cells, but not necessarily between the actual images on the printed page because some images may not fill the cell based on the other settings used.

As you are adjusting the Cell Spacing sliders, you might notice that the Cell Size sliders move in unison with them (Figure 6.22). Because the Page Grid settings determine the number of cells that appear on the page, the Cell Spacing and Cell Size settings maintain an inverse relationship. In order for the cells to be larger, there needs to be less space between them, and vice versa. You can therefore adjust the overall size and spacing of the cells by using only Cell Spacing or Cell Size. The Cell Size options include sliders for Height and Width, allowing you to designate specific dimensions for the cells.

Figure 6.22 The Cell Spacing and Cell Size sliders move in unison because changing one requires a change in the other, in an inverse relationship.

Below the Cell Size sliders is the Keep Square check box. When you select this check box, the Height and Width sliders for Cell Size are locked to the same value, so that moving one of them causes the other to adjust to the same value. This results in square cells, as the name of the checkbox indicates (Figure 6.23).

Figure 6.23 When you use the Constrain To Square option, the Cell Size sliders are locked to the same value, resulting in square cells.

Note: Using the Constrain To Square option will not necessarily result in square images on the printed page. Then printed images will show up as squares only if the source image is also square, or if you have used the Zoom to Fill Frames option.

The last set of options in the Page Layout section allows you to show or hide the various guides in the preview shown in the primary display (Figure 6.24). The Show Guides check box serves as a master control, determining whether any of the guides are visible. When you select this check box, all of the options selected below it

are displayed. When you clear this check box, none of the guides will be displayed, regardless of which options are selected below it.

Figure 6.24 The Show Guides options determine which guides will appear on the primary display.

Below the Show Guides check box are three check boxes that control the individual types of guides that you can display in the primary display. The available options are Page Bleed (shows a shaded overlay on the non-printable edge area of the page), Margins And Gutters (shows lines that identify the edge of the printable area), and Image Cells (shows lines identifying the cells containing images if the template is configured for more than one image per page).

Note: The Show Guides options are for information purposes only and won't print in your final output.

Overlays

Lightroom provides considerable flexibility in the creation of printed output that ranges from contact sheets for customers through fine-art prints. When you are producing prints that are intended for customer review or your own reference, you'll likely want to have additional information printed on the page, and the Overlays section provides a variety of options to do exactly that.

The first set of options in the Overlays section allows you to place your Identity Plate information onto the print. Select the Identity Plate check box and the current Identity Plate will be displayed on the print layout in the primary display area. The button to the right of the check box allows you to rotate the display to match the orientation of your images as needed. To change the identity plate click the dropdown in the preview area just below the Identity Plate check box, selecting Edit to make changes.

Below the preview of the Identity Plate are sliders to adjust the Opacity (reduce the setting to make the overlay more transparent) and Scale (to adjust the size). Below are two check boxes. The "Render behind image" checkbox causes the identity plate overlay to be displayed behind the images you are printing. At first glance this may seem like a useless feature, as it will at times render the overlay invisible. However, if you would like your logo to appear as a faded watermark below all images (partially obstructed by those images), this provides exactly that capability. The "Render on every image" checkbox will cause the overlay to be repeated on every image in the print layout, which can be useful as a copy-protection measure.

The Page Options check box serves as a master control for some additional print options below it (Figure 6.25). When this check box is selected, the options selected

below it will be printed. When it is cleared, the options below won't print, even if they are selected. The Page Numbers option results in page numbers being printed at the bottom-right corner of each page. The Border option determines whether a border is printed around each image. When this option is selected, a Border Width slider is enabled below it, allowing you to specify the point size of the border around each image. The Page Info option places details about whether sharpening was applied for printing and which profile and printer was used for printing. These details are placed at the bottom-left corner of the page. Finally, the Crop Marks check box determines whether marks are placed around each image to indicate the edge of the image within the cell. This option is particularly useful if you plan to cut the individual images out of the page when printed.

The Photo Info check box enables you to include various metadata fields below each image on the page (Figure 6.26). When you select the Photo Info check box additional information will be printed with each image based on the option you select from the dropdown menu to the right. The options include a variety of information you can have printed below each image, including Custom Text (which will cause a text box to be displayed below so you can enter that text), Date, Equipment, Exposure, Filename, and Sequence. You can also select Edit to change the settings for the metadata templates.

Figure 6.25 The Page Options settings allow you to specify additional information to be included on the printed page.

Figure 6.26 The Photo Info options allow you to choose specific image data that you would like to have printed below the images.

Below the check box and dropdown for the Photo Info options is a Font Size drop-down list that allows you to specify how large you want the text to appear. The smaller the font, the more information you can include in a given amount of space, but that also translates into text that is more difficult to read. For those with good eyes, I consider 8 points to be a minimum size, and you might want to use a setting of 12 or more for those whose vision isn't as acute.

Configuring Output Settings

After you've established all the settings for your print job (and saved them as a template if you think you'll want to use the same settings for a future print job), you're ready to configure the final output settings and send the job to the printer. This requires establishing output settings in the Print Job section of the right panel, as well as configuring the page setup and printer settings for your particular printer.

Print Job

The Print Job section contains options related to the actual printed output (Figure 6.27). The first option in this section is the Draft Mode Printing check box. When this option is selected, all of the other controls in this section are disabled, and Lightroom will use baseline settings for the printed output. This option is designed for producing prints quickly and doesn't result in optimal print quality. I therefore recommend using this option only when you are printing contact sheets for internal reference. For any printed output you'll share with others, I recommend turning this option off and using settings that will produce the best output possible for your printing conditions.

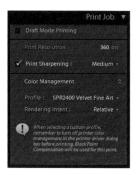

Figure 6.27 The Print Job section contains options related to the actual printed output.

The Print Resolution setting allows you to specify the output resolution that should be used for producing the final printed output. For high-quality output, I recommend a value of 360dpi, although settings as low as around 200dpi will still produce excellent results.

You already saw in Chapter 4, "Develop," that it is possible to apply sharpening to your images in the Develop module. However, this sharpening is intended primarily for compensating for the lack of sharpness in the original capture rather than the softening that occurs in the final print. The Print Sharpening check box allows you to apply some sharpening for the printed output. When you select this check box, sharpening is enabled and the strength is determined by the drop-down to the right of this

check box. The options are Low, Medium, and High. Because print sharpening is designed to compensate for the behavior of your printer in conjunction with the specific paper you're using, the best setting will vary. I recommend testing all three options, though I find the Medium setting works well across most printer and paper combinations.

The Color Management section includes options that will help you ensure the most accurate color possible in your prints. The Profile option is the key here, allowing you to specify a printer profile to ensure the most accurate results for the printer, ink, and paper combination you're using for printing. When you click on the drop-down, the options include Managed By Printer, any printer profiles you've previously selected, and Other (Figure 6.28).

Figure 6.28 The Profile drop-down contains various options for setting the color management option to be used for the current print job.

Selecting the Managed By Printer option causes Lightroom to send the data to the printer without any compensation to ensure the most accurate results. This means that the printer properties will determine the accuracy of the final output. This isn't an option I recommend. Instead, I recommend using a custom printer profile for the specific printer, ink, and paper combination you're using for this print job. If you have previously selected a printer profile to be included on this list, you can simply select it from the list.

If you need to specify a printer profile that is not on the drop-down list, select Other to bring up the Choose Profiles dialog box (Figure 6.29). This dialog box includes a list of all profiles available on your system, with check boxes to the left of each. To make a profile available on the drop-down list, simply select the check box to the left of the profile name. Click OK when you are finished selecting profiles to include, and the list on the drop-down will be updated to reflect all selected profiles from this list. You can then select the specific profile you want to use from the drop-down.

The Rendering Intent option is a drop-down list that allows you to choose between Perceptual and Relative (the full name is Relative Colorimetric) rendering intents (Figure 6.30). A rendering intent determines how colors in your images that can't be produced by your printer with the ink and paper you are using will be handled. The Perceptual rendering intent causes the color gamut of the entire image to be compressed to fit within the color gamut that the printer is able to produce. This ensures that the relationships between all colors in the image are retained, but also results in a less vivid printed image. The Relative rendering intent leaves colors that are in the gamut as-is. Out-of-gamut colors are shifted to the closest in-gamut value. This means that the relationships between colors can be modified, but it also means that only colors that can't be printed get changed. I therefore prefer to use the Relative option.

Figure 6.29 The Choose Profiles dialog box allows you to select which profiles should be listed on the Profile drop-down.

Figure 6.30 The Rendering Intent drop-down allows you to choose between the Perceptual and Relative rendering intents.

Note: You can learn more about color management from my book *Color Confidence, Second Edition: The Digital Photographer's Guide to Color Management* (Sybex, 2006).

Page Setup

Note: Although the Page Setup options are being covered near the end of this chapter, you may find it helpful to apply them early on as you create a print job in the Print module so the preview reflects the output paper size you'll ultimately be using.

Below the primary display area is a Page Setup button that allows you to change the page settings for the print job (Figure 6.31). Clicking this button brings up the Print Setup dialog box. This dialog box allows you to select the printer you want to send the print job to, as well as to set the paper size and source options. I don't ever use the options here, because I can access them by clicking the Print button. However, if you need to only adjust the paper size so you can see the effect immediately in the primary display area, this is a quick way to do so.

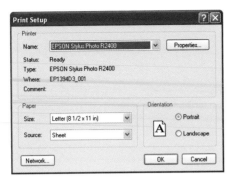

Figure 6.31 The Page Setup button enables you to change the page settings for the current print job.

Print

At this point you have configured a number of settings for your print job, and from the perspective of Lightroom you're ready to send the job to the printer. The next step is to click the Print button at the bottom of the right panel (Figure 6.32) to start the actual print process.

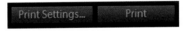

Figure 6.32 Clicking the Print button at the bottom of the right panel is the first step in sending the print job to the printer.

Of course, you still have some more settings to configure. When you click the Print button, the Print dialog box appears (Figure 6.33). This dialog box allows you to select the printer you want to use for output. Select the desired printer from the Name drop-down list and then click the Properties button. This brings up the printer properties dialog box for your printer, which means the settings you need to use will vary depending on the specific model of printer you are using (Figure 6.34). Configure all settings for the desired output and click OK. Be sure that you have selected the appropriate option (such as "No Color Adjustment") to ensure that the printer won't apply any adjustments to your output if you have selected a specific profile in the Print Job settings of Lightroom.

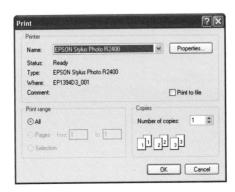

Figure 6.33 When you click the Print button, the Print dialog box appears.

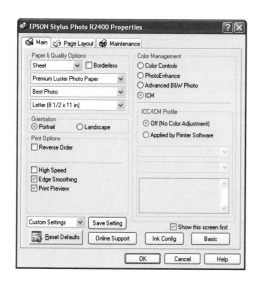

Figure 6.34 Clicking the Properties button in the Print dialog box opens the properties dialog box for your specific printer. Shown here is a sample printer properties dialog box for the Epson Stylus Photo R2400 printer.

After you have configured the printer properties, click OK to return to the Print dialog box. Click OK in that dialog box, and the job will be sent to the printer.

For many photographers, the output settings will be exactly the same for every print job because they tend to use the same printer, ink, and paper combination for all printing. If that is the case, you don't need to reconfigure the printer properties because they'll be exactly the same as the last time you printed. If you hold the Alt/Option key before clicking Print, Lightroom will bypass the Print dialog box and send the print job directly to the printer using the current printer properties. This is especially helpful if you need to send several different print jobs to the same printer during a single session and you don't want to set (or confirm) the settings for each and every print job. You might notice as you hold the Alt/Option key that the Print button changes to no longer show an ellipsis after the word *Print*. The lack of an ellipsis indicates that a dialog box will not be presented before the command is executed.

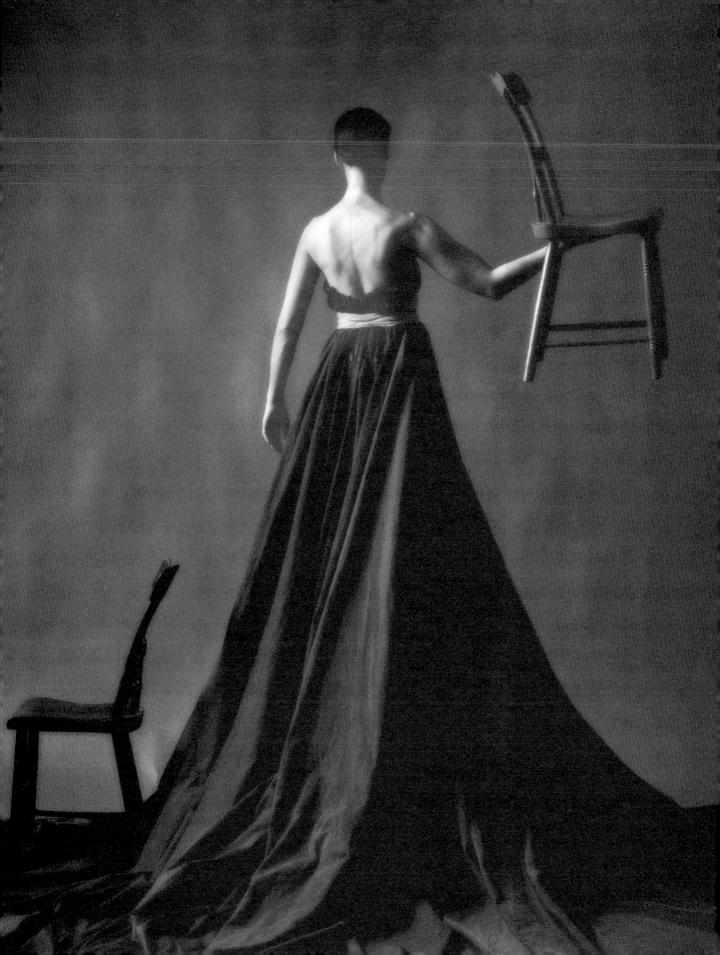

Web

Gone are the days when photographers would share a collection of images almost exclusively as prints. Although prints are still a major and important part of the process of sharing photographic images, photographers are increasingly sharing their images via the Web. Doing so provides a quick way to show clients the results of a photo shoot and a convenient way to make an entire portfolio available. Lightroom makes it remarkably easy to share your images in a web gallery, providing a simple solution that still offers the ability to customize the result that your website visitors will see.

7

Chapter Contents

Selecting a Web Gallery

The process of creating a web gallery in Lightroom is very similar to creating a slideshow. The Web module includes a variety of settings that allow you to customize the website appearance. The process is simply a matter of creating a collection of the images to be included, configuring the settings, and then saving the resulting files or having them posted automatically to a website.

The best part is that after you've defined a preset (or template) for your web gallery, creating a gallery with a set of new images requires almost no time at all. You select the images, select the preset, and post your images. That represents a tremendous benefit in terms of efficiency, and provides a clear example (along with others demonstrated earlier in this book) of why workflow software such as Lightroom can help you with your day-to-day tasks related to your photography.

Selecting images for a web gallery is identical to selecting images for a slideshow as discussed in the Chapter 6, "Print." By way of review, the process generally starts by selecting an appropriate option from the Library module (Figure 7.1) in the Library, Folders, Collections, or Keywords sections of the left panel. If you want to further refine a selection of images to use for a web gallery, you can add them to the Quick Collection and use that as the basis of your gallery. You can refer to Chapter 5, "Slideshow," for a review.

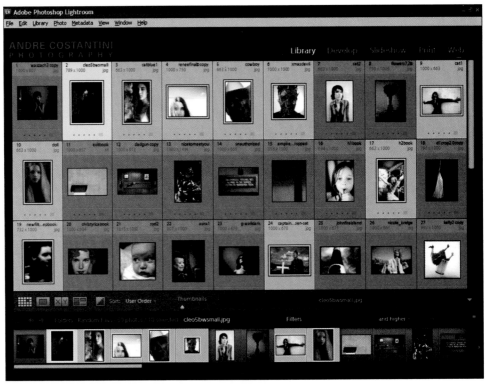

Figure 7.1 After you've defined the images to be included in the web gallery, you're ready to start creating the site.

It is worth noting that if you change the selection of images while you're in the middle of working on a website, the gallery preview and therefore the final web gallery will be automatically updated on the fly to reflect the change in images to be included.

> **Note:** Thanks to photographer André Costantini for providing the incredible images that grace the pages of this book. More of his work and details about him can be found on his website at www.sillydancing.com.

Configuring the Website

After you've selected the images you want to include in the web gallery, you're ready to start defining the appearance and other settings for the gallery. As you adjust settings, the preview in the primary display area updates automatically to reflect the changes you make. This makes it easy to fine-tune the settings to your liking, because you can immediately get an idea of what setting you like best.

Gallery Template

I recommend starting the process of configuring your web gallery with the left panel, where you can select a template from the Template Browser (Figure 7.2). A template saves all the settings made in the right panel, which means it is effectively a shortcut to a specific gallery configuration, or to a setup that you want to start from as you define a new style.

Figure 7.2 You can select a template from the Template Browser on the left panel to start the process of defining the settings for your web gallery.

When you hover the mouse pointer over a name in the Template Browser, a preview of the layout appears in the Preview section above (Figure 7.3). This gives you a general sense of the overall appearance of the gallery as it will appear with the saved settings, and of course you can always fine-tune the results at any time.

Figure 7.3 When you move the mouse over a name in the Template Browser, a preview of the layout appears in the Preview area above.

 Note: The Preview section shows previews only for templates included with Lightroom. If you add your own templates, they will not include a preview.

After you've found the template that best meets your needs, click on it and you're ready to start fine-tuning the settings on the right panel.

Adding and Removing Templates

As long as we're looking at the left panel, it is worthwhile to discuss the Add and Remove buttons at the bottom of the panel. The Add button provides you with the ability to create a new template. When you click this button, a new template called "Untitled Template" will be added to the list, and you can simply start typing to rename it to something more meaningful for you, then press Enter/Return (Figure 7.4).

Figure 7.4 After you've added a preset, it will appear on the Template Browser list so you can access it for any future galleries.

If you decide that you need to remove a preset for any reason, select it from the Template Browser list and click the Remove button. You will not be prompted to confirm that you are sure you want to remove the preset, but you can choose Edit → Undo if you remove a template by mistake.

Gallery Settings

On the right panel you'll find a wide variety of settings that allow you to fine-tune the appearance and behavior of your web gallery (Figure 7.5). As you've seen in the other modules, the settings are divided into sections.

Figure 7.5 The right panel includes many settings for fine-tuning the appearance and behavior of your web gallery.

Gallery

The Gallery section includes options that enable you to choose a style to apply to the web gallery you're creating. I really think of this as a reflection of whether the template you selected will produce an HTML or Flash website. If you change this option the template you already selected will also be removed. I therefore recommend that you never use this Gallery option, and instead use the Template Browser to set the overall appearance of your web gallery.

Note: The Gallery section will not move when you scroll the right panel in the Web module, so it will always be visible.

Labels

The Labels section relates to the text labels that will appear in the web gallery. Available options differ depending on the preset you're using, but the concept is the same for all of them. Below the title of these fields, you can click and modify the text. You can also select from recently used values by using the pop-up menu to the right of each field. These will include the values you have previously entered in the fields, providing quick access to the text you're most likely to use for future web galleries. You don't need to do anything to add a value to the list. After you have entered new text and moved the cursor out of the field, the text will be added to the list automatically.

Note: Besides updating values in the Labels section, you can also change the text by clicking on it within the primary display and then typing a new value.

One text label that deserves special attention is the Web or Mail Link option. The value you enter here will be used as a link for the Contact Name label. This allows you to either have a contact page be displayed when the label is clicked, or have a new e-mail message created to be sent to an address you specify. For example, if you want to have the user taken to a contact information page that includes a variety of information, you can enter the web address for the contact information page on your website. If you want the link to generate an e-mail to you, simply enter "mailto:" and then your e-mail address.

Color Palette

The Color Palette section allows you to define a color scheme for the web gallery by defining colors for specific elements. To change a color, click on the colored box to the left of the field name. That brings up the Color dialog box, where you can select the color you would like to use for that element. There are different color options for the Flash Gallery and HTML Gallery presets (Figure 7.6).

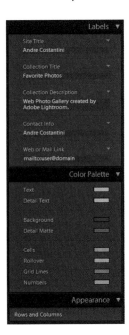
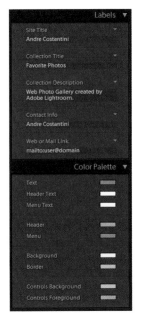

Figure 7.6 The Flash Gallery (left) and HTML Gallery (right) presets include different options for colors.

The color options for the Flash Gallery preset are as follows:

Text defines the color of the title and caption text if you add that text (discussed later) to your gallery.

Header Text defines the color of the Site Title text you have defined, which appears in the header of the page.

Menu Text defines the color of the text that appears on the menu bar.

Header defines the color of the bar that includes the title and appears across the top of your gallery page.

Menu defines the color of the menu bar that appears below the header.

Background defines the color of the background for the overall page.

Border defines the color of the borders that appear around the display areas of your gallery.

Controls Background determines the background color of the control buttons that appear in your gallery (for example, for navigating to the next image).

Controls Foreground determines the foreground color of the control buttons that appear in your gallery.

The color options for the HTML Gallery preset are as follows:

Text defines the color of the primary text (such as headings) that appears on the pages in your web gallery.

Detail Text defines the color of other text within the gallery, such as the text links used to navigate to the previous and next images.

Background defines the color of the background for the overall page, which does not include the cells in which the thumbnails are displayed.

Detail Matte defines the color of the area around the large image (displayed when you click on a thumbnail) in the gallery.

Cells defines the color of the cells in which the thumbnails are displayed.

Rollover defines the color of the cells in which the thumbnails are displayed when the mouse pointer is hovered over the cell.

Grid Lines defines the color of the lines that divide the display area (cells) for each of the thumbnail images.

Numbers defines the color of the index numbers that appear in the top-left corner of the thumbnail images in your web gallery.

Appearance

The controls available in the Appearance section vary based on whether you are using an HTML or Flash preset. If you are using the HTML Gallery preset, it will include additional controls that allow you to specify the appearance of thumbnails in the gallery. The Rows and Columns control is a grid that allows you to specify how many thumbnail images should be displayed on a single "page" in the gallery. To set a value, simply click on the grid to define the number of images you want on each page. Think of it as clicking at the bottom-right corner of the page of thumbnails to define the grid. The minimum is nine images in a 3×3 grid, and the maximum is forty images in an 8×5 grid. Below this control is the Show Cell Numbers check box. Selecting this check box causes index numbers to appear in the cell for each thumbnail image. This can be helpful for clients who need to refer to a specific image on a given page of thumbnails, but using this option is largely a matter of personal preference.

The Identity Plate option is available for both HTML and Flash galleries. You saw in Chapter 2, "Configuring Lightroom," how you can customize the identity plate display in Lightroom. You can use those same settings to display an identity plate as the main header of your web gallery. To include the identity plate, select the Identity

Plate check box. This will cause your Lightroom identity plate to be used in the web gallery. If you'd like to change the settings, click on the identity plate box in the Appearance section and choose Edit from the popup menu.

The final option in the Appearance section is the Web or Mail Link option, which is only available for HTML galleries. As with the text label available in the Labels section, this allows you to turn the identity plate into a link to a different web page or e-mail address. The most common use of this option is to create a link to the home page on your website. Enter a website address or "mailto:" followed by your e-mail address in this field and that link will be used for the identity plate display.

Output Settings

The Output Settings section allows you to specify the size and quality of the JPEG images created for your web gallery. The specific controls vary based on whether you are using an HTML or Flash template for your web gallery.

For an HTML gallery the size of the "large" image displayed when the user clicks a thumbnail is controlled by a Preview slider (you can't adjust the size of the thumbnail images for HTML galleries). The default value is 450 pixels (for the "long" side of the image), which represents a good compromise. For one thing, the end user may not have their display set to a particularly high resolution, and so you don't want the images to be too large or they may extend off the available display area. Also, it is a good idea to limit the size of the images so that if they are taken without your permission they aren't particularly useful.

For a Flash gallery you can designate a size for both the thumbnail and preview images. Both are controlled by a dropdown that includes options for Small, Medium, Large, and Extra Large. While the same options are available for both the Thumbnail and Preview controls, the resulting images won't be the same size (a "small" thumbnail is much smaller than a "small" preview).

Both types of gallery include the Quality slider. Obviously it is always preferred to have your images displayed at the best quality possible, but that also results in larger file sizes. I find a setting of about 80 provides an excellent balance between file size and image quality. The files remain relatively small, but the quality is still very good.

Selecting the "Add Copyright Watermark" check box at the bottom of the Output Settings section will place a text overlay over each image reflecting the information you have entered in the Copyright field in the Metadata section of the Library module. The main decision to be made here is whether you want to mark your images as your own, or whether you want to provide a more pleasing viewer experience by not having any marks on the images.

Image Settings

The Image Settings section (Figure 7.7) contains two options that allow you to include a Title and Caption for each image. However, it is important to understand how these fields work so you'll get the expected results. Whatever is entered into these fields applies the same to all images in your web gallery. In other words, if you were to type a title

and caption for a single image, that same title and caption would apply to all images within your gallery—you wouldn't have individual captions for each image. This would seem a bit pointless if not for the power of metadata.

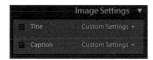

Figure 7.7 The Image Settings section of the right panel includes options for applying Title and Caption text to the images in your web gallery.

As you saw in Chapter 3, "Library," you can view and apply a significant amount of information about each photo via metadata. That metadata can be leveraged for the Title and Caption fields in the Web module. Therefore, you'll first need to apply metadata to your images if you're going to use this option effectively for a web gallery. This probably comes as no surprise, but I recommend using the Title and Caption fields of IPTC metadata for the Title and Caption fields in the Image Settings section. However, you aren't restricted to using those fields, so feel free to come up with your own system if there is other information you would like to display. Regardless of the metadata fields you'd like to use for these options, be sure those fields have data in them. You can use the Library module to add or modify metadata for your images.

It is worth noting that there are slight differences in how the Title and Caption fields appear in the Flash Gallery versus HTML Gallery presets. Because the Flash Gallery preset causes the large image to be displayed as part of the main page, the title and caption information is displayed as soon as you view the gallery. The HTML Gallery preset doesn't show the large image until you click on one of the thumbnails, so the title and caption information isn't visible immediately upon opening the gallery.

To actually apply a metadata field to the Title or Caption, select the check box for one (or both) and then select an option from the dropdown to the right. A variety of common options are included in the popup menu (Figure 7.8).

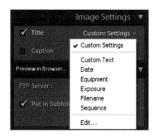

Figure 7.8 To add a metadata field to the Title or Caption text, select the desired option from the pop-up menu.

If you select the Custom Text option from the dropdown, a Custom Text field will be displayed below and you can enter anything you'd like here. Just remember that whatever you enter will appear as a title or caption for every single image in the gallery.

If you'd really like to customize the title or caption displayed for your images, select Edit from the dropdown. This will bring up the Text Template Editor dialog box, which enables you to define a structure that incorporates metadata into the title or caption for your images.

In the various sections of the Text Template Editor dialog box you can select a metadata field from the appropriate dropdown. You can then use these fields to construct a custom text that includes metadata values. As an example, let's assume you want to apply a title to each image that indicates the photographer's name and the date the image was captured. This example assumes you have entered your name in the Creator field of IPTC metadata. Start by entering Photographed By and a space in the large text box at the top of the Text Template Editor dialog box. Then select Creator from one of the dropdowns in the IPTC Data section and click the corresponding Insert button. Then press the spacebar and type "on" and spacebar again. Make sure the Date Time Original option is selected in one of the dropdowns in the EXIF Data section and click the corresponding Insert button. This will define the naming structure for your images (Figure 7.9). Click Done and the changes will be applied and reflected in the preview for your web gallery.

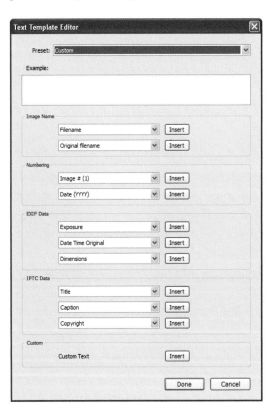

Figure 7.9 You can use the Text Template Editor to define custom text to be used as a Title or Caption for your images in a web gallery.

Output

The Output section of the right panel (Figure 7.10) contains the settings required to allow Lightroom to post the web gallery files to a web server so the gallery will be available to anyone with an Internet connection.

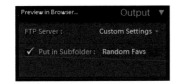

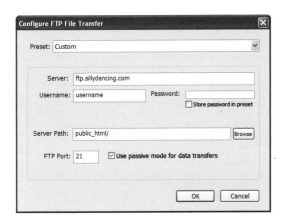

Figure 7.10 The Output section of the right panel allows you to configure settings for uploading web gallery files to your server.

The first time you prepare to post a web gallery to your website, you'll need to add a new preset for your site. To do so, click the FTP Server drop-down and select Edit Presets. In the Configure FTP File Transfer dialog box (Figure 7.11) you can enter the information so Lightroom can automatically post the web gallery to your site.

Figure 7.11 The Configure FTP File Transfer dialog box allows you to establish settings for uploading web gallery files to your server.

The following options are available in the FTP Presets Editor dialog box:

Server is the specific address of the server you will post your files to. This is usually a file transfer protocol (FTP) address. Check with your Internet service provider for this information.

Username is the login name you need to use in order to access your server.

Password is the password you need to use in order to access your server.

Store Password In Preset is an option to have Lightroom remember your password. Selecting this check box will make it easier to upload web galleries to your site, but you may not want to save the password if you share your computer with others.

Server Path allows you to specify a location on your server to save the galleries. I recommend using a specific folder on the server for your web galleries. To select a folder based on the server and login details you already provided, click the Browse button.

FTP Port should be left to 21 unless your Internet service provider instructs you to use a different value. Leave the Use Passive Mode For Data Transfers check box unselected unless instructed to do otherwise by your Internet service provider.

Note: To save these settings as a preset, click the Preset dropdown, select Save as New Preset, enter a name in the New Preset dialog box, and click Create.

After you've entered the appropriate values, click the OK button. If you created a new preset it will be available from the FTP Server drop-down list so you can select it as you prepare to post your web gallery.

The Put in Subfolder check box allows you to have the web gallery created in a folder within the main folder you selected in the Configure FTP File Transfer dialog box. In most cases you'll want each web gallery you create to be placed into its own folder, instead of replacing the gallery you created last. Therefore, you'll want to select this check box. The default name for the subfolder will be the name of the folder for the images you are currently using in the gallery, but you can change this if desired. Below the checkbox you will see an indication of the folder location on the server where the images will be placed.

At any time you can click the Preview In Browser link in the Output section to view the gallery with the current settings in your web browser (Figure 7.12), without the need to post the files to a web server.

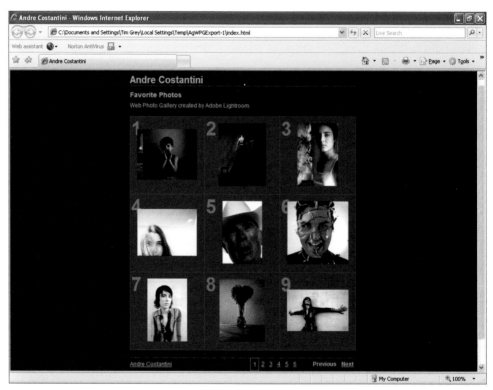

Figure 7.12 When you have finished configuring your web gallery, clicking the Preview In Browser link in the Output section will open the site in your default web browser.

Publishing the Website

After you've configured all the settings for your web gallery, you're ready to publish. There are a couple of options available to you depending on your specific needs and how you intend to share your images. The most automated option is to publish directly to your website by using the settings you established in the Output setting of the right

panel. However, you can also export the files to your local computer and then view the site in a browser, share those files with others, or even upload them manually later. Both of these options are available by using the Export or Upload buttons at the bottom of the right panel ▮Export... ▮Upload...▮.

Export

Usually the idea of a web gallery is to post the files to a website so anyone with an Internet connection can view the images. However, at times you'll want to save the files to your local computer instead. This may be for the purpose of sharing the gallery on a computer serving as a kiosk in your gallery, or so you can send the files on a CD or other media to share with clients, or for a variety of other purposes.

If you want to save the web gallery files to your computer, you can click the Export button at the bottom of the right panel. This brings up the Save Web Gallery dialog box (Figure 7.13), where you can specify a location for saving the files. While you're specifying a location where you want to save the files, think of this as a typical Save As dialog box, where you're specifying both a location and filename for the file to be saved. In this case, that filename translates into the folder name that will contain the many files that make up your gallery.

Figure 7.13 The Save Web Gallery dialog box allows you to specify the folder and filename for the gallery, which will determine where the main folder for the gallery will be created and what it will be called.

For example, if you want to Export the files into the Web Galleries folder under the name Favorites Gallery, you would select the Web Galleries folder in the Save Web Gallery dialog box and then type **Favorites Gallery** in the File Name field. The result will be a folder called Favorites Gallery in the Web Galleries folder, with all of the files necessary for the website saved within the Favorites Gallery folder. When you click the Save button, Lightroom will process your images and create all the necessary files (Figure 7.14). You can then navigate to the location where the images were saved and double-click the index document to open your web gallery in your web browser.

 Note: Choosing File → Export from the menu produces the exact same result as clicking the Save button at the bottom of the right panel in the Gallery module.

Figure 7.14 When you click Save, Lightroom creates a folder in the specified location containing all the files required for your gallery.

Upload

The final step in making a new web gallery available on the Web is to click the Upload button at the bottom of the right panel. When you do so, you might initially think that Lightroom didn't respond. But if you look up at the left side of the identity plate, you'll see that Lightroom is indeed processing your web gallery.

After the progress indicator disappears, you'll know that the gallery is live on your website. The address for accessing your gallery will be based on the FTP Server configuration settings you set along with the Server Output Path you specified. For example, if your website is www.example.com, and you entered **gallery** in the Put in Subfolder field, the final address will be www.example.com/gallery/.

Private Web Gallery

Many photographers want to take advantage of the convenience of having a gallery of images available on the Internet without making the images available to anyone in the world who has an Internet connection. In those cases you'll want to protect your web gallery with a password.

Although Lightroom doesn't include the ability to create a password-protected gallery, you may still be able to accomplish this by working directly with the company that hosts your website. The basic process involves marking a folder as password protected, and then defining a username and password for that folder. That way, whenever someone tries to navigate to that folder, they'll be required to enter a username and password before they can view the folder's contents. The specifics of how to accomplish this will depend on your server configuration, so contact your hosting service or Internet service provider for details.

Keep in mind that even if you aren't able to password-protect your web gallery, the simple fact that the files are contained within a folder and that your website doesn't include a link to that folder offers some level of protection. For example, if your website is www.sillydancing.com, and you place the files in a folder called notforpublicconsumption, it would be necessary to type the full address (www.sillydancing.com/notforpublicconsumption) into the address bar of a web browser in order to locate the site, provided there aren't any links to the gallery from elsewhere on your site (or anyone else's). This isn't foolproof protection, but does prevent casual web surfers from finding your gallery if you don't make it available from your main website.

Review

I mentioned the Preview In Browser link earlier (or the button by the same name at the bottom of the primary display area), which allows you to review the web gallery in your web browser before saving the files or posting them to the Web. However, I still recommend carefully reviewing your gallery before sharing it with others, just to make sure everything is working properly and is configured exactly the way you want it.

If you are sharing files that you have saved directly to your computer via the Save option, be sure to navigate to the folder where the files are located and double-click the index file to view the site in your web browser. I also recommend reviewing the files on the final media you'll be using to share the files. For example, if you're going to put the web gallery files onto a CD to send to a client, first put that disc into your drive and review the contents to be sure everything is working properly.

If you are posting the files to a server on the Internet, be sure to visit the site yourself and confirm everything is working properly before you send the web gallery link to anyone else. You want to be sure you find any problems before someone else visits the site and gets a bad impression.

After you've been working with Lightroom for a while, you'll have confidence in the results you're producing, and you won't find it necessary to click every link and view every image. However, when you're getting started creating web galleries in Lightroom, it is a good idea to review the web gallery in great detail before sharing with others. That doesn't just mean looking for problems. You want to be sure you had all the settings and options set the way you want them, producing a result you're happy with. You also want to be familiar with how the web gallery functions so you can explain it to your clients or others you share the gallery with, and so you can answer any questions they may have. For example, you may want to point out that galleries created with the Flash Gallery preset include a button that hides or shows the filmstrip along the bottom of the page. Hiding that filmstrip causes the large image to be even larger, which can improve the user experience.

After you've reviewed the web gallery and feel confident that everything is configured just the way you want it and is working properly, you can share the gallery with others so they can review your images.

Workflow Overview

As you've seen throughout this book, Light-room has a tremendous amount to offer the digital photographer. Although you have become very familiar with how to use Light-room by reading this book, you may find from time to time that it is helpful to have a refer-ence to guide you through a typical workflow. In this appendix I'll present a summary of a workflow that revolves around Lightroom. This appendix assumes that you have already set all the appropriate preferences and settings discussed throughout this book, so you're able to simply step through your normal workflow.

Import Import the images from your latest photo shoot into Lightroom by using the Import function in the Library module. Apply any metadata that can pertain to all images in this shoot (for example, common keywords) to make the most of the import process (which can include downloading directly from your digital media cards if you haven't already done that).

Review Review the imported images by using the Library module. Start by deleting any images that you don't feel are worth keeping, such as those that have extreme exposure problems or that are completely out of focus. You'll start to get a sense of your favorite images at this time as well. This is a good time to rotate any images that weren't rotated to the proper orientation automatically, as well as to start assigning star ratings to the images.

Collections Add selected images from this photo shoot to a collection as appropriate. For example, if you have a "favorites" collection or a collection of images for a project you're currently working on, drag the desired images into those collections.

Metadata Assign metadata to your images. This includes assigning star ratings to your images based on your own ranking of them, assigning keywords to the images in groups as well as individually, and updating other metadata fields as appropriate such as copyright and photographer information.

Optimize Switch to the Develop module and start applying adjustments to your images to optimize their appearance. You can use the presets to apply various effects to images, and also use specific tonal and color adjustments. For images captured under similar settings, you can select a group, apply adjustments to the first image, and then apply those adjustments to the entire group of selected images. For images that require targeted adjustments, edit them in Photoshop before returning to Lightroom.

Slideshow If you'll be sharing your favorite images as a digital slideshow, go back to the Library module or use the filmstrip to select the images you want to include in the slideshow. Then go to the Slideshow module, select a template, fine-tune the settings for the show, and either export or play the slideshow depending on how you'll be sharing it with others.

Print To create prints, again select the images you want to print and go to the Print module. Select a template, ensure that the images you want to print are selected on the filmstrip, fine-tune your settings, and click Print to send the images to the printer.

Web After selecting the images you want to share on a web gallery by using either the Library module or the filmstrip, go to the Web module. Choose a template, adjust the settings as desired, and click Upload to post the gallery to your server.

Index

straightening/rotating images, 86–88
Sync button, 125–126
tonal adjustments, 103
Tone Curves, 108–110
vibrance and saturation adjustments,
 107–108
view options, 80
Develop View, 38–39
digital media cards. *see* memory cards
Digital Negative (DNG), 44
digital photography
 switching from film to digital media, 2
 workflow, 2–3
DNG (Digital Negative), 44
downloading images
 importing and, 50–51
 in workflow reference, 194
draft mode, print jobs, 171
drop shadows, 138–139
duplicates, ignoring duplicate photos during
 import, 45
duration settings, slideshow playback options,
 149–150

E

E shortcut, for Loupe view, 56
Edit Photo dialog, 127
editors, external
 as alternative or supplement to Develop
 module, 127
 preferences, 25–26
EV (exposure value), 104. *see also* exposure
evaluating images
 creating image stacks, 65–67
 deleting outtakes, 65
 filmstrips for, 63–65
 histogram for, 65
 Lights Out option, 60–61
 Navigator section, 62–63
 overview of, 56
 view modes for, 56–60
EXIF, metadata, 71–72
Expanded Cells, Grid View
 compared with compact cells, 32–33
 extra options, 35
exporting images
 overview of, 73–75
 to website, 189–190
exporting slideshows, 151–153

exposure
 adjusting in Develop module, 104
 adjusting in Quick Develop section, 70
 zones of histogram, 99
exposure value (EV), 104
external editors
 as alternative or supplement to Develop
 module, 127
 preferences, 25–26
eyedropper tool, 102

F

File Browser, adding to Adobe Photoshop, 3
file formats
 control for, 25
 exporting images and, 74
 exporting slideshows and, 152
 image adjustments and, 96
file handling options, importing images, 44–45
file management, preferences, 26–27
File Settings, exporting images, 74
file transfer protocol (FTP), 187–188
Filename Template Editor, 46
filenames
 File Name Generation in File Management,
 27
 renaming files during import, 46–47
fill light
 adjusting in Develop module, 105
 zones of histogram, 99
film, digital media compared with, 2
filmstrips
 for evaluating images, 63–65
 filtering options, 131
 overview of, 21–23
 selecting all images, 156
 selecting images for printing, 157
 selecting images for slideshows, 132–133
filtering images
 Collections options, 53–54
 Find options, 52–53
 Folders options, 53
 Keyword Tags options, 55
 Library options, 52
 Metadata Browser options, 55–56
 overview of, 51
 printing and, 156
 slideshows and, 131–132
 web galleries and, 178

201

■

INDEX

INDEX